2495

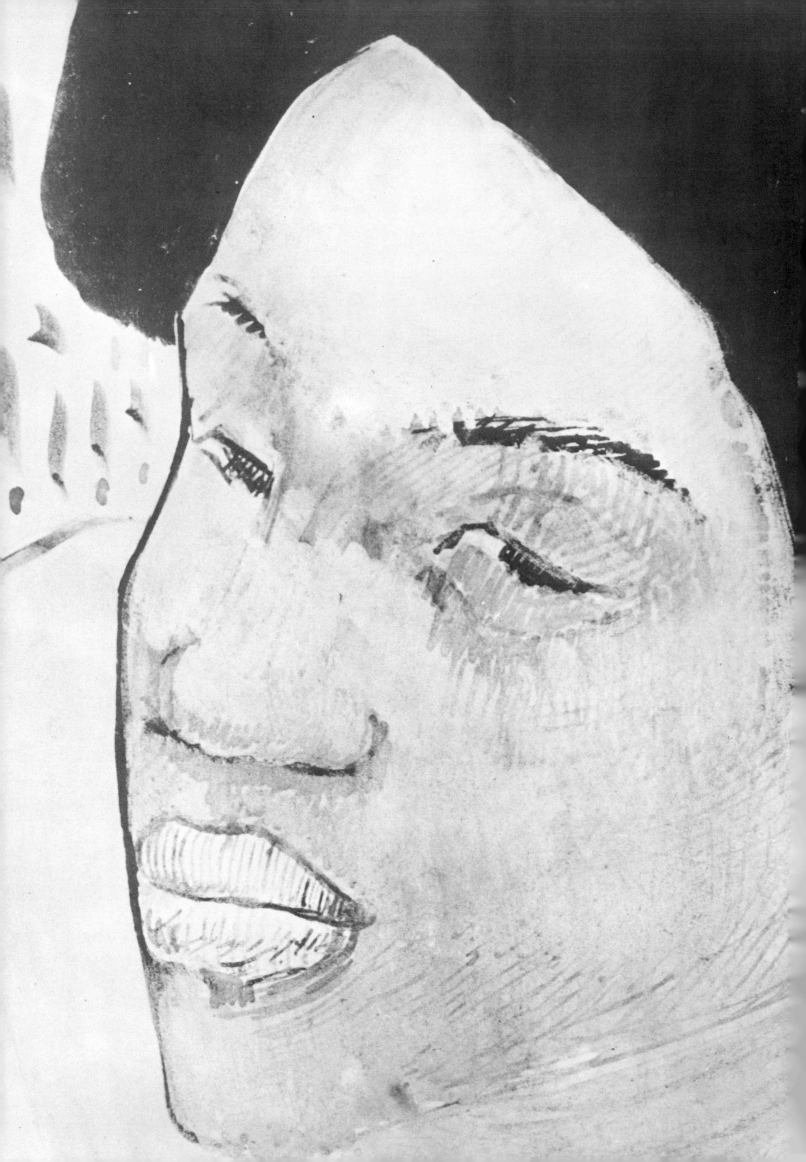

The drawings of Gauguin

Ronald Pickvance

Paul Hamlyn
London/New York/Sydney/Toronto

Acknowledgments

The works by Gauguin in this volume are reproduced by kind permission of the following collections, galleries and museums to which they belong: Mr and Mrs Arthur G. Altschul, New York (Plate 40); Art Institute of Chicago (Plate 94); Art Institute of Chicago: The David Adler Collection (Plate 65); Art Institute of Chicago: Gift of Tiffany and Margaret Blake (Plates 67, XII); Art Institute of Chicago; Gift of Mrs Emily Crane Chadbourne (Plates 69, XV); Art Institute of Chicago: Given in memory of Charles B. Goodspeed by Mrs Gilbert W. Chapman (Plate 16); Mr R. A. Bevan, Colchester (Plate 90); Mr and Mrs Leigh B. Block, Chicago (Plates 49, 59, 101); Trustees of the British Museum, London (Plate 110); Mr and Mrs Sidney F. Brody, Los Angeles (Plate XIII); Brooklyn Museum, New York (Plate XI); Cabinet des Dessins, Musée du Louvre, Paris (Plates 1, 14, 15, 21, 22, 53, 63, 64, 66, 80); Mrs Gilbert W. Chapman, New York (Plate 39); Chrysler Art Museum, Provincetown (Plate 115); Cleveland Museum of Art: Mr and Mrs Lewis B. Williams Collection (Plate 70); Courtauld Institute Galleries, London (Plate 92); Des Moines Art Center, Iowa: John and Elizabeth Bates Cowles Collection (Plate 61); Fogg Art Museum, Harvard University: Bequest of Marian H. Phinney (Plate XIV); Fogg Art Museum, Harvard University: Bequest of Meta and Paul J. Sachs (Plate 43); Fogg Art Museum, Harvard University: Bequest of Grenville L. Winthrop (Plate 87); Mr Ira D. Gale, London (Plate 91); Glasgow Art Gallery and Museum: The Burrell Collection (Plate II); Mr and Mrs William Goetz, Los Angeles (Plate 38); Göteborgs Konstmuseum (Plate 2); Graphische Sammlung Albertina, Vienna (Plate 36); Mr and Mrs Paul Kantor, Beverly Hills (Plate 3); Mrs Siegfried Kramarsky, New York (Plate 46); Mr and Mrs David Lloyd Kreeger, Washington (Plate I); Kupferstichkabinett, Basle (Plates X, XVI); Mr and Mrs Alex M. Lewyt Collection, New York (Plates 57, 83); Marion Kooglcr McNay Art Institute, San Antonio, Texas (Plate VI); Mr and Mrs Paul Mellon, New York (Plate 18); Metropolitan Museum of Art, New York: Bequest of Adelaide Milton de Groot, 1967 (Plate 68); Metropolitan Museum of Art, New York: Rodgers Fund 1921 (Plate 93); Metropolitan Museum of Art, New York: Rodgers Fund 1922 (Plate 30); Musée des Arts Africains et Océaniens, Paris (Plates 13, 19, 35, 100); Musée des Beaux-Arts, Rheims (Plates 37, 56); Musée de Grenoble (Plate 62); Musée du Petit Palais, Paris (Plate 8); Museum of Art, Rhode Island School of Design, Providence (Plate 24); Museum Boymans van Beuningen, Rotterdam (Plate 77); Museum of Fine Arts, Boston: Bequest of W. G. Russell Allen (Plates 51, 58, 60); Museum of Fine Arts, Boston: Otis Norcross Fund (Plate 109); Museum of Fine Arts, Boston: Bequest of John T. Spaulding (Plate 96); National Gallery of Art, Washington D.C., Rosenwald Collection (Plates 81, 89, 111, IX); Stavros S. Niarchos Collection, Paris (Plate 79); Ny Carlsberg Glyptotek, Copenhagen (Plates 6, 10); Private Collection, Paris (Plates 5, 25); Private Collection, Basle (Plate 4); Private Collection, California (Plate 76); Private Collection, London (Plate 9); Private Collection, London: On loan to the Tate Gallery (Plate VII); Private Collections, New York (Plates 42, 105); Private Collections, Paris (Plates 44, 54); Private Collection U.S.A. (Plate 33); M. Denis Rouart, Paris (Plate 84); Royal Museum of Fine Arts, Copenhagen (Plates 29, 32, 95); Arthur Sachs Collection, Paris (Plates 32, V); Mr and Mrs W. B. Dixon Stroud, West Grove, Pennsylvania (Plate 47); Mr and Mrs Eugene Victor Thaw, New York (Plate 106); Vincent van Gogh Foundation, Amsterdam (Plates 26, III, IV); Wadsworth Atheneum, Hartford, Connecticut (Plate 41); Whitworth Art Gallery, University of Manchester (Plate VIII); Sir John and Lady Witt, London (Plate 97); Worcester Art Museum, Massachusetts, U.S.A. (Plate 7). The photographs were supplied by Christie, Manson and Woods, London (Plate 3); Colorphoto Hans Hinz, Basle (Plates 4, X, XVI); A. C. Cooper, London (Plate 9); Durand-Ruel et Cie., Paris (Plate 25); Knoedler Gallery, New York (Plates 23, 78, 79, 82); Phoebus-Verlag, Basle (Plate V); Wildenstein and Co., New York (Plates 71, 76, 105, 106).

Published by the Hamlyn Publishing Group Limited
London, New York, Sydney, Toronto
Hamlyn House, Feltham, Middlesex, England
© Copyright The Hamlyn Publishing Group Limited, 1970

ISBN 0 600 02555 1

Phototypeset by Filmtype Services
Printed by Lee Fung Printing Company, Hong Kong.

Paul Gauguin
1848—1903

'A critic at my house sees some paintings. Greatly perturbed, he asks for my drawings. My drawings? Never! They are my letters, my secrets. The public man—the private man.

Drawing, what is it? Do not look for a lecture from me on this subject. The critic would probably say that it is a number of things done on paper with a pencil, thinking, no doubt, that there one can find out if a man knows how to draw. To know how to draw is not the same thing as to draw well . . . I have never known how to make what they call a proper drawing—or use a paper-stump or a lump of bread. It always seems to me that something is missing: *the colour'*.

Gauguin, *Avant et Après*, 1903.

'This man knows how to draw, that man doesn't. I'm going to confide to you a secret, which you won't tell anyone, as this letter is confidential to you. There isn't a science of drawing. There is a beautiful or an ugly drawing. Raphael, Michelangelo, Vinci and so many others were already drawing in their mother's womb. When still a child, Raphael drew well, only the more his mind developed, the richer became the language that he created.'

Gauguin, letter to Alfred Vallette, July 1896.

'To know how to draw does not mean to draw well. Let us examine that famous science of draughtsmanship we hear so much about. Every *Prix de Rome* has that science at his finger-tips; so have the competitors who come in last . . . It is a science they acquire easily, without the slightest effort, while spending their time in beer-halls and brothels . . . A painter who never knew how to draw but who draws well is Renoir . . . Don't look for lines (in his work), they don't exist; through magic a lovely spot of colour, a caressing light, speak sufficiently for themselves.'

Gauguin, *Racontars de Rapin*, 1902.

In 1900, the Paris dealer Ambroise Vollard sent to Gauguin in Tahiti some Ingres paper and watercolours, requesting that Gauguin send him drawings with all the paper covered. Gauguin replied: 'To start with, I'm afraid your sheets of Ingres paper will not be of much use to me (very poor for watercolours). I am very finicky about paper; your requirement that the entire paper must be covered worries me so that I would never dare begin work. Now an artist (if you consider me such, and not a mere machine for turning out orders) can do well only what he feels, and to the devil with dimensions! I have tried all sorts of things in Brittany and throughout my life; I like to experiment, but if my work must be limited to water-colour, pastel, or anything else all the spirit goes out of it . . . I have at this moment a series of researches in the matter of drawing which I'm fairly pleased with. I'm sending you a small specimen; it's like an impression and yet it isn't. Thick ink replaces pencil, that's all . . . Next month I'm sending with someone who is returning to France, some 475 proofs of woodcuts. 25 or 30 numbered pulls from each

block, then the block destroyed . . . there is in fact *in drawing* a good chance, I believe, for a dealer because of the small edition'.

These excerpts from Gauguin's letters and writings contain virtually all that he said about drawing. But they provide important clues to his conception of its place and purpose in his work. Perhaps one of the most surprising is his insistence on its essentially private nature. For an artist who looms so large in the public image as an open rebel, defying everything and daring all, this defensive attitude strikes an odd note. Now, however, the secrets are out; his drawings are as much public property as the rest of him. With their help, we can move closer to his artistic personality, analyse his methods of working and observe his creative processes.

One of the problems with Gauguin is that his artistic personality can all too easily be lost beneath the legends that surround the man. Our view is distorted by the *Moon and Sixpence* image and by the continued preference, among collectors and public, for those paintings of the South Seas that apparently present an idyllic vision of tropical paradise. This falsifies his achievement—it is like reducing Degas to a painter of dancers, or Cézanne to views of Mont St-Victoire, or Monet to the late waterlilies. It ignores Gauguin's pictures of Brittany, Martinique and Arles. Moreover, it ignores the fact that he was more than a painter. His works in sculpture occupied him from 1877, when he began with marble busts of his family, and continued at intervals with an important series of woodcarvings, either in relief or as free-standing figures. He also made more than a hundred ceramics, one of which, *Oviri*, he considered among his most important works. He was a productive printmaker—well over a hundred lithographs, etchings, woodcuts and monotypes exist. In 1893, one of his friends who had observed Gauguin at work in Brittany, described how he 'could never remain idle for a moment . . . He made use of wood, clay, paper, canvas, walls, anything on which to record his ideas and the result of his observations.'

All this suggests a prolific and many-sided artist. And it may lead one to conclude that his output of drawings was considerable. Yet this was not the case. Excluding those sheets which have been dismembered from sketchbooks, less than a hundred independent drawings exist. There are reasons behind this relatively small output. Some drawings are known to have been lost or destroyed, especially during his last years in the South Seas, but not enough to make any significant difference to the pattern of development provided by those that survive. More relevant are the circumstances of Gauguin's artistic training and, once he had taken the decision to become a full-time artist in 1883, his methods of working.

Gauguin had no formal artistic training. He began as a Sunday painter in 1871, at the age of 23, doing landscapes of St-Cloud under the guidance of Marguerite Arosa, the daughter of his guardian. Drawing in these years seems to have been confined to portraits of his family and friends. These are generally undistinguished, foretelling nothing of his future development. He evidently frequented

Details of Plate 21

the Atelier Colarossi with his fellow Sunday painter, Emile Schuffenecker, in order to draw from the model in an atmosphere free from the discipline of the Ecole des Beaux-Arts. But none of these life drawings seems to have survived. Nor does Gauguin appear to have made any drawings from the antique. Thus a large corpus of work that occupies the attention of anyone looking at the drawings of Ingres, Delacroix, Degas, Seurat, and to a lesser degree those of Cézanne, Lautrec and Van Gogh, is missing in Gauguin.

Also, unlike many of these artists, he made no attempt to copy from works in the Louvre. In his entire œuvre, there are no copies after the Old Masters. All he allowed himself in this field was a handful of copies after the work of artists of his own time. Only two of these are paintings—one from the late 1870s after a Delacroix in the Musée Fabre at Montpellier, the other, after Manet's *Olympia*, which he made in the winter of 1890-91 soon after the picture entered the Luxembourg Gallery. In two of his sketchbooks there are copies after some of Degas' nudes (see Plate 21) and a series of quick pencil studies of heads after Delacroix, which he later made full use of in several works in different media.

Gauguin's taste for paintings of his own century could well have been nourished by the collection of pictures formed by his guardian, Gustave Arosa. This included works by Delacroix, Courbet, Corot and Jongkind, photographs of which Gauguin later took with him to the South Seas; and motifs from which he felt free to use in his own work. Arosa also collected the paintings of Camille Pissarro; and Gauguin's friendship with Pissarro was the most vital influence on his early development.

Pissarro introduced him to the Impressionist vision and technique. The two men worked together on similar motifs at Pontoise and Osny in 1881 and 1883. Gauguin joined the ranks of the Impressionists and his work was included in their last four exhibitions (1880-86). Moreover, as he prospered on the stock exchange, he began to collect himself, eventually owning two works by Manet, a Renoir, a Degas pastel, two Sisleys, six Cézanne oils, eleven Guillaumins and ten Pissarros. In little more than a decade, the Sunday painter had moved into the vanguard of contemporary French painting.

But Pissarro was more than an Impressionist landscape painter in the sense of Monet or Sisley. Unlike them, he attached great importance to the human figure and to drawing. He admired Millet and thought Degas the greatest modern artist because of his mastery as a draughtsman. Some of his ideas on drawing were conveyed in his letters written in 1883 to his son Lucien. Pissarro exhorted Lucien to 'draw, and draw again . . . It is only by drawing often, drawing everything, drawing incessantly that one day you are amazed to discover that you have found the way to render a thing with its own character . . . Little bits of sketches are not enough. You need them too, of course, to learn to see rapidly and render the overall character, but in order to get strong you must apply yourself seriously to large drawings with very *firm outlines* . . . Don't make pretty, clever little lines

but be simple and insist on the major lines that count in a face.' He warned Lucien to guard against facility in execution, and against the academic system, as taught then by Legros at the Slade School, of working from preconceived ideas on proportion ('la théorie grecque') at the expense of looking for oneself. He reminded him to look at– and copy–Holbein and the Primitives, Egyptian sculpture and Persian miniatures.

Here, in embryo, is much of Gauguin's later thinking and practice: his insistence on the overall character and the strong, simple lines in a drawing; his denial of facility and the science of draughtsmanship; his admiration for Holbein, the Primitives and Egyptian art. No wonder he wrote later of Pissarro: 'He looked at everybody, you say? Why not? Everyone looked at him, too, but denied him. He was one of my masters and I do not deny him.'

But in the early 1880s, Gauguin was still somewhat tentative in his drawing (compare Pissarro's drawing with his own, Plate 1). He still largely confined himself to portraits of his family and friends. Often these were executed in pastel, a medium favoured not only by Manet and Degas, but by more fashionable artists like de Nittis (the use of pastel enjoyed a general revival in the 1880s; it was by no means limited to the 'advanced' artists). Gauguin exhibited some of his pastel portraits at the Impressionist exhibition of 1882. His more ambitious compositions, like those of Aubé and his son (Plate 8) and of his own children, Aline and Pola (Plate I) show a knowledge of Monet in their technique and of Degas in their asymmetrical lay-out. These are accomplished pastiches. And when he produced a series of seven fans in Copenhagen in 1885, his technique was still Impressionist. His designs in two instances (e.g. Plate 10) are taken from paintings by Cézanne then in his own collection; in others, they are partly based on etchings of Rouen by Pissarro, which he also owned; while the rest (e.g. Plate 9) were based on composite motifs drawn from his own paintings. The example of Degas and Pissarro, who had exhibited fans at the Impressionist exhibition of 1879, possibly lay behind Gauguin's adoption of this art form (and presumably he hoped to sell some to Danish collectors). He continued to make fans as a means of reproducing, often with variations, his own paintings, whether of Brittany, Martinique or Tahiti (c.f. Plate XIII). But the Danish group of 1885 introduces one significant element that will henceforth characterise his work: that of lifting compositions, or parts of compositions, from other artists and incorporating them in his own paintings.

The loss of Gauguin's early drawings, whether pastels or fans, would hardly impoverish the state of 19th-century French drawing. Their value is mainly documentary; they provide a record of his artistic progress and reflect the influences that affected him. But they have no distinctive style and they reveal nothing of what was to follow. Another peculiar feature of the drawings done before 1886 is their independence from the paintings. Apart from two landscape studies (one with colour annotations) in an early sketchbook now in

Detail of Plate 10

Detail of Plate 9

the National Museum, Stockholm, and a study of a nude, none of the early drawings relates directly to a painting. In effect, Gauguin appears to have drawn in moments of relaxation: to catch a likeness of his children and friends, or to try out a new medium. Having adopted the Impressionist vision, he also adopted the Impressionist way of working. Most of his landscapes must have been painted on the spot; others begun thus were then finished in the studio.

Moreover, the figures in his pre-1886 landscape paintings–and about a hundred survive–are generally small and unimportant. They are included to indicate scale, to act as colour accents, or to add some narrative interest. (Perhaps one ought to except a group of canvases of 1885, where cattle appear noticeably, as if Gauguin were reviving aspects of the Barbizon painter, Troyon.) From 1886, however, figures assume a greater prominence; indeed, in several compositions they become the dominant interest. And with this new emphasis Gauguin began to make preliminary studies of figures. It is significant that most of the drawings executed in Brittany, Martinique and Arles between 1886 and 1890 served as studies for this new type of figure painting.

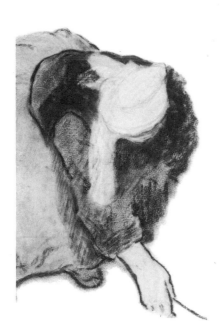

Detail of Plate 18

This concentration on the figure clearly owed something to Degas. Gauguin saw Degas' series of ten nudes at the last Impressionist exhibition of 1886, where he himself showed nineteen paintings. When, two years later, Theo van Gogh exhibited a further group of Degas' nudes, Gauguin made a page of copies after some of them (Plate 21). Talking of Degas' nudes in *Avant et Après*, Gauguin wrote: 'Design was at its lowest ebb; it had to be restored; and looking at these nudes, I exclaim, "It is on its feet now!"' Several poses that Gauguin used in his drawings of Breton peasants and bathers are re-markably close variations on certain dancers and nudes by Degas (Plates 15, 16, 18 and 19). And even in Martinique and Arles (Plates 20 and 27), something of Degas' example persists. Significantly, Van Gogh's high regard for Gauguin's talent was founded upon the powerfully expressive figures of the Martinique negresses in the *Fruitpickers*, a picture which he persuaded his brother Theo to pur-chase. When the two artists were together in Arles in 1888, it was again Gauguin's figure paintings that Van Gogh particularly admired. In 1890, he based four of his own paintings on Gauguin's boldly simplified drawing of *L'Arlésienne*.

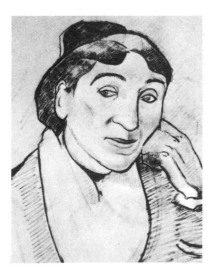

Detail of Plate 27

Gauguin's work from 1886 to his death in 1903 is often seen as a series of chronological episodes determined by the places he visited. Thus, his stays in Brittany (1886, 1888, and 1889-90) are broken by his trip to Martinique in 1887 and his two months' sojourn with Van Gogh in Arles the following year. Winters were spent in Paris, cul-minating in the five months that he spent there before his departure for Tahiti in April 1891. His first stay in Tahiti lasted until 1893; from 1893 to 1895 he was back in France, again visiting Brittany. His final years in the South Seas were spent in Tahiti (1895-1901) and the Marquesas Islands (1901-3). However, these periods should provide convenient breakdowns, rather than rigid barriers, for a strong

underlying rhythm marks Gauguin's life and work, transcending divisions of time and place.

His artistic decisions have a slow, calculated and regulated quality, which contradicts any image one might have of an impetuous, feverish Expressionist. His talent unfolded gradually, and after 1886 his evolution is marked by a steady, controlled tempo. Even the changes in style are not as sudden as might be imagined. The 'breakthrough' of the *Vision after the Sermon* of 1888 evolved over a period; it was adumbrated in his letters and notes of 1885, some of its stylistic features were experienced in the making of ceramics, as well as in some paintings. His method of working was considered and deliberate; he never possessed an intuitive facility; he never expressed Van Gogh's desire for speed in execution.

Similar considerations apply to his drawings. There is nothing of the impulsive stroke of Delacroix: mercurial lines, explosive touches and speedy completion are not part of Gauguin's language. His methods were at once more laborious and more economical. There is evidence for this in the way he would often work over his drawings. For example, the bathing girl of 1886 (Plate 16) was certainly rephrased, her outlines simplified and strengthened. The same process was applied to *L'Arlésienne*, while the *Head of a Breton Girl* (Plate 43) was begun in pencil and then reworked in crayon and wash. Pentimenti are clearly visible in the watercolour of 1889 (Plate 46) and in the study for the *Loss of Virginity* (Plate 49). Also, several drawings in the album that Gauguin labelled *Documents de Tahiti* are retouched with a strengthening contour.

Further insights into his methods of working can be gained from his writings. In his manuscript, *Avant et Après*, completed a few months before his death, he wrote: 'I have never had the mental facility that others find without any trouble, at the tips of their brushes. These fellows get off the train, pick up their palette and turn you off a sunlight effect at once . . . Wherever I go I need a certain period of incubation, so that I may learn every time the essence of the plants and trees, of all nature, in short, which never wishes to be understood or to yield herself.' Earlier, he had expressed similar sentiments in his letters. From Brittany in 1888, he wrote to his wife: 'I must work seven or eight months at a stretch, in order to penetrate the character of the people and the country, an essential thing for good painting.' In 1887, he wrote from Martinique: 'What tempts me most are the figures. Every day there is a continuous coming and going of Negresses attired in colourful rags, their graceful movements infinitely varied. For the time being I am merely making sketch after sketch in order to grasp their character, but later I shall ask them to pose.' In November 1891, five months after his arrival in Tahiti, he wrote to his friend Sérusier: 'Not yet a painting, but a host of researches which may prove fruitful; a great many documents which will serve me a long time, I hope—for example in France.'

Many of these 'documents' were made in his sketchbooks. Several have fortunately survived and Gauguin's pattern of working is con-

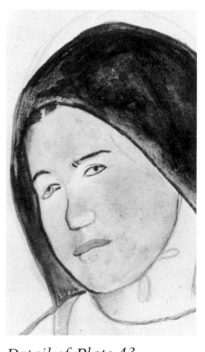

Detail of Plate 43

10

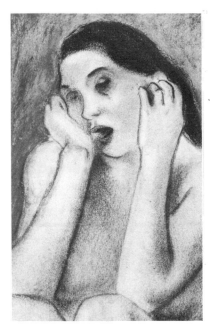

Detail of Plate 33

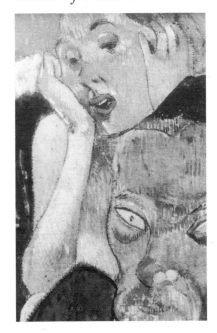

Detail of Plate 41

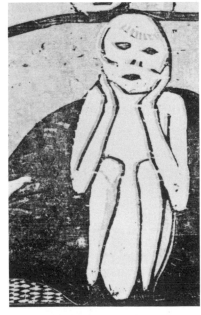

Detail of Plate 95

firmed by their contents. One of the earliest in date was purchased in Rouen in 1884, taken to Copenhagen in 1885 (but hardly used there), brought back to Paris that summer, and then used extensively at Pont Aven in the summer of 1886. It contains many rapid pencil and crayon sketches of peasants, cattle and sheep. The genesis of many elements in a painting now in the Laing Art Gallery, Newcastle-upon-Tyne, can be traced to these sketches, while the major figure of a reclining shepherdess was worked out on a separate sheet (Plate 13). This typifies Gauguin's working procedures in Martinique, Arles and Tahiti. He confided his first impressions to sketchbooks, some of which would provide elements for paintings. In certain cases, he would make an independent drawing whenever he wished to develop a pose more fully.

Another important feature of Gauguin's work is his continuing use of a fairly restricted range of poses. Rather than constantly inventing a new series, he was content to build up a repertoire of figure studies which would then serve him over a period of time. For example, during his first stay in Brittany in 1886, he made several drawings of the local peasantry. Two of these (Plates II and 11) were first used in a painting of that year; in Paris the following winter they appear as part of the decoration of a stoneware vase; their heads and shoulders subsequently emerge in the middle distance of a summer landscape of 1888; finally one of them is seen in a lithograph of 1889. Other instances show how Gauguin used sketches made in 1886 for paintings executed two years later (Plates 18 and 19). The study of a nude bathing girl (Plate 16) appears in a painting of 1887, as well as in two ceramics and a lithograph. The process was accelerated during Gauguin's first stay in Tahiti. Not only might the same pose occur in several paintings, but it could also be repeated in a woodcarving or a watercolour and eventually, on his return to France, in a woodcut, a ceramic or a monotype.

Perhaps the most interesting example of Gauguin's persistent use of a pose is that of the seated nude whom we first encounter in a drawing of 1889 (Plate 33). She was first transformed into a figure of Eve (Plate VI), and then became a symbol of *Death* in a painting where a second nude symbolises *Life*. As such, the two figures occupy the background of *Nirvana* (Plate 41). She next appeared, more frontally posed, in a carved wood relief, *Soyez amoureuses, vous serez heureuses,* of autumn 1889. Even in Tahiti the image persisted for Gauguin—in a painting of 1892, in two woodcuts (Plate 95), and finally in *Where do we come from? What are we? Where are we going?* of 1897 (Plate 100).

Gauguin's use of a limited number of motifs in a variety of media, over a period of time, and with significant changes in the meaning and interpretation of the image, is also connected with a further leitmotiv that characterises his work. At various times, he would take stock of his position and produce a convenient summary of a period of activity. The clearest example of this is his largest canvas, *Where do we come from? . . .* which he deliberately conceived as his final testament, a summing-up of his artistic Odyssey. But there are other

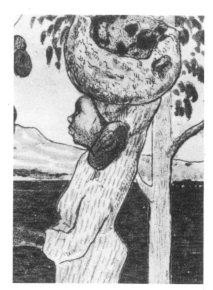

Detail of Plate 29

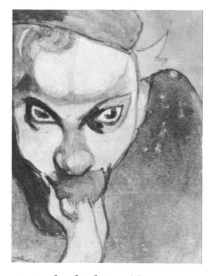

Detail of Plate 40

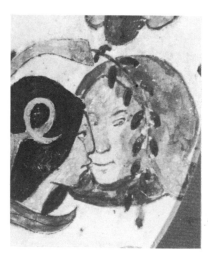

Detail of Plate 47

instances, perhaps undertaken less consciously, but nonetheless providing in retrospect a sequence of apt summaries. These share certain characteristics: they consist of a group of works, they were generally undertaken in moments of relaxation, and they were executed in a new medium, thus giving free rein to Gauguin's love of experimentation. The earliest, and least important, is the group of seven fans painted in Copenhagen in 1885, which have already been discussed. His first batch of ceramics, made in the winter of 1886-7, sums up his experience of Brittany (a few contain motifs after Cézanne and Delacroix, but the rest are based on his idyllic view of the Breton peasantry that characterised his first stay at Pont Aven). And in using a new medium, Gauguin applied unconventional methods and techniques; most of his early pots are hand-coiled.

In the early months of 1889, Gauguin produced a series of lithographs in Paris. These were eventually made into an album of ten, with an additional design on the cover, and placed on sale at the exhibition which Gauguin, Schuffenecker and Bernard organized at the Café Volpini during the official International Exhibition of 1889. Disregarding conventional ideas of finish, Gauguin skilfully contrasted deep black areas with untouched spaces and occasional broken tones, and used the zinc plates for exercises in a free, linear inventiveness. The results are often witty and also herald aspects of Art Nouveau (Plates 29-32). He varies the format of each plate, even introducing a fan-like shape (which is then broken by elements extending beyond the edges) and a circular one for the cover. Iconographically, the album brings together themes and motifs from Brittany, Martinique and Arles, some of which had already appeared in paintings and drawings (c.f. Plates II and 16).

One often feels that Gauguin should have been given the opportunity of producing large-scale decorations. The nearest he got to this was in the isolated inn run by Marie Henry at Le Pouldu, Brittany, where he and other artists (mainly the Dutchman, Meyer de Haan) carried out a series of decorations in the winter of 1889-90. Some were painted directly on the plaster in a sort of fresco technique; others were painted on wood—either on doors, or on the panelling, or even on a large wooden cupboard. No consistent theme unites the decorations; labours of the fields are mixed with more esoteric subjects which loosely combine visions of Paradise with novel interpretations of the Fall of Man. Thus there is the self-mocking *Bonjour, Monsieur Gauguin*; the demonic *Self-portrait with Halo*; the portrait of Meyer de Haan, seen with Milton's *Paradise Lost* and Carlyle's *Sartor Resartus* (c.f. the study, Plate 40). The remaining subjects include a *Caribbean Woman* surrounded by sunflowers, a vision of Joan of Arc set in a Le Pouldu landscape, an interpretation of Adam and Eve, the *Terrestrial Paradise*, and a representation of a goose, inscribed 'Maison Marie Henry'. Eventually Gauguin also thought of a set of decorated plates, for which several circular designs would seem to be studies (c.f. Plate 47). These employ playful and somewhat obscure symbols, with a private in-joke quality that emphasises the

sense of the initiated and the chosen. And it was not without significance that the dining-room of the inn carried a painted quotation from Wagner, who had become one of the darlings of the Symbolists.

It was in Symbolist circles that Gauguin found himself during the winter of 1890-91 in Paris. He etched the portrait of Mallarmé, and made a drawing of Jean Moréas, who had launched the Symbolist manifesto in 1886. He also made a not entirely successful attempt to produce a Symbolist painting, the *Loss of Virginity*, for which a study exists (Plate 49). The young poet and art critic, Albert Aurier, endeavoured to systematise Gauguin's ideas within Symbolist terms, clarifying as it were the confused painted statement of the inn.

If it is too fanciful to see a series of fans, a set of ceramics, an album of lithographs and a painted decoration in a Breton inn as a sequence of statements that have the quality of summaries, such is certainly not the case with the next enterprise. Here, Gauguin planned to combine the illustrated with the explanatory. In 1893, on his return from his first visit to Tahiti, he conceived with the poet Charles Morice the collaborative idea of explaining his Tahitian stay and the meaning of his Tahitian paintings. Together, they would provide a key to his experience and vision of the South Seas. Once again, Gauguin chose a new medium: the woodcut. The ten woodcuts that he produced must have appeared clumsy and untutored to eyes then accustomed to a highly finished, almost photographic use of the medium. But he came unfettered by technical considerations; he pursued a direct, expressive confrontation with the medium. Using a variety of tools, some unfamiliar to the hardened professional, his experiments in cutting, inking and printing produced the most subtle, refined and allusive images wholly consonant with the title of his book—*Noa Noa* (Fragrance). But for various reasons, the ten woodcuts were never used. Ironically, their initial, didactic purpose was lost, and ultimately they spread Gauguin's fame as heralds of a new technique in woodcut that would influence Munch and the German Expressionists. It was the medium, not the message, that created the stir.

Gauguin, however, did succeed in combining text and woodcuts, but in rather different circumstances. In August 1899, he began the publication in Papeete, the capital of Tahiti, of a monthly broadsheet, *Le Sourire*, which ran for nine numbers until April 1900. It carried something of the ironical and diabolical elements of his Le Pouldu decorations of a decade earlier. But it was more in earnest; it was a political weapon intended to discredit the colonial administration. And while publishing *Le Sourire*, Gauguin appears to have worked on a number of independent woodcuts. These were announced in a letter to Vollard in the early months of 1900—'. . . some 475 proofs of woodcuts. 25 or 30 numbered pulls from each block, then the block destroyed.' It would seem that *Soyez amoureuses vous serez heureuses* (Plate 95) belongs to this last group of woodcuts, which show again his love of technical experiment. After printing his block in black or brown on fairly heavy Japan paper, he would then rework it and

print in black, this time on tissue paper, which was laid down over the first impression. He thereby achieved a two-tone impression, giving a chiaroscuro effect of black and brown, or black and grey.

Less familiar, and therefore less influential, than the woodcuts are Gauguin's monotypes. Monotypes are produced in a variety of ways, but the essence of the medium lies in the use of ink on a zinc or copper plate and the drawing of the image with a brush or rag. A sheet of paper is then applied for the transfer of the image, which is best achieved by the use of a press. By definition, one pull is enough; but occasionally a second, very faint one can be taken. The medium had been revived by Degas and his friend Lepic in the 1870s, and Pissarro had also tried his hand. Gauguin's monotypes have little in common with Degas'; it seems doubtful that he used a plate or a press. Whatever the complexities or otherwise of his technical procedures, two series of monotypes may be distinguished. The first series was undertaken as a result of Gauguin's enforced relaxation following the breaking of his ankle in Brittany in May 1894, after which he spent some considerable time in bed. The subjects are largely those of his first Tahitian visit. They include *Ia Orana Maria*, based on his painting of 1891; *Mysterious Water*, based on a painting of 1893; a variation on his now familiar Tahitian Eve and several evocations of the Tahitian deities that had peopled his canvases (Plates 58, 60, 84, 85, 86 and 89). One of them was inscribed and given to the English painter, Robert Bevan, who we know was in Pont Aven in the summer of 1894 (Plate 90). Another, appropriately enough showing a local Breton scene, was inscribed and given to another English—or rather Irish—painter, Roderic O'Connor, who was also in Pont Aven at that time (Plate 91). From the evidence of these two monotypes, it seems reasonable to assume that the rest were produced in the summer of 1894. There are probably as many as two dozen. Technically, they are characterised by a fluid, watercolour-like treatment—and some of them have wrongly been called watercolours. It is, however, possible that a few were retouched with watercolour to add colour accents, just as earlier Gauguin had retouched some of his lithographs.

The second group of monotypes dates from between 1899 and 1901 —and maybe later, as six were used to illustrate the manuscript of *Avant et Après*, written in January—February 1903. They differ greatly from the earlier group. Instead of a fluid, watercolour-like technique, seemingly applied with a brush, we find a much drier, inkier surface, with forms that are more drawn, as it were, with pen. Gauguin mentioned them in a letter of 1900 to Vollard, already quoted at the beginning of this introduction. He referred to them at greater length in a letter to his wealthy patron, Gustave Fayet, of March 1902. 'Using a roller, you coat a sheet of paper with printer's ink; then on another sheet placed on top of it, you draw what seems good to you. The more your pencil is hard and thin—your paper too— the finer will be the line, that comes of itself. Coating the sheet of paper with lithographic ink, couldn't one profit by it to make litho-

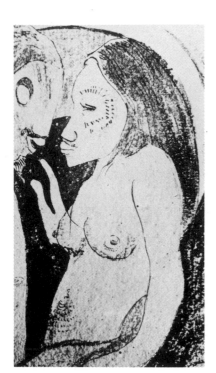

Detail of Plate 85

graphs quickly etc. . . . It remains to be seen. I have always had a horror of all this cookery needed to make drawings: paper which gets greasy, pencils which are never strong enough, then loss of time etc.'

Gauguin seems to have found a medium that could take the place of drawings, woodcuts and lithographs. As a means of working, it was simpler, more immediate, less fussy. Many of these late monotypes can be seen as substitutes for drawings. Some are squared-up, which suggests that they served as 'documents'—preliminary studies for paintings. Certainly, individual motifs and also entire compositions can be directly related to paintings done in the Marquesas Islands in 1901 and 1902 (Plates 102, 104, 106, 107, 109 and 110). In this sense, this last series was not so much a summing-up, a rephrasing of existing poses, motifs and imagery into a new medium, as a starting-point for a series of new inventions which then provided the guide-lines to his paintings.

Detail of Plate 104

Lithographs, woodcuts and monotypes are normally classed as printmaking. But there is every justification for including them in a volume on Gauguin's drawings, for he himself saw them as an extension of drawing; he refers to them as 'dessins' in his letters. Distinctions of media are for him artificial categories. Not only did he extend the technical possibilities of woodcut and monotype, he also broke down the divisions between various media. He brought the experience of sculpture to pottery; the revelations of colour that he found in making ceramics were then used in his paintings; he transformed a woodblock intended for a woodcut into a bas-relief carving, while another relief carving, *Mysterious Water*, has the surface quality of a woodblock; some of his monotypes look like watercolours, others like modified ink-drawings.

Inventive, imaginative, original: all this can be said of Gauguin's exploitation of the technical resources of his art. Against this, however, is the surprising degree to which he relied on other images for inspiration. He was a persistent and unashamed borrower of motifs. Whenever he found a ready-made source for a figure or a group, he had no compunction about using it. Generally, he would 'lift' it straight; occasionally he would disguise it, not to hide his act of plagiarism, but for pictorial or stylistic reasons. To call him a plagiarist *tout simple* is to misunderstand the springs of his creative process. In addition to the stock of his own drawings, he built up a store of photographic documents which he could refer to whenever he needed a particular motif. This store became a sort of *musée imaginaire*, and also, in the South Seas, a vivid reminder of the European tradition. For while Gauguin is one of the first artists to extend his interests outside the purely European tradition—to use sources which were considered primitive and barbaric—he nonetheless remained a 'civilised' artist, and never cut the lifeline of his immediate cultural past.

Take, for example, the figure of *Eve* or *Death* whose repeated appearances in his œuvre have already been mentioned. The figure

15

may well be based on a Peruvian mummy which Gauguin could have seen in the Museum of Ethnology in Paris in the 1880s. But he removed a great deal of the emaciated horror elements of the death image. His recreation was based on one of his rare drawings from the nude model (Plate 33), which is closer to Degas than to a Peruvian mummy. And in all his representations of this figure, no matter what the symbolic interpretations may be, she is always more 'Europeanised' than 'primitive'.

The Peruvian mummy was a three-dimensional object. And other pieces of sculpture provided sources for him in Brittany in 1889. His *Yellow Christ* was based on a wooden polychrome crucifix which he saw in the chapel of Trémalo, near Pont Aven. He made a quick drawing of it (Plate 38); the watercolour (Plate 39) shows how he adapted it to the needs of his own composition. The companion piece, the *Green Christ*, was based on a Romanesque stone Calvary. These are the only instances of his actually using pieces of sculpture in the round which he had seen for himself, as a starting-point.

Otherwise, his imaginary museum contained many photographs of sculpture, predominantly relief sculpture. By the late 1880s he owned at least two photographs of reliefs from the great Javanese temple of Barabuḍur. From then until his death these were to prove a veritable pattern-book. He could take a standing figure amidst stylised vegetation and transform it into a tropical Eve (Plate 48) at the moment, in 1890, when he was dreaming of returning to the Tropics. Once in Tahiti, the same figure sparked off another representation of Eve, which he repeated in several drawings and woodcuts (Plates 60, 61, IX, 62 and 92), as well as a painting of 1892. Three other figures from this same photograph supplied him with poses for the angel and two native Tahitian women who hail the Virgin and Child in a canvas of 1891, *Ia Orana Maria*. (c.f. Plate 59).

Other photographs, which were used less extensively than those of Barabuḍur, included Egyptian wall-paintings, Trajan's Column, the Parthenon frieze and the Theatre of Dionysus on the Acropolis. In addition, Gauguin had photographs of works by Corot, Delacroix, Courbet, Prudhon, and Tassaert that once formed part of the collection of his guardian, Gustave Arosa. These too provided motifs for paintings, short-circuiting the need for making drawings of his own. In Brittany and in the South Seas he would decorate his studio with photographs of the works of Manet, Puvis de Chavannes and Degas, of Holbein, Raphael and Rembrandt, of Giotto, Fra Angelico and Botticelli, of Utamaro and Hokusai.

It is tempting to see Gauguin as a wilful creator, turning his back on accepted artistic values and hallowed European cultural traditions. But his attitude towards the Old Masters contains surprises for those who think of him as the iconoclast of all that was European and the harbinger of all that was primitive. For the artist he admired most was Raphael. In *Avant et Après* he wrote: 'What, I a revolutionary! I who adore and respect Raphael!' His first Tahitian model is described in *Noa Noa*: 'All her features have a Raphaelesque harmony

16

in the play of curves.' For Gauguin, Raphael was a born draughtsman who needed neither teacher nor systematic instruction; and he was an artist with an instinctive command of composition. What Gauguin hated was the perversion of Raphael in the teaching at the Ecole des Beaux-Arts and in the paintings of such contemporary Salon favourites as Bouguereau and Cabanel.

But if Gauguin carried his European heritage with him, he nonetheless sought out new countries to enlarge his choice of subjects and to familiarise himself with the life of primitive peoples. He was greatly disappointed to find on his arrival in Tahiti that native art and religion had virtually disappeared. He was forced to rely on a textual evocation of the lost myths—on two volumes published in 1837, *Voyages aux Iles du Grand Océan*, by an American consul, J. A. Moerenhout. He transcribed much of Moerenhout's account in his own manuscript, *Ancien Culte Mahorie*, which he wrote and illustrated in Tahiti, and which then provided the key to his more important description in *Noa Noa* of his Tahitian stay. He was forced to invent his representations of the Maori pantheon, and here he largely relied on Marquesan *tikis* (stylised images of the Gods, from big stone sculptures down to oar-handles and clubs) and on the decorated fabrics called *tapas*. His imaginative use of his sources enabled him to illustrate his vision of the ancient Tahitian myths (Plates 85-89 and XVI). A drawing that he made from a Marquesan ear-plug (Plate 65) was transformed into a fence impaled with human skulls that surrounded the hallowed territory of his imagined God. He depicted the scene in a painting and a watercolour (Plate XIV).

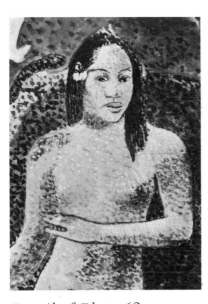

Detail of Plate 62

Watercolour was often used by Gauguin for his illustrations to *Ancien Culte Mahorie* and *Noa Noa* (Plates 66 and 80). Several independent sheets show his subtly evocative use of the medium (Plates IX, 62, 79, XV, and 88). Of these, one of the most fascinating is *Pape Moe—Mysterious Water* (Plate XV). In *Noa Noa*, Gauguin described an excursion that he made alone into the depths of the island. 'All of a sudden there was a sharp bend and I saw, standing erect against a rock wall which her two hands seemed rather to caress than to cling to, a young girl, naked: she was drinking at a spring that gushed out high up among the rocks.' But sensing the presence of a 'stranger', she dived into the water with a shriek of terror. 'I rushed to the water's edge and gazed into its depth—not a soul to be seen; only a huge eel gliding among the pebbles on the bottom.' But when Gauguin illustrated the mystery of this episode, he simply relied on an old Tahitian photograph showing a girl drinking at a waterfall.

His evocations of the Maori deities and myths declined during his second stay in the South Seas. By 1899, he had also ceased using Tahitian titles for his pictures. He pursued his own brand of Symbolism, which is neither literary nor literal, but open and allusive. Thus he wrote of his watercolour, *Te Arii Vahine* (Plate 98): 'A nude queen reclining on a green lawn, a servant girl picking fruit, two old men by the big tree arguing about the tree of knowledge, in the background the sea . . . I think that in colour I have never done any-

17

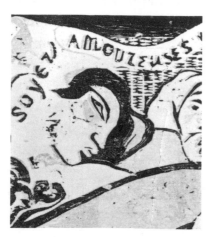

Detail of Plate 95

thing with such a grand, solemn resonance. The trees are in bloom, the dog keeps watch, on the right two doves coo.' The composition can be seen as a variation on Giorgione's Venus and Manet's Olympia —and also on works by Puvis de Chavannes. During his final period in the South Seas, he continued to use the Barabuḍur frieze as a source for his figures. His own drawings become progressively fewer. Yet ironically, the only two squared-up compositional studies that survive are of this last period (Plates 100 and 101).

The economy of his means is highlighted by his adaptations of a few heads by Delacroix which he had copied much earlier in a sketchbook which, characteristically, he had taken with him to Tahiti. These adaptations were made in woodcuts (see the upper part of *Soyez Amoureuses* . . . Plate 95) and in monotypes (Plate 110), in several paintings and in the carved wood reliefs which he did in 1901 for his new house in the Marquesas Islands. This concentrated homage to Delacroix underlines the deep admiration that Gauguin always had for him. From Copenhagen in 1885, he wrote: 'Delacroix's drawing always reminds me of the tiger's supple, strong movements.'

Gauguin had no special regard for his own drawings. They were private documents to assist him in the making of pictures. A few were given to artist-friends–Laval, Schuffenecker, Maufra and Comte Antoine de la Rochefoucauld (Plates 12, 25, 35 and 59). *L'Arlésienne* was left in Arles with Van Gogh, for whom it became something of a talisman. Very occasionally, in the late 1880s, he sold drawings to Theo van Gogh. But he rarely included them in his exhibitions–two pastels and a watercolour were among the works that he showed at the Café Volpini in 1889. Possibly to make them saleable, drawings were sometimes worked up in pastel, as we learn from one of Vollard's letters to Gauguin. Vollard was referring to pastels of Breton subjects, which may include the *Breton Girl Knitting* (Plate 34) and *Two Breton Girls* (Plate VII). In fact, Gauguin virtually ceased using pastel after 1894. One of his last and most powerful images is the *Tahitian Woman*, now in the Brooklyn Museum (Plate XI).

'Figures are what I prefer,' Gauguin wrote in 1900. And the bulk of his drawings are concerned with the human figure. Only one still life composition exists (Plate 96). His few Tahitian landscapes are generally in watercolour, expressing his desire 'to suggest a wild and luxuriant nature, a tropical sun that makes everything around it blaze.' In his mature figure drawings, Gauguin searches for simple and bold masses and for clear and emphatic outlines. There is a controlled sobriety that eschews a dashing technical brilliance. The rhythms of his drawings unfold slowly. *L'Arlésienne* (Plate 27) is reminiscent in pose of Degas's famous *Woman with Chrysanthemums*. But the style is Gauguin's. In *Avant et Après* he wrote: 'Study the silhouette of every object; distinctness of outline is the attribute of the hand that is not enfeebled by any hesitation of the will.' Here, the line binds and simplifies; it looks back to Ingres and on to Matisse.

'A strange grandeur has crept into Gauguin's figures, a grandeur that recalls Michelangelo,' wrote Sickert in 1911. In his *Crouching*

Tahitian Girl (Plate XII) Gauguin creates an image that is at once decorative and monumental. It is fiercely challenging, confidently clear-cut, decisive. It illustrates why so many artists have responded to Gauguin's organisation of surface and volume, to his subtle manipulation of repeated and overlapping shapes. Yet within these formal means, Gauguin also caught the specific physical type of the Maori woman, as he described it in *Avant et Après*. 'What distinguishes the Maori woman from all other women, and often makes one mistake her for a man, is the proportions of the body. A Diana of the chase, with large shoulders and narrow hips. However thin one of these women's arms may be, the bony structure is unobtrusive; it is supple and pretty in its lines.' He retains the local truth, born of his close observation during his period of 'incubation' but raises it to the point of a grand, monumental statement.

No anthology of 19th-century drawing would be complete without Gauguin. He takes up the torch from Ingres and Delacroix, from Pissarro and Degas, and passes it on to the Nabis, Munch, Matisse, Kirchner and Kandinsky. In 1900, he wrote to Maurice Denis: 'I wanted then (in 1889) to dare everything, to liberate in some way the new generation . . . today you can dare everything and what is more, no one will be surprised.' His drawings, interpreted in the widest sense to include his pastels, fans, lithographs, woodcuts and monotypes convincingly demonstrate the validity of his claim.

Abbreviations:

Bodelsen =
Merctc Bodelsen,
Gauguin's Ceramics,
London, 1964.

Gray =
Christopher Gray,
*Sculpture and
Ceramics of Paul
Gauguin*, Baltimore,
1963.

Guérin =
M. Guérin,
*L'Œuvre grave de
Paul Gauguin*,
2 vols., Paris,
1927.

Leymarie =
Jean Leymarie,
*Paul Gauguin,
Watercolours,
Pastels and
Drawings*,
London, 1961.

Rewald =
John Rewald,
Gauguin Drawings,
New York, 1958.

W =
Georges
Wildenstein,
*Gauguin, vol. I,
Catalogue*, Paris,
1964.

Notes on the Plates

Plate 1 Portrait of Gauguin by Pissarro and Portrait of Pissarro by Gauguin. Black chalk and coloured chalks on blue paper. 35·8 × 49·5 cm. *c.* 1881. Cabinet des Dessins, Musée du Louvre, Paris (Gift of Paul-Emile Pissarro, 1947; RF 29.538).

Gauguin probably met Camille Pissarro in about 1875 through his guardian, Gustave Arosa. He made several stays with Pissarro at Pontoise and Osny–probably in 1879, certainly in 1881, when Cézanne was also there, and again in 1883. The present drawing probably dates from the visit of 1881. Note how Pissarro confines himself to black chalk and draws with firm decision, whereas Gauguin uses coloured chalks–red, blue, yellow and green–and creates a softer effect. Another drawing of Pissarro exists (Rewald Plate 5), while Pissarro made a sketch of Gauguin carving a small wooden figure exhibited as *Dame en Promenade* at the sixth Impressionist exhibition of 1881 (National Museum, Stockholm).

Plate 2 Portrait of Ingel Fallstedt. Black chalk. 20 × 25 cm. 1877. Göteborgs Konstmuseum, Sweden.

Ingel Fallstedt (1848-99) was a Swedish sculptor, whom Gauguin knew in Paris in the late 1870s. They must have met again in Copenhagen in 1885, for Gauguin asks after Fallstedt in several letters to his wife written from Paris in 1885-6.

19

Plate 3
Portrait of William Lund. Pastel on brown paper. 24 × 19cm. *c.* 1884. Mr and Mrs Paul Kantor, Beverly Hills.

Gauguin executed several portraits in pastel during his early years as an artist (c.f. Plates I and 5-8). The sitter, William Lund, was a friend to whom Gauguin dedicated a landscape of Rouen in 1884 (W.118).

Plate 4
Portrait of Aline Gauguin. Watercolour. 18·6 × 16·2cm. *c.*1879-80. Private Collection, Basle.

Many of Gauguin's early portraits were of his wife Mette and their five children. This small sketch shows his only daughter, Aline, born on Christmas Day 1877 and named after his mother. She was his favourite child; he wrote the *Cahier pour Aline* during his first stay in Tahiti and her death, in January 1897, as a result of pneumonia, deeply shocked him.

Plate I
Portrait of Aline and Pola Gauguin. Pastel. 70·5 × 52cm. 1885. Mr and Mrs David Lloyd Kreeger, Washington.

This is Gauguin's latest portrait of his children, showing Aline (c.f. Plate 4) and his youngest son, Pola (1883-1961). Executed during Gauguin's stay in Copenhagen (December 1884 to June or July 1885), the spatially complicated arrangement clearly owes something, via photography and the Japanese Print, to Degas.

Plate II
Breton Girl. Chalk 48 × 32cm. 1886. The Glasgow Art Gallery and Museum (The Burrell Collection).

During his first stay in Pont Aven, Brittany (June-October 1886), Gauguin made several drawings of Breton peasant girls, both in his sketchbook and, as here, on separate sheets. These formed the basis for his paintings of that summer, in which his vision is idyllic and pastoral; on his return to Paris, he used them for fans and ceramics (c.f. Plates 11-14). In these drawings the influence of Pissarro and Degas is still apparent. The present figure appears in the painting *Four Breton Women Talking,* now in the Bayerische Staatsgemäldesammlung, Munich, signed and dated 1886; she reappears in a glazed stoneware vase (now in Brussels) which Gauguin produced in the winter of 1886-7; and her head and shoulders are seen in a Pont Aven landscape of 1888 (W.253).

Plate 5
Portrait of Clovis. Pastel. 25 × 27cm. *c.*1882. Private Collection.

In his review of the seventh Impressionist exhibition of 1882, J. K. Huysmans referred to Gauguin's *croquis d'enfants.* These could be sketches of his own children and might have included the present pastel of his second son, Clovis (1879-1900). An oil portrait of Clovis also exists (W.81).

Plate 6
Portrait of Charlotte Flensborg. Pastel. 33·5 × 26·5cm. *c.*1882. Ny Carlsberg Glyptotek, Copenhagen.

A portrait–again in pastel–which shows something of Manet's influence. The notes of music in the background refer to Mlle Flensborg's profession as pianist and teacher of music in Paris.

Plate 7 Young Woman in a Hat. Pastel. 40 × 33cm. 1884. Worcester Art Museum, Massachusetts, U.S.A.

This pastel-portrait of an unidentified sitter was executed during Gauguin's stay in Rouen from January to December, 1884.

Plate 8 The Sculptor Aubé and his Son. Pastel. 53 × 72cm. 1882. Musée du Petit Palais, Paris.

This pastel double-portrait of the sculptor Jean-Paul Aubé (1837-1916/20?) and his son is signed and dated 1882. By this date, Gauguin owned a fine collection of contemporary paintings, which included works by Cézanne, Pissarro, Manet and Degas. The influence of the last two is apparent in the composition of this, one of his most ambitious early pastels.

Plate 9 Winter Landscape. Fan. Gouache. 14·5 × 55cm. 1885. Private Collection, London.

During his six months' stay in Copenhagen, Gauguin produced several fans, some of which were presented to friends. These were either based on paintings by Cézanne or derived from his own paintings. The present one combines motifs from two paintings (W.37 and 140).

Plate 10 Study for a Fan after Cézanne. Gouache. 27·9 × 57·5cm. 1885. Ny Carlsberg Glyptotek, Copenhagen.

This fan, dedicated to his Danish friend, Pietro Krohn, reproduces much of a Cézanne landscape of the Midi which belonged to Gauguin (now in the National Museum of Wales, Cardiff). A second fan after a Cézanne painting exists (W.116).

Plate 11 Breton Girl. Chalk. 48 × 32cm. 1886. Present owner unknown.

This study is clearly of the same date as Plate II–the paper has the same lay-lines, the same coloured chalks are used, and the figure reappears alongside the one in Plate II in the 1886 Munich painting, the Brussels vase of 1886-7, and the landscape of 1888.

Plate 12 Breton Girl. Charcoal and pastel. 33 × 48·2cm. 1886. The Art Institute of Chicago (Mr and Mrs Carter H. Harrison Collection).

The figure is seen from above and the stronger, simplifying contour shows hints of Gauguin's cloisonnism which he developed more fully in his ceramics. Like those in Plates II and 11, the figure was used in the Brussels vase. It also appears in a fan (W.202), but not in a painting. The drawing is inscribed to Charles Laval (1862-94), whom Gauguin met in Pont Aven in 1886 and who accompanied him to Panama and Martinique in 1887.

21

Plate 13 Breton Girl Seated. Pastel and watercolour. 30 × 40 cm. 1886.
 Musée des Arts Africains et Océaniens, Paris.
 This study was used in the painting *The Breton Shepherdess* of
 1886, now in the Laing Art Gallery, Newcastle-upon-Tyne
 (W. 203). She reappears, with variations in the pose of the head, in
 two ceramics that Gauguin made in the winter of 1886-7—a
 stoneware jar (Bodelsen Fig. 1) and a *jardinière* (Bodelsen Fig. 20).

Plate 14 Breton Peasant Knitting. Coloured chalks. 60·2 × 41·5 cm. 1886.
 Cabinet des Dessins, Musée du Louvre, Paris (Bequest of Raymond
 Koechlin, 1934; RF 23.342).
 This and Plate 15 were drawn on the recto and verso of the
 same sheet. The study on the verso of the peasant girl knitting,
 executed in the same coloured chalks as Plates II and 11, does not
 recur in any surviving painting. But the study of the head on the
 right is connected with a portrait-vase of a Breton girl which
 Gauguin modelled in the winter of 1886-7 (Bodelsen Fig. 33).
 Compare a later drawing of a girl knitting (Plate 34).

Plate 15 Study of Nude Boy. Sanguine and coloured chalks. 60·2 × 41·5 cm.
 1886. Cabinet des Dessins, Musée du Louvre, Paris (Bequest of
 Raymond Koechlin, 1934; RF 23.342).
 Executed in black chalk and sanguine on the recto of Plate 14,
 this signed study was squared-up and used in the painting *Two
 Boys Bathing*, now in the Kunsthalle, Hamburg (W. 275) and dated
 1888. There are several instances of Gauguin making use of
 drawings of 1886 for paintings which were done during his
 second stay in Pont Aven in 1888 (c.f. Plates 18 and 19).

Plate 16 Study of Female Bather. Coloured chalks. 57·2 × 34·5 cm. 1886.
 The Art Institute of Chicago (Given in memory of Charles B.
 Goodspeed and Mrs Gilbert W. Chapman).
 Like Plate 15, the present drawing is squared-up and served as a
 study for a nude bather in a painting now in Buenos Aires
 (W.215), as well as a fan (W.216), both of which are dated 1887. It
 seems probable that Gauguin made the drawing in 1886, but
 strengthened the contours when he decided to use it for the
 painting. The pose recurs in two ceramics of 1887-8 (Bodelsen
 Figs. 58 and 66), and finally, in reverse, in a lithograph (Guérin 3).
 Possibly because of its constant use the sheet has been cut down to
 its present uneven edges; initially, its size may have been the
 same as that of Plates 14 and 15.

Plate 17 Head of Boy. Pastel. 19 × 18·5 cm. 1886. Mr and Mrs George N.
 Richard, New York.
 The strengthening of the contours, already noted in Plates 15
 and 16, occurs again here. In type, the boy is related to two
 paintings of fighting boys (W.273-4) of 1888, and also to a ceramic
 of the following year (Bodelsen Fig. 88).

Plate 18 Study of Breton Gleaner. Chalk. 46 × 38 cm. 1886. Mr and Mrs Paul Mellon, New York.

 A squared-up study which formed the basis for a similar figure in the painting *Petit Berger Breton* (Museum of Western Art, Tokyo), a winter scene executed in February 1888. As with Plates 15 and 19, Gauguin used a drawing of 1886 (compare the style of Plates 11-14) for a painting of 1888. The pose is reminiscent of some of Degas' nudes exhibited at the last Impressionist exhibition of 1886.

Plate 19 Study of Breton Peasant. Chalk and pastel. 27·5 × 39 cm. 1886. Musée des Arts Africains et Océaniens, Paris.

 This study of a young peasant tying his sabot adapts poses frequently used by Degas in studies of dancers. The drawing was used for a painting which was executed in February-March 1888 (now in the Ny Carlsberg Glyptotek, Copenhagen ; W.258). Once again Gauguin has drawn on his stock of sketches from the summer of 1886 (c.f. Plates 15 and 18).

Plate 20 Martinique Women. Pastel. 48·5 × 64 cm. 1887. Mme Pierre Goujon, Paris.

 Unlike Plate 19, this is a sheet which can be related to a painting, *Fruit-pickers*, acquired by Theo van Gogh in 1888 (now in the Stedclijk Museum, Amsterdam). The two figures, squared-up in the drawing, appear in reversed positions in the painting.

Plate III Head of Martinique Girl. Pastel. 36 × 27 cm. 1887. Vincent van Gogh Foundation, Amsterdam.

 Very few drawings exist from Gauguin's stay in Martinique (June-October 1887). The present one of a young negress holding a fruit may refer to an episode that Gauguin relates in a letter to his wife (June 20, 1887). There Gauguin tells how a young negress of 16 'offered me a split guava squeezed at the end,' as a means of sexual bewitchment. The brothers Van Gogh greatly admired Gauguin's Martinique work and Theo acquired this pastel for his collection.

Plate IV Breton Girls Dancing. Pastel. 22 × 41 cm. 1888. The Vincent van Gogh Foundation, Amsterdam.

 This study of Breton girls dancing—a sort of animated Three Graces—is a preparatory study for a painting of the same title now in the collection of Mr and Mrs Paul Mellon (W.251). The sheet carries colour notes (e.g. 'vert' on the right-hand figure). There are slight differences in the finished painting—more space between the left and central dancers and minor changes in the headdress of the figure on the right. The two figures to the right were sketched in a letter to Schuffenecker of 14th August, 1888 (Bodelsen Fig. 132). The pastel belonged to Theo van Gogh, who also owned the one shown in Plate III.

23

Plate 21 Studies of Nudes after Degas. Black chalk. 34·6 × 23cm. 1888.
 Page 6 from the *Album Briant*, Cabinet des Dessins, Musée du
 Louvre, Paris.
 If the influence of Degas is less obvious in Plates III and 20, here
 Gauguin expresses his admiration. For these studies of nudes were
 copied from an exhibition of Degas' work organised by Theo van
 Gogh at the gallery of Boussod Valadon, Paris, in January 1888.

Plate 22 Studies after Ceramics. Black chalk. 34·6 × 23cm. 1888. Page 25
 from the *Album Briant*, Cabinet des Dessins, Musée du Louvre,
 Paris.
 Just before the Degas exhibition in January 1888, Theo van
 Gogh had shown in his gallery a large number of Gauguin's
 ceramics. The present sheet consists of copies after these ceramics,
 a sort of miniature *liber studiorum*. Other sketches after his
 ceramics appear in the same sketchbook (pages 1, 20 and 21).

Plate 23 Study of Portrait-Vases. Charcoal and watercolour. 31·8 × 41·6cm.
 1888. Present owner unknown.
 Together with Plate 22, this sheet is clearly a drawing after
 Gauguin's own ceramics. The three sketches show portrait-vases
 which were executed in the winter of 1887-8–the one on the right
 is of Mme Schuffenecker (Bodelsen Fig. 43), the other two of the
 'Leda vase' (Bodelsen Fig. 50). A date of January 1888 seems
 probable for this drawing.

Plate 24 EMILE SCHUFFENECKER (1851-1934). Portrait of Gauguin. Black
 crayon. 36·5 × 29·3cm. 1888. Museum of Art, Rhode Island School
 of Design, Providence.
 'Schuff', as Gauguin always called him, was a close and
 hospitable friend, especially in the difficult years from 1886 to
 1891. He housed Gauguin for the most part during his stays in
 Paris and bought–or stored–his paintings, drawings, ceramics and
 sculpture. In this drawing, Gauguin is seen holding one of his
 ceramics, with the flames of the kiln in the background consuming
 one of his statues.

Plate 25 Heads of Breton Peasants. Pastel. 30 × 42cm. 1888. Private
 Collection, Paris.
 This pastel study of two Breton girls seems 'advanced' in style
 for 1888 : neither head appears in a painting of that year.
 Stylistically, the closest analogy seems to lie in the heads of two
 Breton peasants that appear in a painting of 1894 (W.521). It was
 also presumably in the latter year that Gauguin dedicated the
 pastel to the painter Maxime Maufra (1861-1918)–'à l'ami Maufra,
 à l'artiste d'avant garde Aïta Aramoe.'

Plate 26 Study for *Woman in the Hay*. Charcoal and watercolour. 26·3 × 40cm. 1889. The Vincent van Gogh Foundation, Amsterdam.

Clearly related to a painting (Niarchos Collection, Paris; W.301) executed during Gauguin's stay in Arles in November 1888, this drawing may have been done *after* the painting, probably in the early part of 1889. Gauguin adopted this practice in several instances (c.f. the two fans, Plates V and 28).

Plate 27 L'Arlésienne. Charcoal. 56 × 48cm. 1888. Dr. and Mrs T. Edward Hanley Collection, U.S.A.

Just as remarkably few drawings exist from Gauguin's four months stay in Martinique in 1887, so there is a paucity of drawings from his two months stay with Van Gogh in Arles in 1888. His procedure in Arles was to consign his first ideas to his sketchbook, which still survives (edited by René Huyghe, 1952). He used the same sketchbook in Brittany in 1889-90. The present drawing shows Mme Ginoux, wife of the proprietor of the café which Van Gogh had painted in September 1888 (now in the Yale University Art Gallery). Gauguin made a painting of the same café (Museum of Modern Art, Moscow; W.305), in which Mme Ginoux sits at a marble-topped table in the right foreground. Gauguin gave the drawing to Van Gogh who used it later at St-Rémy as a starting-point for four paintings of *L'Arlésienne*.

Plate 28 Washerwomen at Arles. Watercolour on silk. 10·1 × 20·3cm. 1889. Present owner unknown.

This and Plate V are two watercolour paintings on silk probably done in Paris in the early part of 1889. Each reproduces parts of paintings which Gauguin had executed in Arles in November 1888 (W.302 and 303). A lithograph also exists (Guérin 6) which reverses the composition of this plate.

Plate 29 Locusts and Ants: A Memory of Martinique. Lithograph. 21·3 × 26cm. 1889. Royal Museum of Fine Arts, Copenhagen.

Plate 30 Dramas of the Sea: A Descent into the Maelstrom. Lithograph. 18 × 27·5cm. 1889. Metropolitan Museum of Art, New York. Rodgers Fund, 1921.

Plate 31 Misères Humaines. Lithograph touched with watercolour. 28·4 × 32·1cm. 1889. Present owner unknown.

Plate 32 Old Woman of Arles. Lithograph. 19 × 21cm. 1889. Royal Museum of Fine Arts, Copenhagen.

Plates 29-32 illustrate four of the album of eleven lithographs on zinc which Gauguin included in the exhibition of *Peintures du Groupe Impressionniste et Synthétiste,* held at the Café Volpini during the Paris International Exhibition of 1889. This suite of lithographs consisted of memory images of Brittany, Martinique and Arles. Some impressions were retouched with watercolour (e.g. Plate 31).

Plate 33 Seated Nude. Pastel. 56 × 24 cm. 1889. Private Collection, U.S.A.

This Degas-inspired drawing from the nude model, together with a second study in pastel, formed the basis of a painting exhibited in Copenhagen in 1893 as *La Vie et la Mort* (W.335). The figure of *La Mort* was transformed into Eve (c.f. Plate VI) and also became one of Gauguin's stock images (see Plate 41).

Plate 34 Breton Girl Knitting. Pastel and charcoal. 83 × 49·5 cm. 1889. Mme Huc de Monfreid, Paris.

The increased simplification and power of Gauguin's drawing may be seen by comparing a similar subject of 1886 (Plate 14). The present drawing was used in two paintings, *Girl Tending Pigs* (W.354) and *La Barrière* (W.353), both of the summer of 1889.

Plate 35 Studies of Breton Boys. Pencil. 26 × 38 cm. 1889. Musée des Arts Africains et Océaniens, Paris.

The inscription, deliberately mock-formal, is to Schuffenecker (see note to Plate 24). The studies on the present sheet are more schematic, with a strongly articulated contour, than those of Breton boys done in 1886 (compare Plates 15 and 17). In style, they are close to Plate 44, and to two paintings which include boys, dating from the late summer and autumn of 1889 (W.367 and 370), the latter, painted on panel, once forming part of the decoration of Marie Henry's Inn at Le Pouldu.

Plate 36 Study for *The Harvest*. Charcoal and watercolour. 27 × 17·6 cm. 1889. Graphische Sammlung, Albertina, Vienna.

These studies of peasants and cows were made in connection with the painting of *The Harvest* of July 1889, now in the Courtauld Institute of Art, London (W.352).

Plate V Washerwomen at Arles. Watercolour on silk. 10·1 × 20·3 cm. 1889. Arthur Sachs Collection, Paris.

See the note on Plate 28.

Plate VI Breton Eve. Pastel and watercolour. 33 × 31 cm. 1889. The Marion Koogler McNay Art Institute, San Antonio, Texas.

The present drawing is clearly related to Plate 33, but transformed by the addition of tree and serpent into a figure of Eve. Eve, original sin and the idea of primitive paradise all worked strongly in Gauguin's imagination from 1889 until his departure for Tahiti in April 1891 (c.f. Plate 48).

Plate 37 Study for *The Harvest*. Pencil. 17·5 × 22·5 cm. 1889. Musée des Beaux-Arts, Rheims.

This curious drawing consists of two unrelated vignettes, one formed by the shape of a head, the other of a haystack, existing in the same flat plane. The schematic compartmentalisation and the junction of unrelated images are also found in *La belle Angèle*

(Musée du Louvre; W.315) and the sculpture, *Soyez amoureuses* (Museum of Fine Arts, Boston; Gray 76), both executed in 1889. The vignette on the left contains a portrait of Meyer de Haan (c.f. Plates 40 and 41); that on the right is related to two harvesters in the painting, *The Harvest*, now in the Louvre (W.351).

Plate 38 Study for *The Yellow Christ*. Pencil. 31·9 × 24cm. 1889. Mr and Mrs William Goetz, Los Angeles.

Plate 39 The Yellow Christ. Watercolour. 15·2 × 12·1cm. 1889. Mrs Gilbert W. Chapman, New York.

These two drawings differ in intention. The pencil study was done from a piece of sculpture, a wooden polychrome crucifix in the chapel of Tremalo, near Pont Aven. This formed the starting-point for the famous painting, *The Yellow Christ* (Albright Knox Art Gallery, Buffalo, N.Y. The watercolour would appear to have been done after the painting, just as earlier Gauguin had produced two versions of the *Washerwomen at Arles* after his own paintings (c.f. Plates V and 28).

Plate 40 Portrait of Meyer de Haan. Gouache. 16·5 × 11·5cm. 1889. Mr and Mrs Arthur G. Altschul, New York.

The Dutch artist, Meyer de Haan (1852-95) met Gauguin in Paris in early 1889. By June of that year, they were together at Pont Aven and the following October moved to Marie Henry's Inn at Le Pouldu. Among the painted decorations which they did at this inn was a portrait of de Haan by Gauguin (David Rockefeller Collection, New York; W.317), for which this small gouache served as a study.

Plate 41 Nirvana: Portrait of Meyer de Haan. Oil and turpentine on silk. 20 × 29cm. 1889. The Wadsworth Atheneum, Hartford, Connecticut.

In this painting on silk (c.f. Plates V, 28 and 42), Gauguin shows his friend against *les Roches noires*, the Black Rocks near Pont Aven which carried powerful superstitious associations for the local inhabitants. The two nudes in the background appear separately in paintings and drawings (c.f. Plates 33 and VI), but were first combined in a wash drawing used as frontispiece for the catalogue of the Café Volpini exhibition. In the present work, de Haan sits in front of them like a Buddhist divinity sunk in Nirvana. Notice how the snake round his right arm is used decoratively by Gauguin to form part of his signature. Note also the stylisation of the eyes.

Plate 42 Breton Woman at Le Pouldu. Watercolour on silk. 18·3 × 10·5cm. 1889. Private Collection, New York.

A study which is related to the painting, *Bonjour, Monsieur Gauguin*, National Gallery, Prague (W.322). The pose of the peasant woman is identical in both, but in the watercolour the landscape elements have been reduced, giving a more simplified,

linear and decorative effect. This again suggests that the water-colour was done *after* the painting.

Plate 43 Head of a Breton Girl. Pencil, crayon and gouache. 22·4 × 20 cm. 1889. Fogg Art Museum, Harvard University (Bequest of Meta and Paul J. Sachs).

The model wears Le Pouldu costume and the sheet must date from the autumn of 1889. Similar costume appears in other works of this period, e.g. W.340, 344, 360 (c.f. Plates 50, 51, VII and VIII). The pose of the present figure does not recur in any painting, but a near parallel may be found in one of the decorations for Marie Henry's Inn, *Jeanne d'Arc* (W.329).

Plate 44 Studies of Peasant and Dog. Charcoal. 53 × 71 cm. 1889. Private Collection, Paris.

Both the seated peasant and the studies of the dog are connected with the painting, *The Seaweed Gatherers* (Folkwang Museum, Essen; W.349), executed in the autumn of 1889. Again the peasant wears Le Pouldu costume.

Plate 45 Breton Peasants Harvesting. Charcoal. 18 × 28 cm. 1889. Present owner unknown.

A study for *The Seaweed Gatherers* (Private Collection, Japan; W.392) executed in the autumn of 1889. In the painting Gauguin altered the pose of the left-hand figure. On the verso are studies of children (Rewald 91) used in the painting *Knitting* (Bührle Collection, Zurich; W.358).

Plate 46 Landscape with Cows. Watercolour. 26·4 × 31·9 cm. 1889. Mrs Siegfried Kramarsky, New York.

Willows form a feature in the Oslo painting (c.f. Plate VIII). In the background of this watercolour, they are given a witty life of their own, echoing the cows' horns in the foreground. The repeated ornamental curves—and the decorative treatment of his signature—give hints of Art Nouveau. The relaxed, playful mood characterises several works done at Marie Henry's inn during the winter of 1889-90 (c.f. Plate 47).

Plate 47 Les Folies de l'Amour. Gouache. Diameter 26·7 cm. 1889. Mr and Mrs W. B. Dixon, Westgrove, Pennsylvania.

The playful, witty shapes of Plate 46 may be found again here. The design is one of four which must have been executed as light relief during the long winter evenings at Marie Henry's inn in 1889-90. The circular shape common to all four suggests that they may have been designs for plates which were never carried out. The theme of love, jokingly presented, often with obscure symbols, makes them a light-hearted interlude between the two wood-carvings of the same theme—*Soyez amoureuses* of autumn 1889 and *Soyez mystérieuses* of the following autumn.

28

Plate 48 Exotic Eve. Oil on carton. 43 × 25cm. 1890. Private Collection, Paris.

 This small painting is included here because of its stylistic and thematic importance. Signed and dated, in reverse, *P. Gauguin 90*, it was almost certainly executed at Le Pouldu—c.f. the painting of *Adam and Eve* (W.390), which used to hang at Marie Henry's inn. The pose is based on a figure that appears in a photograph of a relief from the Temple of Barabudur, Java, a copy of which was found among Gauguin's papers after his death. The head is based on a photograph of his mother, of which he also made a separate painted copy (W.385). The landscape elements derive from his memories of Martinique. From these sources, Gauguin produced his tropical Eve, in succession to his Brittany Eve of 1889 (c.f. Plate VI). In 1892, the same pose was adapted for his Tahitian Eve, which he represented in a painting, several drawings, a woodcut and a monotype (c.f. Plates 60-62, IX and 92).

Plate 49 Study for the *Loss of Virginity*. Black chalk on yellow paper. 31·3 × 32·5cm. 1890. Mr and Mrs Leigh B. Block, Chicago.

 A study for a large painting (Walter P. Chrysler Jnr. Collection; W.412) which was executed during Gauguin's stay in Paris before his departure for Tahiti (November 1890-March 1891). The drawing once belonged to Octave Mirbeau, the critic whom Gauguin met in January 1891, and who published a laudatory article on him in *L'Echo de Paris* of 18th February 1891.

Plate 50 Portrait of Stéphane Mallarmé. Pencil and pen. 24 × 18·5cm. 1891. Present owner unknown.

 Gauguin first met the Symbolist poet Stéphane Mallarmé (1842-98) during the five months he spent in Paris before his departure for Tahiti. The present drawing is a study for the etching (Plate 51).

Plate 51 Portrait of Stéphane Mallarmé. Etching. 18·2 × 14·3cm. (plate). 1891. Museum of Fine Arts, Boston (Gift of William G. Russell Allen).

 Some dozen proofs were pulled of this, Gauguin's only etching. (In 1919 a second printing of 79 proofs was made). The original proofs were presented to close friends. Technically, it shows the wide range of tools used by Gauguin, as was his wont later in his woodcuts (c.f. Plates 92-95). One of his biographers, Rotonchamp, described how he borrowed them from Léon Fauché—'needle, pen, burin and scraper.' Working from the drawing (Plate 50), Gauguin added the raven, a reference to Mallarmé's translation of Poe (1875); and appropriately, he based it on a drawing by Manet, who was not merely an earlier friend of Mallarmé's, but in fact illustrated the Poe volume. Manet was very much in Gauguin's mind at this period: he had just completed a painted copy of Olympia (W.413).

Plate 52 Soyez symboliste–Portrait of Jean Moréas. Pen, brush and ink.
35 × 42cm. 1891. Present owner unknown.
 Jean Moréas (1856-1910) published the manifesto of Symbolism
in *Le Figaro* of 18th September 1886. By the end of 1890, he had
published three volumes of poetry–*Les Syrtes. Les Cantilènes* and
Le Pèlerin passionné. Gauguin met him in December 1890, for the
present drawing must have been executed in that month, as it was
published on 1st January 1891 in a special number of *La Plume*
devoted to the symbolism of Jean Moréas. There, the drawing is
referred to as *Composition allégorique de Paul Gauguin.* The allegory
contains a familiar Gauguin injunction–Soyez symboliste–together
with a peacock in full plumage and a cherub holding a sprig of
laurel. Beneath the peacock's feet is inscribed *Les Cantilènes*, a
reference to Moréas' earlier volume. The pose of the poet is very
close to that of Mallarmé in the drawing, Plate 50.

Plate VII Two Breton Girls. Pastel on cardboard. 74·5 × 51cm. 1889. Private
Collection, London (On loan to the Tate Gallery).
 The many pinholes in the corners of the sheet of this drawing
attest to its use as a study for the painting now in the National
Museum of Western Art, Tokyo (W.340), which shows two young
peasant girls occupying the whole of the picture surface, with a
view of the sea behind them. The only major difference in the
painting is the enlargement of the feet. The sentimental,
picturesque elements inherent in the situation are subordinated to
a search for simple, expressive shapes, as in Plates 43-45. Compare
the other pastels executed at much the same period (W.346) and
Sotheby's, 25th November, 1959, lot 82.

Plate VIII En Bretagne. Watercolour and gold paint. 37·4 × 26cm. 1889. The
Whitworth Art Gallery, University of Manchester.
 In costume and type, as well as in pictorial simplifications, this
study is close to Plates 43-45 and VII. But its surface is enriched by
the addition of gold paint. The motif is closely connected with, but
differs in specific details from, a painting now in the National
Gallery of Oslo (W.357).

Plate IX Standing Tahitian Nude. Watercolour. 41·9 × 26cm. 1892.
National Gallery of Art, Washington D.C. (Rosenwald Collection).
 This variation on the Eve theme is related to the woodcut, *Te
Nave Nave Fenua* (Guérin 27-29)–c.f. Plate 92. The watercolour is
inscribed in pidgin French, *Pas écouter li li menteur* ('Do not listen
him . . . him liar').

Plate X The Devil's Words (Eve). Pastel. 77 × 35·5cm. 1892.
Kupferstichkabinett, Basle.
 If Plates 60, 61, IX and 62 show Eve before the Fall, this
adaptation of the pudic nude shows Eve after the Fall. It acted as a
study for the painting *Parau na te Varua ino* (The Devil's Words)

in the Averell Harriman Collection, New York (W.458). A photograph of the drawing is pasted on to page 51 of *Noa Noa*. The profile head of the devil was used in the painting *Manao Tupapau* (Spirit of the Dead Watching), in the A. Conger Goodyear Collection, New York (W.457). The figure of Eve is reversed, and the background changed, in a monotype (Plate 105) and a woodcut (Guérin 57). c.f. also Plates 64 and 73.

Plate 53 Madame la Mort. Charcoal. 23·5 × 29·3cm. 1891. Cabinet des Dessins, Musée du Louvre, Paris. (RF 29.492).

 Gauguin wrote two letters to Rachilde (2nd and 5th February 1891) regarding illustrations to her Théâtre. The volume was published by Savine in 1891, with Gauguin's drawing to her play, *Madame la Mort*, as frontispiece. The resemblance to Redon's charcoal drawings is not fortuitous—Gauguin was one of Redon's warmest admirers.

Plate 54 Head of a Child. Charcoal. Size unknown. *c*. 1889. Private Collection, Paris.

 This drawing once formed part of a portfolio which Gauguin labelled *Documents Tahiti 1891, 1892, 1893* (the cover is illustrated in Malingue, Plate 13). The portfolio, now dismembered, was exhibited at the Galerie Marcel Guiot, Paris, in 1942, where the present sheet was no. 8. Despite the title, the portfolio contained drawings that clearly date from Gauguin's stay in Brittany in 1889-90; and there are monotypes and drawings that must date from his last years in the South Seas—indeed, several of these are closely related to some of the illustrations in *Avant et Après* which Gauguin was composing in January-February 1903. The present sheet belongs to the Brittany group. A related oil-study exists. See also Plate 55.

Plate 55 Head of a Child. Coloured chalks. 28 × 19·8cm. *c*. 1889. Present owner unknown.

 Together with Plate 54, this sheet served as a preparatory study for a painting of two children, now in the Ny Carlsberg Glyptotek, Copenhagen (W.530). Dated by the artist's son Pola to 1895, the painting seems more likely to be of 1889 (c.f. W.388, a portrait of a child, dated 1890).

Plate 56 Studies of Heads. Pencil. 31 × 21·2cm. 1891. Musée des Beaux-Arts, Rheims.

 This sheet of three heads is one of several that Gauguin produced during his first year in Tahiti. For closely related studies, see Rewald 31-35—c.f. especially the profile heads in Rewald 35 with the one in the lower right of the present drawing. The sheet formerly belonged to Louis Brouillon, who, under the pseudonym of Jean de Rotonchamp, wrote an important study of Gauguin in 1925.

31

Plate 57 Head of Tahitian Boy. Pencil and pen. 15 × 10·5cm. 1891. Mr and Mrs Alex M. Lewyt Collection, New York.
 This sheet formerly belonged to a sketchbook, *Carnet de Tahiti*, published in facsimile in 1954 with an introduction by B. Dorival. The album was later dismembered; two further studies from it (Rewald 32 and 34) are now in the same collection as Plate 57. Together, they were first ideas for the painting, *The Repast*, of 1891 (W.427).

Plate 58 Ia Orana Maria. Monotype, retouched with watercolour. 22·9 × 14cm. 1894. Museum of Fine Arts, Boston (Bequest of W. G. Russell Allen).

Plate 59 Ia Orana Maria. Charcoal. 59 × 36·5cm. 1893(?). Mr and Mrs Leigh B. Block Collection, Chicago.
 This drawing would seem to have been done after Gauguin's painting of the same title, one of his first Tahitian works of 1891 (now Metropolitan Museum of Art, New York, W.428). Only part of the painting appears in the drawing, and significantly Gauguin excludes one of the adoring natives. The drawing is dedicated to Comte Antoine de la Rochefoucauld, editor of the periodical *Le Cœur* and owner of *The Loss of Virginity* (C.f. Plate 49). The composition is reversed in a zincograph (Guérin 51) and two monotypes—one of the latter is Plate 58. These, like the drawing, were probably done after Gauguin's return to France in 1893.

Plate 60 Standing Tahitian Nude. Monotype, retouched with watercolour. 38·5 × 23·5cm. 1894. Museum of Fine Arts, Boston (Bequest of W. G. Russell Allen).
 This sheet, together with Plates 61, 62 and IX, may be compared thematically to the small painting of 1890 (Plate 48). Gauguin presents Eve before the fall, innocently plucking a tropical flower as the serpent whispers in her ear. The pose was taken from a figure in a Buddha relief at Barabudur, Java, of which Gauguin owned a photograph. He made several variations on the pose, sometimes reversing the image—in this instance, caused by the monotype process. Together with Plates 58, 85, 86 and 89, it would seem to have been executed after his return to Tahiti, almost certainly in Brittany during the summer of 1894.

Plate 61 Standing Tahitian Nude. Charcoal and pastel. 92 × 55cm. 1892. Des Moines Art Center, Iowa, U.S.A. John and Elizabeth Bates Cowles Collection.
 This is a study for the figure of Eve in the painting *Te Nave Nava Fenua* (The Land of Sensuous Pleasures), dated 1892 and now in the Ohara Museum, Kurashiki, Japan (W.455). There are various studies on the verso. Two related drawings exist—Plate 62 and Rewald 60.

Plate 62 Standing Tahitian Nude. Watercolour. 40 × 32cm. 1892. Musée de
 Grenoble.
 Compared with Plate IX, this watercolour shows a freely spotted
 technique, a sort of haphazard pointillism. The pose repeats that of
 Plate 61 and Rewald 60.

Plate 63 Studies of Tahitian Figures. Charcoal and watercolour.
 24 × 31·3cm. 1892. Cabinet des Dessins, Musée du Louvre, Paris.
 This sheet of quick studies contains poses and types that recur
 elsewhere, both in drawings (c.f. Plates 74 and 75) and paintings
 (W.441 and 515).

Plate 64 Study for *Words of the Devil*. Pencil. 22 × 21·5cm. Cabinet des
 Dessins, Musée du Louvre, Paris. (RF 29.332).
 A sheet from the *Documents Tahiti 1891-93*, in which the stand-
 ing nude figure reverses the pose of the Basle drawing (Plate X).
 The figure with the mask reappears, without the mask, in three
 paintings of 1892 (W.458-60). On the verso are studies of a female
 head facing three-quarters right, and a hand.

Plate 65 Tahitian Women. Pencil and pen on parchment. 24 × 31·5cm.
 1892. The Art Institute of Chicago (David Adler Collection).
 The object in the upper right has been identified as a Marquesan
 earplug, which Gauguin transformed into a fence in the painting
 Parahi Te Marae (W.483), for which Plate XIV is a study.

Plate 66 Studies of Tahitian Women. Pen and watercolour. 18·5 × 26cm.
 c.1892. Cabinet des Dessins, Musée du Louvre.
 Pasted on to page 185 of *Noa Noa*, this sheet's major interest lies
 in the squatting figure on the right. Inspired by a statue of
 Dionysus of which Gauguin had a photograph, the pose reappears,
 somewhat modified, in paintings of 1892 (W.461), 1894 (W.512)
 and 1897 (W.579), all three of which are now in Russia. Compare
 the costume of the figure on the left with Plate 74.

Plate 67 Tahitian Girl. Charcoal. 55·3 × 47·8cm. 1892. The Art Institute of
 Chicago (Gift of Tiffany and Margaret Blake).
 This study of a seated figure is on the verso of Plate 66. There is
 no comparable pose in a painting.

Plate 68 Head of a Tahitian Girl. Pastel and gouache. 39 × 32cm. 1892.
 Metropolitan Museum of Art, New York (Bequest of Adelaide
 Milton de Groot, 1967).
 The pose of this powerfully conceived figure is not repeated in
 any known painting.

Plate XI Tahitian Woman. Pastel. 56 × 49·6cm. 1892. The Brooklyn
 Museum, New York.
 This powerfully composed pastel has been dated as late as 1900

33

But it seems related in type and technique to Plate X. The pose does not recur in any painting.

Plate XII Crouching Tahitian Girl. Pencil, charcoal and pastel. 55·3 × 47·8cm. 1892. The Art Institute of Chicago (Gift of Tiffany and Margaret Blake).

This squared-up drawing served as the final study for the central figure of the picture, *Nafea Faa Ipoipo* (When are we getting married?) dated 1892 and now in the Öffentliche Kunstsammlung, Basle (W.454). The pose also recurs in several other works of 1891-93 (W.445, 447, 448 and 501). A related preparatory drawing exists (Rewald 46).

Plate 69 Head of a Tahitian Man. Black and Red Crayon. 32·5 × 29cm. *c.*1892 The Art Institute of Chicago (Gift of Emily Crane Chadbourne).

As with Plate 68, no equivalent pose of this head exists in any surviving painting. On the verso, however, is a sketch of two standing figures which was used for *Tahitian Landscape* (Metropolitan Museum of Art, New York; W.442), dated 1891.

Plate 70 Head of a Tahitian Woman. Pencil. 31 × 24cm. 1891. Cleveland Museum of Art (Mr and Mrs Louis B. Williams Collection).

This head is a study for one of the six assembled Tahitian women in the painting *Les Parau Parau* (Conversation), dated 1891 and now in the Pushkin Museum, Moscow, (W.435). Plate 71 is also a study for this painting. C.f. a page of studies in watercolour, page 173, *Noa Noa.*

Plate 71 Head of a Tahitian Woman. Watercolour. 31 × 24cm. 1891. Mrs Diego Suares Collection, New York.

Like Plate 70, this drawing acted as a study for one of the six assembled Tahitian women in the painting *Les Parau Parau.*

Plate 72 Head of a Tahitian Woman. Black chalk. 30·5 × 24cm. *c.*1892. Mr and Mrs Bernard Lande, Quebec.

Although this drawing is remarkably close to a figure in the painting *Tahitian Women in their Hut* (W. 626) which is dated 1902, it probably dates from Gauguin's first stay in Tahiti.

Plate 73 Head of a Tahitian Woman. Charcoal. 48 × 31·5cm. 1892. M. Marcel Laloe, Paris.

This is a study for the head of Eve in the painting *Te Nave Nave Fenua* of 1892 (W.455). For a full-length study, c.f. Plate X.

Plate 74 Standing Tahitian Woman. Charcoal. Size unknown. 1892. Present owner unknown.

Inscribed *P. Go Tahiti 1892*, this drawing was used for a background figure in the painting, *Pêcheuses Tahitiennes* (W.429),

34

which is dated 1891. Could the drawing have been wrongly dated by Gauguin later? C.f. a similarly costumed figure in Plate 66.

Plate 75 Seated Tahitian Boy. Charcoal. Size unknown. 1892. Present owner unknown.

Very close in style to Plate 74, this casually seated figure does not recur in any surviving painting.

Plate 76 Studies of a Greyhound. Charcoal and wash. 17·8 × 27·3cm. c. 1892. Private Collection, California.

This sheet once formed part of the portfolio *Documents Tahiti 1891-93* already mentioned under Plates 54 and 64. Dogs appear in several paintings of 1891-2; the present studies may be connected with the animals in W.468 and 470.

Plate 77 Studies of Horses. Brown and black ink on parchment. 24·3 × 31·9cm. 1891. Museum Boymans van Beuningen, Rotterdam.

In these studies of horses, Gauguin used a brush and black ink to strengthen parts of his initial pen and brown ink drawing. The two studies on the right are for the horse that appears in the *Rue de Tahiti* dated 1891 (Toledo Museum of Art; W.441). The other studies, together with a horse in Rewald 70, form the basis for a series of animals in several pictures (W.442-3, 446, 474-5, 505).

Plate 78 Tahitian Woman with a Pig. Pencil and watercolour. 6 × 16·7cm. 1893. Mr and Mrs Richard Rodgers, New York.

This playful confrontation is reminiscent in spirit of some of the drawings that Gauguin did at Le Pouldu in the winter of 1889-90 (c.f. Plates 46 and 47). The crouching nude reappears, alone, in a painting of 1893, *Otahi* (W.502).

Plate 79 Tahitian Landscape. Watercolour. 26·5 × 35cm. c. 1892-3. Stavros S. Niarchos Collection, Paris.

A closely related watercolour was pasted on page 179 of *Noa Noa*. These are among several studies of the 'wild and luxuriant nature' of Tahiti, which Gauguin tried to capture in watercolour. The present landscape reappears in the background of one of Gauguin's last paintings, *Women and a White Horse* (Museum of Fine Arts, Boston; W.636).

Plate 80 Tahitian Hut under Palm Trees. Watercolour. 30 × 22·5 cm. c. 1892-3. Cabinet des Dessins, Musée du Louvre, Paris.

Gauguin pasted this watercolour on page 181 of *Noa Noa*.

Plate 81 Tahitian Landscape. Monotype. 19·7 × 35·3cm. c. 1894. National Gallery of Art, Washington D.C. (Rosenwald Collection).

In addition to this view of mountains, lagoon and palm-clad island, a further landscape in watercolour exists on the verso.

Plate 82 Petites Babioles Tahitiennes (Little Tahitian Knick-knacks). Pencil, charcoal, pen and watercolour. 44 × 32 cm. 1892. Present owner unknown.

The sheet is inscribed *à Monsieur de Marolles. Comme un Bon Souvenir de notre entrevue chez les Maories.* Of the three studies of figures on the right, the upper one is related to a reclining nude in the painting *Aha Oe Feii* of 1892 (W.461), the lower one reappears in *Tahitians on the Beach* (W.462). The larger study on the left appears to be pasted on to the sheet; no identical pose exists in any surviving painting.

Plate 83 Letter to unknown Collector. Pen. 25·5 × 20·5 cm. 1896. Mr and Mrs Alex M. Lewyt, New York.

The rapid pen sketch reproduces most of the figures in the painting, *Mahana no atua* (The Day of God), executed in the summer of 1894 (Art Institute of Chicago; W.513). The drawing, however, accompanied a small painted panel of 1896, *Trois Tahitiennes* (W.539), which Gauguin gave to Dr Nolet, who was returning from Tahiti to France.

Plate 84 Pape Moe (Mysterious Water). Monotype. 29 × 16·5 cm. 1894. M. Denis Rouart, Paris.

Henri Rouart, artist, collector, and a close friend of Degas, bought this monotype from Gauguin, probably in 1895. It belongs to a series of monotypes that Gauguin executed in Brittany in 1894 (c.f. Plates 58, 60, 85, 86 and 89). The composition reverses the figure in the watercolour, Plate XV.

Plate XIII Joyousness. Fan. Watercolour. Diameter 56 cm. 1892. Mr and Mrs Sidney F. Brody, Los Angeles.

This fan is based on the painting *Arearea* (Joyousness), now in the Louvre (W.468), which Gauguin executed in December 1892 when he was in a particularly happy mood. Its idyllic paganism embodied the vision he had of tropical paradise. Only two fans exist which reproduce Tahitian scenes (the other is W.438) and they are the last fans that Gauguin produced. It seems likely that both were painted in Paris or Brittany in 1894 after his return from Tahiti. The idol and dancing figures recur in a woodcut that almost certainly dates from 1894 (c.f. Plate 94) and also have parallels in two paintings which are dated 1894 (W.512-13).

Plate XIV Parahi Te Marae. Watercolour. 18·5 × 22·9 cm. 1892. Fogg Art Museum, Harvard University. Bequest of Marian H. Phinney.

This seemingly decorative watercolour represents a harsher reality: Gauguin's evocation of the sacred mountain of the ancient Maori cult, the image of the God in the distance, and in the foreground a fence on which human skulls are impaled. These skulls are clearer in the related painting of 1892 (W.483), where their derivation from the Marquesan earplug in Plate 65 is obvious.

Plate 85 Parau Hina Tafatou. Monotype, retouched with watercolour. Size unknown. 1894. Present owner unknown.

This illustration of Tahitian mythology, showing Hina, the Spirit of the Moon, talking to Tafatou, the Spirit of the Earth, was frequently used by Gauguin in a variety of media. The initial study is probably a pencil drawing (Bodelsen Fig. 101). It recurs in his illustrated manuscript, *Ancien Culte Mahorie* (Bodelsen Fig. 102), in a woodcarving (Gray 96), on a vase (Bodelsen Fig. 104) and in part of a woodcut, *Te Atua* (Guérin 31). The present sheet was executed in Brittany in the summer of 1894. For technically related works done at the same time see Plates 58, 60, 86 and 89. Gauguin illustrated the same myth, with a different composition, in a painting of 1893 (Museum of Modern Art, New York; W.499).

Plate 86 Oviri. Monotype retouched with watercolour. Size unknown. 1894. Present owner unknown.

Like Plate 85, this sheet is a monotype retouched with watercolour executed in Brittany in the summer of 1894. A related woodcut (Guérin 48) also dates from this time. *Oviri* means 'the savage'. Gauguin gave this title to his largest and most important stoneware sculpture (Bodelsen Fig. 99) which he probably made in Paris in the winter of 1894-5, and which takes up the pose of the figure in the present drawing. A plaster relief (Gray 109), showing the artist's head in profile, is also called Oviri; it too probably dates from 1894-5. There are three related drawings: one in pen inscribed *Diane,* one on page 61 of *Noa Noa,* and one in the Louvre, illustrating a special number of Gauguin's broadsheet *Le Sourire,* of 1899. The pose may be traced to a painting of 1892 (W.478) and recurs, with modifications, in a painting of 1898 (W.568; c.f. also the drawing, Plate 101), but in neither of these does the figure wear a death's mask, nor does she crush the animal against her thighs. It is only in another painting of 1898, *Rave te hiti aamu* (W.570) that the figure has these attributes.

Plate 87 Parau Hanohano (Fearful Words). Watercolour. 15·1 × 21·2cm. 1892. Fogg Art Museum, Harvard University, (Bequest of Grenville L. Winthrop).

This watercolour was painted in 1892 in the Papeete house of Paulin Jénot, a lieutenant of the Marines, who befriended Gauguin in Tahiti. Gauguin gave it to Jénot—the word *Opoi* after the signature means 'given'. A painting of the same title exists, but the composition differs radically from the watercolour. For a similar confrontation of two figures in a landscape setting, c.f. Plate 88.

Plate 88 Tahitian Legend. Watercolour. 15 × 23cm. 1892. Robert Lehman Collection, New York.

Close to Plate 87 in the mysterious confrontation of two figures in a landscape setting, this composition is repeated on page 17 of *Ancien Culte Mahorie,* and on page 57 of *Noa Noa.*

37

Plate 89	Arearea No Varua Ino (The Amusement of the Evil Spirit). Monotype in colour, retouched with watercolour. 23·5 × 15·9 cm. 1894. The National Gallery of Art, Washington, D.C. (Rosenwald Collection).

The seated figure and the idol recur in a painting of the same title of 1894 (Ny Carlsberg Glyptotek ; W.514), which Gauguin dedicated to Mme Gloanec, patronne of the Pension Gloanec at Pont Aven. Thus, like Plates 58, 60, 84, 85, and 86, the drawing was almost certainly executed in the summer of 1894. It is actually executed on the back of the right half of the woodcut, *Auti Te Tape* (Guérin 35). The drawing once belonged to Degas. Another monotype, also retouched with watercolour, exists (Rewald 87), which reverses the pose of the seated figure and includes a different idol in the background.

Plate 90	Two Tahitian Girls. Monotype 18·5 × 16·5 cm. 1894. R. A. Bevan, Colchester.

This monotype was given to the English artist Robert Bevan (1865-1925), whom Gauguin met at Pont Aven in the summer of 1894—it is inscribed *à l'ami Baven* (sic) *P. Go 1894*. A larger variant of the composition exists (Rewald 86), probably one of the series of monotypes retouched with watercolour (c.f. Plates 58, 60, 85, 86 and 89).

Plate 91	L'Angélus en Bretagne. Monotype in colours. 27·4 × 30·5 cm. 1894. Ira D. Gale, London.

Inscribed *For my friend O'Conor, one man of Samoa*, this monotype, like Plate 90, was executed in Pont Aven in the summer of 1894. At this time, Gauguin hoped that the Irish-born artist Roderic O'Conor (1860-1940) might accompany him on his second visit to the South Seas. The central figure in this monotype is related to the painting *Breton Girl Praying* of 1894 (W.518).

Plate 92	Nave Nave Fenua (Land of Sensuous Pleasure). Woodcut. 35·6 × 20·3 cm. 1894. Courtauld Institute Galleries, London.

In Paris during the winter of 1893-4, Gauguin worked on a series of ten woodcuts which would sum up his experiences of Tahiti, just as his album of eleven lithographs of 1889 (c.f. Plates 29-32) summed up his experiences of Brittany, Martinique and Arles. In this instance, however, the suite of ten woodcuts were to have a further purpose ; they were intended to illustrate his manuscript of *Noa Noa* (see Richard Field, *Gauguin's Noa Noa Suite*, Burlington Magazine, September, 1968). His revolutionary procedures in methods of cutting and printing the blocks and their effects on the resultant images have been sensitively demonstrated by Richard Field. C.f. Plate IX.

Plate 93	Noa Noa (Fragrance). Woodcut. 35·7 × 20·5 cm. 1894. Metropolitan Gallery of Art, New York. Rodgers Fund, 1921.

Like Plate 92, this woodcut was one of the series of ten intended as illustrations to Gauguin's manuscript of *Noa Noa*. The composition is based on two paintings of 1891 (W.431-2). A related watercolour (National Museum, Belgrade) and a monotype in colours exist.

Plate 94 Manao Tupapau (The Spirit of the Dead Watches). Woodcut coloured by hand and stencils. 22·7 × 52 cm. 1894. The Art Institute of Chicago.

This is Gauguin's largest woodcut. It is one of several (c.f. Guérin 44, 45, 47 and 48) that were executed in Brittany in the summer of 1894. It includes motifs from three paintings of December 1892 (W. 467, 468 and 470; c.f. also the fan, Plate XIII): the dog, the idol and the dancing figures, and certain landscape elements. Some of these motifs recur in a painting of 1894 (W.512), while the foetus-like nude in the foreground recurs in another painting of 1894 (W.513) and in two woodcuts of the same title (Guérin 18 and 20). Both these paintings, like the woodcut, combine several memory-images of Gauguin's first Tahitian stay.

Plate 95 Soyez amoureuses, vous serez heureuses (Be in Love and you will be Happy). Woodcut. 16·2 × 27·6 cm. c.1899. Royal Museum of Fine Arts, Copenhagen.

This woodcut probably belongs to Gauguin's second stay in Tahiti (1895-1901). The confluence of images includes his seated Eve or Death (c.f. Plates 33 and VI), a series of four heads in the background based on copies after Delacroix, while the child and the goat in the foreground refer to *D'où venons-nous?* . . . The title was also used in a woodcarving relief of 1889 (Museum of Fine Arts, Boston). Similar motifs are found in Gauguin's carved door frame, from his house in the Marquesan Islands, where he moved in 1901 (Gray 132).

Plate 96 Still Life with Flowers and Fruit. Black crayon. 24 × 32·4 cm. 1894. Museum of Fine Arts, Boston (Bequest of John T. Spaulding).

A compositional study, complete with colour notes, for a painting now also in Boston (W.406), which Gauguin produced during his convalescent period at Pont Aven in the summer of 1894. Both drawing and painting were given to the French artist, Gustave Loiseau (1865-1930).

Plate 97 Head of Breton Woman. Charcoal and watercolour. 19 × 26 cm. 1894. Sir John and Lady Witt, London.

One of many works which once belonged to Gauguin's Spanish friend, the artist Paco Durrio. The style of the drawing shows how the influence of his Tahitian stay affected Gauguin's vision of Brittany in 1894. No related pose in a painting exists, but there are similarities to the right-hand figure in *Two Breton Peasant Girls* (W.521).

39

Plate 98 Te Arii Vahine (Queen of Beauty). Watercolour. 17·2 × 22·9 cm. 1896. Mr and Mrs Ward Cheney, New York.

A study for the painting of the same title (also called *Woman with the Mangoes*), dated 1896 and now in the Pushkin Museum, Moscow (W.542). Gauguin described and sketched the composition in a letter to Daniel de Monfreid of April 1896: 'A nude queen reclining on a green lawn, a servant girl picking fruit, two old men by the big tree arguing about the Tree of Knowledge, in the background the sea . . . I think that in colour I have never done anything with such a grand, solemn resonance. The trees are in bloom, the dog keeps watch, on the right two doves coo.' The reclining nude reappears in two woodcuts (Guérin 62 and 80), one of which was inserted into the front cover of *Noa Noa*, the other used as the heading of his Tahitian newspaper, *Le Sourire* (1899-1900). There is also a carved relief in the Ny Carlsberg Glyptotek, Copenhagen (Gray no. 74). C.f. Plate 99.

Plate 99 Decorative Person. Pen and ink. 21 × 29 cm. 1903.

This signed and dated pen drawing, here given the title of *décorative personne*, reverses the image of Plate 98. It was illustrated on page 121 of *Avant et Après*, a sequence of autobiographical fragments which Gauguin wrote for the critic André Fontainas. For other drawings from *Avant et Après*, c.f. Plates 112 and 113.

Plate 100 Study for *Where do we come from? What are we? Where are we going?* Charcoal. 20 × 37 cm. 1898. Musée des Arts Africains et Océaniens, Paris.

A study for Gauguin's largest painting and one which he intended as his last testament (now in the Museum of Fine Arts, Boston; W.561). In a letter to Daniel de Monfreid of February 1898, Gauguin tells how he worked day and night for a month directly on the canvas (actually a piece of ordinary coarse jute material used in Tahiti for making copra sacks) without using any preparatory studies. He completed it in December 1897 and then went to the hills and attempted suicide by poisoning. This drawing, however, squared-up for transfer to the painting, proves that he carefully thought out the composition, which incorporates many motifs from his previous works, some going back as far as 1888 and 1889, others more recent. The drawing is inscribed: *de l'amitié dans le souvenir, cette pâle esquisse. Paul Gauguin. Tahiti 1898.*

Plate XV Pape Moe (Mysterious Water). Watercolour. 31·8 × 21·6 cm. 1893. The Art Institute of Chicago (Gift of Mrs Emily Crane Chadbourne).

This watercolour reproduces a scene witnessed by Gauguin and described in *Noa Noa* (pages 87-8). But the composition was based on a photograph. It recurs in a painting of the same title (Bührle Collection, Zurich; W.498), dated 1893, in a relief wood-

carving (Gray page 239) and in a monotype (Plate 84).

Plate XVI Musique Barbare. Watercolour on silk. 12×21 cm. 1892. Kupfer-stichkabinett, Basle.

In this richly-coloured watercolour, executed on silk (c.f. Plates VI, 28, 41 and 42, also on silk), Gauguin creates the effect of a polychrome bas-relief. His evocation of the Maori spirits finds echoes in *Ancien Culte Mahorie* (pages 14 and 21) and *Noa Noa* (page 56) as well as in four woodcuts (Guérin 25, 26, 30, 31).

Plate 101 Study for *Te Pape Nave Nave* (Delicious Water). Charcoal. 1898. Mr and Mrs Leigh B. Block, Chicago.

This squared-up study reproduces part of the composition of a painting, which is now in the collection of Mr and Mrs Paul Mellon (W.568). The painting repeats, with modifications, the right-hand part of *Where do we come from?* ... (c.f. Plate 100). The most significant change is in the standing nude. And one may further note that this particular figure is an adaptation of the pose of *Oviri* (c.f. Plate 86). In the drawing, the dog's body may be seen rearing up across her body, its head between her breasts. In the painting, however, the animal—and all the symbolic overtures of *Oviri*—are eliminated. This study and Plate 100 are probably the only working drawings that survive from Gauguin's second stay in Tahiti.

Plate 102 The Escape (or The Ford). Monotype. Size unknown. *c.* 1900. Present owner unknown.

This is one of a series of monotypes (c.f. Plates 103-107, 109-111) which Gauguin worked on in 1900, and possibly later. Several of them are very closely related to specific paintings, the large majority of which are dated 1902. The present figure on horseback is seen in reverse, and without the accompanying dog, in a painting *Le Gué* (The Ford) (W.597), which is dated 1901. Two related watercolours exist, one of which is included in Rewald (Plate 108).

Plate 103 Tahitian Couple Walking. Monotype. Size unknown. *c.* 1901(?). Present owner unknown.

Although the sheet is squared-up for transfer, only the male figure appears in a painting, one dated 1896 (W.537). The dog appears too, but in a slightly altered pose and in front of, rather than behind, the man. The male figure is also used alone, his image reversed, in a monotype (*Avant et Après*, page 153) and a woodcut (Guérin 64, one proof pasted on page 180 of *Noa Noa*).

Plate 104 Tahitian Family. Monotype. Size unknown. *c.*1901. Present owner unknown.

Like Plate 103, this monotype is squared-up and appears to have been used as a working drawing for a painting of a Tahitian family, dated 1902 (W.618). One difference between monotype and paint-

41

ing, however, is that the figure in profile at the left is seen at the extreme right in the painting. The central figure recurs in another painting of 1902, *Sister of Charity* (W.617). A related monotype (Rewald 110) shows variations in the composition; for example a standing figure on the left also reappears in the latter painting.

Plate 105 The Nightmare. Monotype. Size unknown. *c.*1901. Private Collection, New York.

 The standing nude reproduces, in reverse, the pose of the Eve figure in the drawing of 1892 (c.f. Plate X). For the figure on horse-back, c.f. Plate 102.

Plate 106 Crouching Nude. Monotype in colours. 48·3 × 29·3cm. *c.*1902. Mr and Mrs Eugene Victor Thaw, New York.

 The present monotype, and Plate 107, are connected with a painting of 1902 (W.613). A variation of the pose recurs in another painting of 1902, *The Call* (W.612). Compare also the drawing of the nude seen from the back in Plate 82.

Plate 107 Crouching Nude. Monotype in black and ochre. 31·5 × 27cm. *c.*1902. Private Collection, New York.

 See the note on Plate 106.

Plate 108 The Call. Pencil. Size unknown. 1902. Present owner unknown.

 A study of the two foreground figures in *The Call* (Cleveland Museum of Art; W.612), which is dated 1902. The disposition of the landscape elements differs in the painting. The two heads are in fact based on copies that Gauguin made after Delacroix. C.f. Plate 109.

Plate 109 The Call. Monotype. 43·2 × 26·8cm. 1902. Museum of Fine Arts, Boston. Otis Norcross Fund.

 Compositionally related to Plate 108, with a second study of the left-hand figure added. Another monotype exists (45 × 28cm.), now in the Musée Léon-Dierx, St-Denis, Réunion.

Plate 110 Two heads. Monotype. 32·1 × 51cm. 1902. British Museum, London.

 The poses of the two heads are close to those in Plates 108 and 109 and like them are based on sketches inscribed *d'après Delacroix* which Gauguin made in a sketchbook now known as the *Album Walter* (Cabinet des Dessins, Louvre). But the gestures and sex of the right-hand figure are changed and the headdress removed from the left-hand figure. Thus, they become figures of lovers (Adam and Eve?) and as such are seen in a dated painting of 1902, *The Flight,* now in the National Gallery, Prague (W.614). A monotype showing only the male figure exists; and there is also a second monotype which once belonged to Victor Ségalen.

Plate 111 Two Tahitian Women. Monotype. 46 × 34 cm. 1902. National Gallery of Art, Washington D.C. (Rosenwald Collection).

 A compositional variant of this monotype (Rewald 116) is related more directly to a painting of 1902, *Tahitian Women in their Hut* W.626). On the verso is a pencil sketch of a head. A related drawing is on page 155 of *Avant et Après*, entitled there *Causeries sans Paroles*.

Plate 112 Holy Images. Pen and ink. 29 × 21 cm. 1903.

 Drawn on page 105 of *Avant et Après*, this image takes up the central motif from Gauguin's *Green Christ* of 1889 (Royal Museum of Fine Arts, Brussels; W.328). The same Calvary occurs in a woodcut (Guérin 68). For other drawings from *Avant et Après*, see Plates 99 and 113.

Plate 113 What are you thinking of? Pen and ink. 29 × 21 cm. 1903.

 Another pen drawing from Gauguin's last illustrated manuscript, *Avant et Après* (page 103). C.f. Plates 99 and 112.

Plate 114 Self-Portrait. Pen and ink. Size unknown. 1888. Present owner unknown.

 This quick sketch must date from 1888: it is very close to the portrait of Gauguin that is seen on the wall in the background of Emile Bernard's Self-Portrait, painted in September of that year and dedicated to Vincent van Gogh.

Plate 115 Self Portrait. Pencil. 16·5 × 11 cm. c. 1891. Chrysler Art Museum, Provincetown.

 This drawing, inscribed *Gauguin par lui-même*, comes from the *Carnet de Tahiti* (page 4, verso). For another sheet from the same sketchbook, c.f. Plate 57.

Plate 116 Self Portrait. Pencil. 24 × 14·5 cm. c. 1896. Collection Mme Annie Joly-Ségalen, Paris.

 This drawing was among Gauguin's effects found in his hut after his death in May 1903 and auctioned later that year at Papeete. It was bought, along with many other objects, paintings, drawings and prints, by Dr Victor Ségalen, a physician of the French navy and a friend of Daniel de Monfreid. For this reason, it is often considered to be among Gauguin's last self portraits, but it could be earlier, perhaps about 1896.

Bibliography

Alley, Ronald. *Gauguin*, Spring Art Books, London 1961.
Bodelsen, Merete. *Gauguin's Ceramics*, London 1964.
Bodelsen, Merete. *Gauguin Og Impressionisterne*, Copenhagen 1968.
Chassé, Charles. *Gauguin et son Temps*, Paris 1955.
Goldwater, Robert. *Gauguin*, New York-London 1957.
Gray, Christopher. *Sculpture and Ceramics of Paul Gauguin*, Baltimore 1963.
Guérin, Marcel. *L'Œuvre gravé de Gauguin*, two vols., Paris 1927.
Leymarie, Jean. *Paul Gauguin, Watercolours, Pastels and Drawings*, London 1961.
Loize, Jean. *Noa Noa par Paul Gauguin*, Paris 1966.
Malingue, Maurice. *Gauguin, le Peintre et son Œuvre*, Paris-London 1948.
Malingue, Maurice. *Lettres de Gauguin à sa Femme et à ses Amis*, Paris 1946.
Morice, Charles. *Paul Gauguin*, Paris 1919 and 1920.
Perruchot, Henri, and others. *Gauguin, Collection Génies et Réalités*, Paris, 1961.
Rewald, John. *Gauguin*, Paris-London-New York 1938.
Rewald, John. *Gauguin Drawings*, New York and London 1958.
Rewald, John. *Post-Impressionism from Van Gogh to Gauguin*, New York 1961.
Wildenstein, Georges, and Cogniat, Raymond. *Gauguin*, vol. I, Catalogue, Paris 1964.

Writings and Sketchbooks of Gauguin

Ancien Culte Mahorie (1892-1893), Présentation par René Huyghe, Paris 1951.
Racontars de Rapin (1902), Paris 1951.
Avant et Après (1902-1903), Paris 1923.
Le Carnet de Paul Gauguin, ed. by René Huyghe, Paris 1952 (Facsimile-edition).
Carnet de Tahiti, ed. by Bernard Dorival, Paris 1954 (Facsimile-edition).
Carnet de Gauguin, ed. by Raymond Cogniat and John Rewald, New York 1962.

Magazine Articles

Bodelsen, Merete. *Gauguin's Bathing Girl*, Burlington Magazine, CI 1959.
Bodelsen, Merete. *The Missing Link in Gauguin's Cloisonnism*, Gazette des Beaux-Arts, Année 98, 1959.
Bodelsen, Merete. *Gauguin and the Marquesan God*, Gazette des Beaux-Arts, vol. 57, 1961.
Bodelsen, Merete. *Gauguin's Cézannes*, Burlington Magazine, CIV, 1962.
Bodelsen, Merete; Danielsson, B.; Gottheimer, T.; Anderson, W. V. and Landy, B. *Contributions to Gauguin Studies*, Burlington Magazine, CIX, 1967.
Dorival, Bernard. *Sources of the Art of Gauguin from Java, Egypt and Ancient Greece*, Burlington Magazine, XCIII 1951.
Dorra, Henri. *The First Eves in Gauguin's Eden*, Gazette des Beaux-Arts, Année 95, 1953.
Dorra, Henri. *More on Gauguin's Eves*, Gazette des Beaux-Arts, vol. 69, 1967.
Field, Richard. *Gauguin's Noa Noa Suite*, Burlington Magazine, CX 1968.
Kane, William M. *Gauguin's 'Le Cheval Blanc': Sources and Syncretic Meanings*, Burlington Magazine, CVIII, 1966.
Malingue, Maurice. *Du Nouveau sur Gauguin*, L'Œil, no. 55-56, 1959.

Plate 1

Plate 2

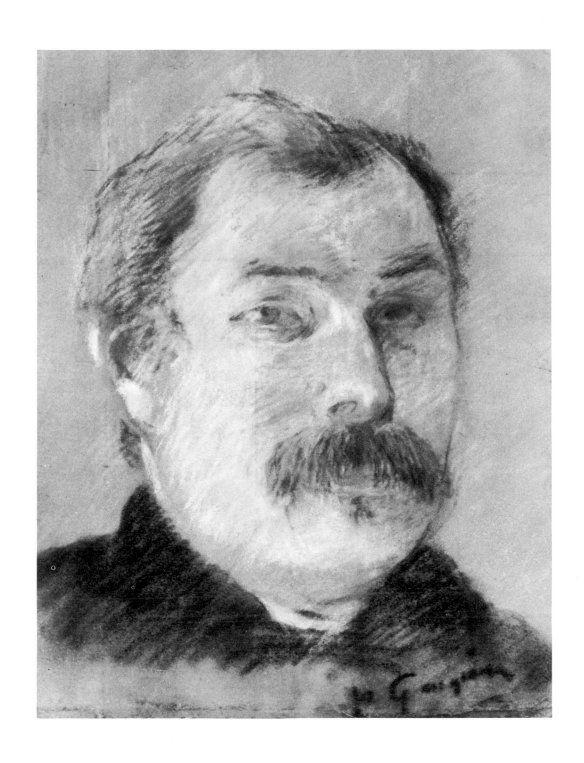

Plate 3

Plate 4

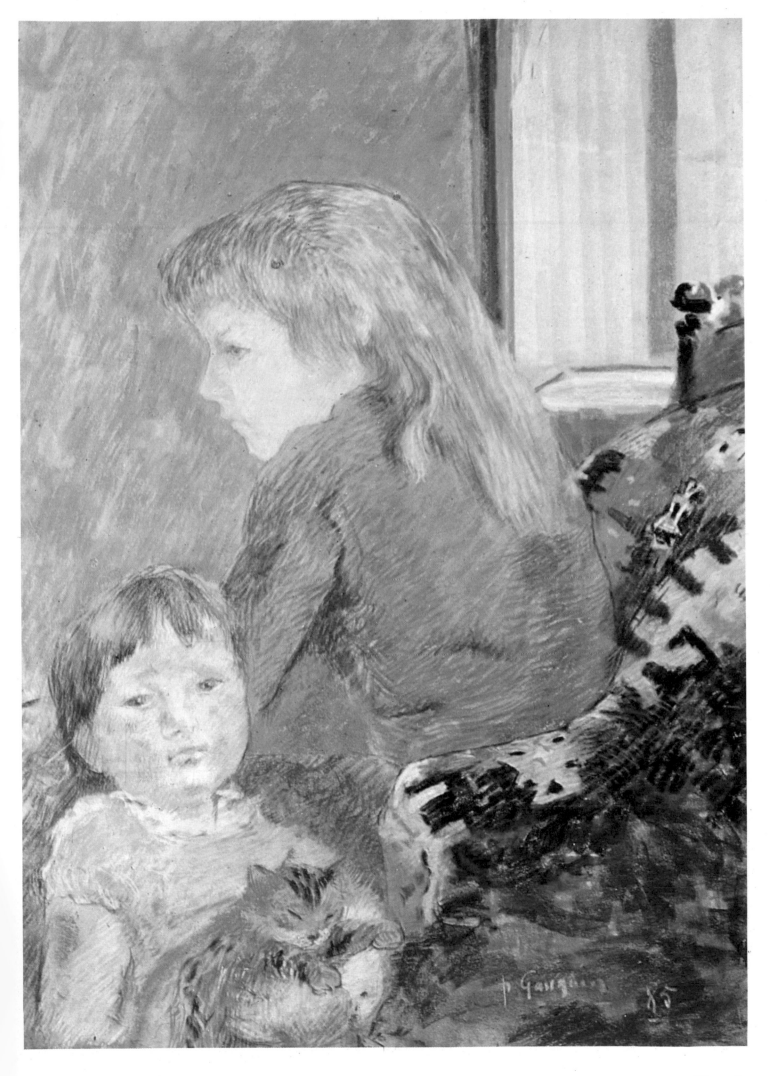

Plate I

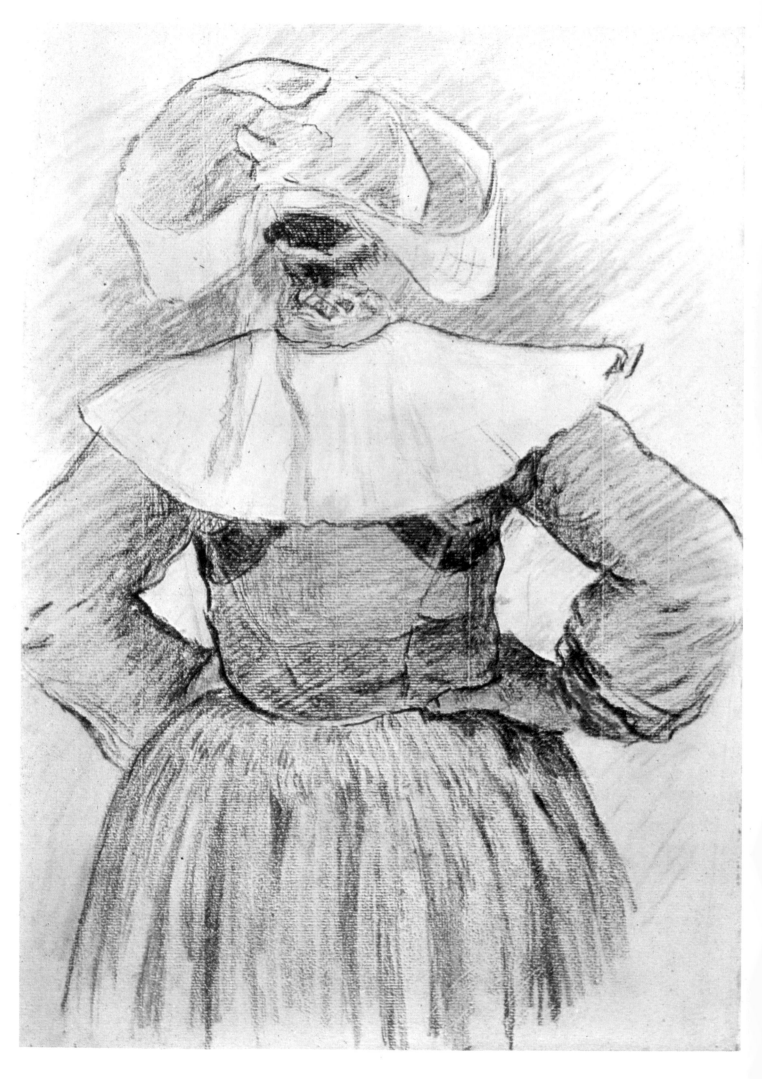

Plate II

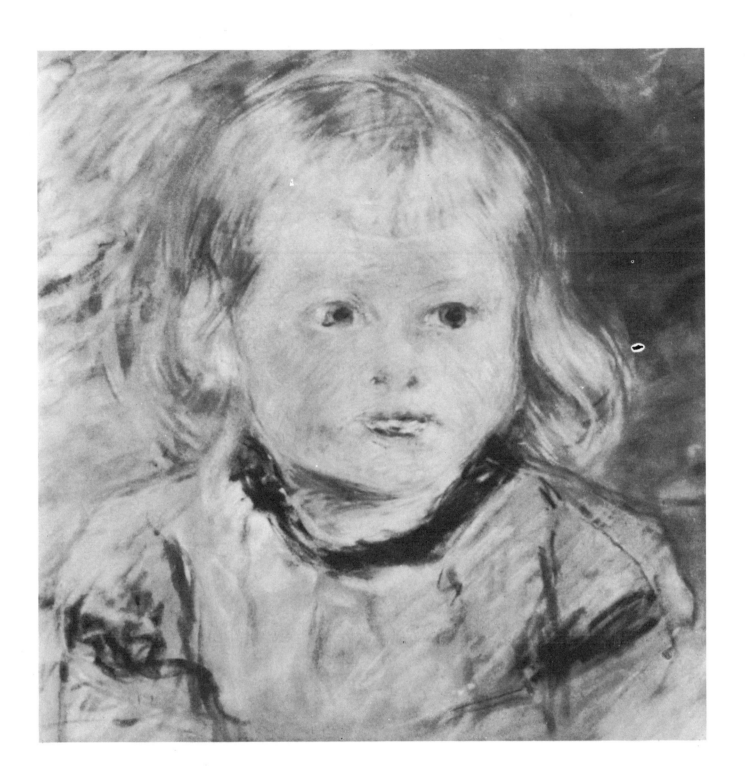

Plate 5

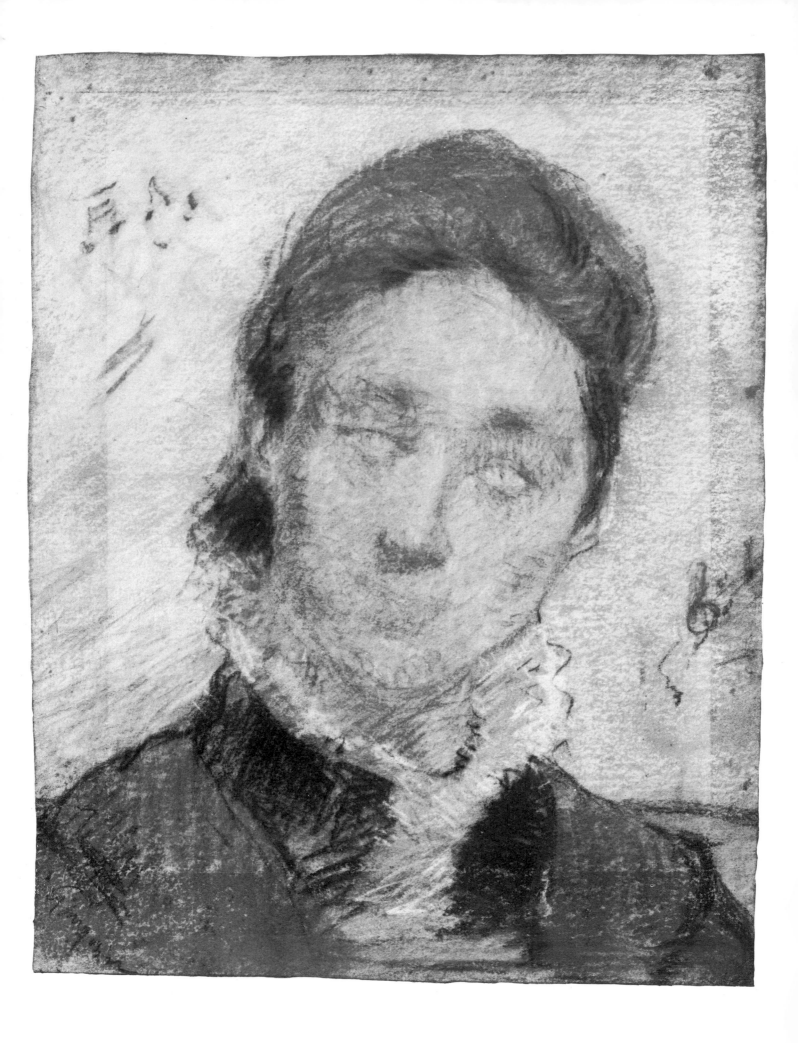

Plate 6

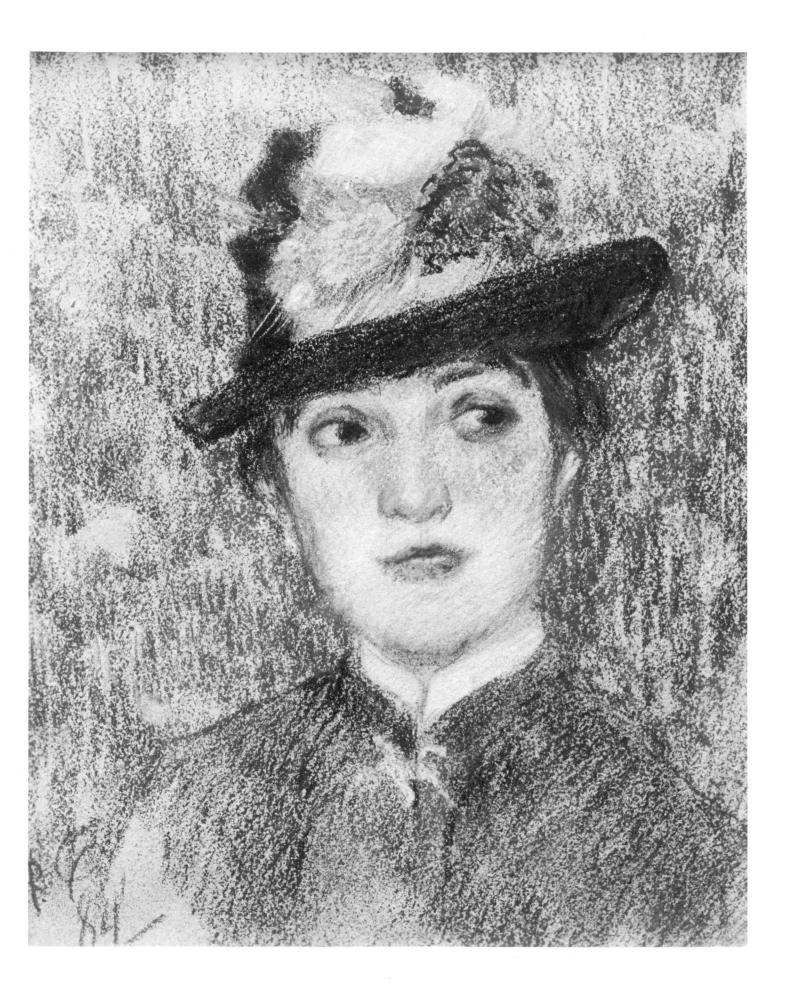

Plate 7

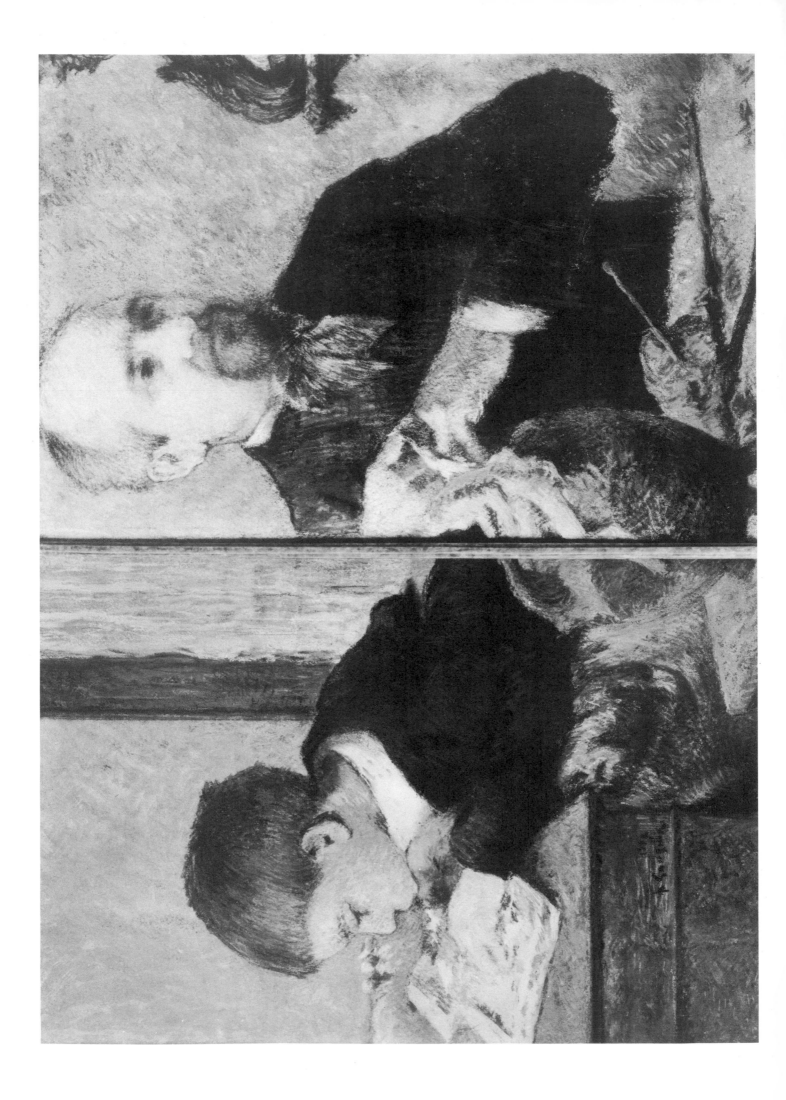

Plate 8

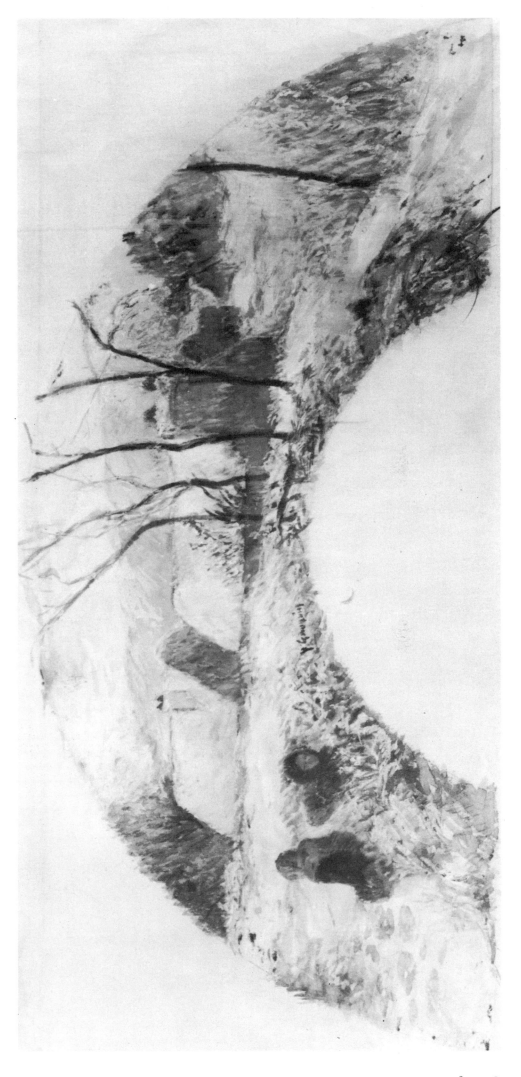

Plate 9

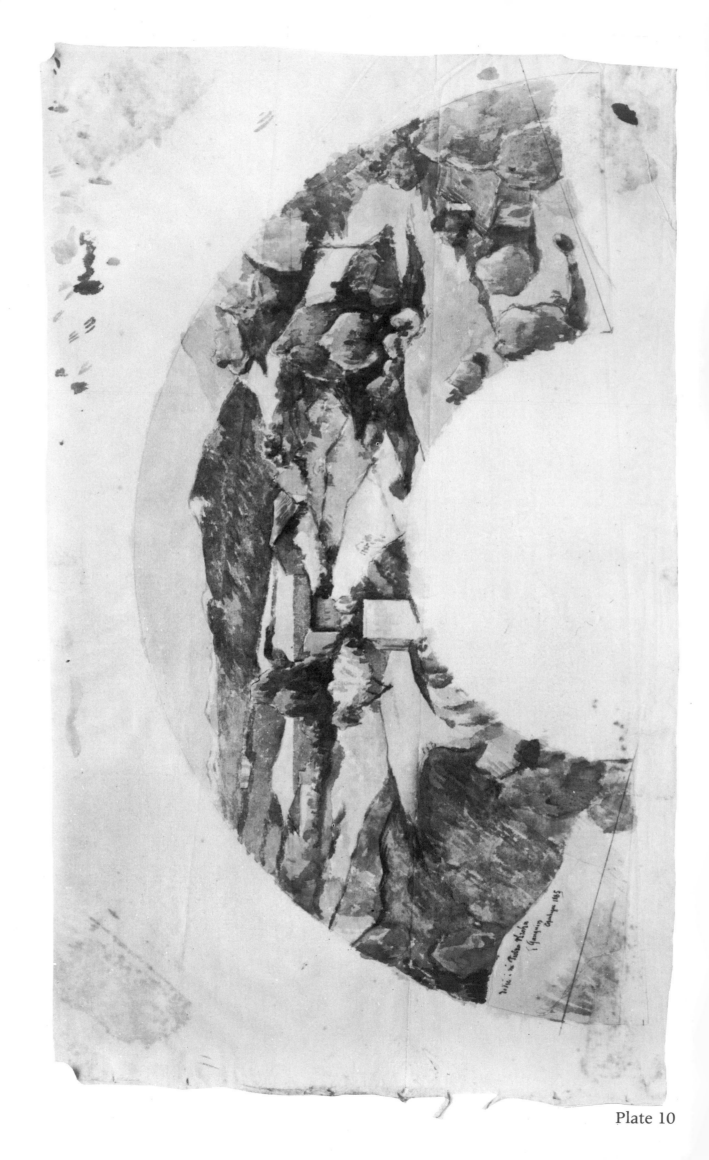

Plate 10

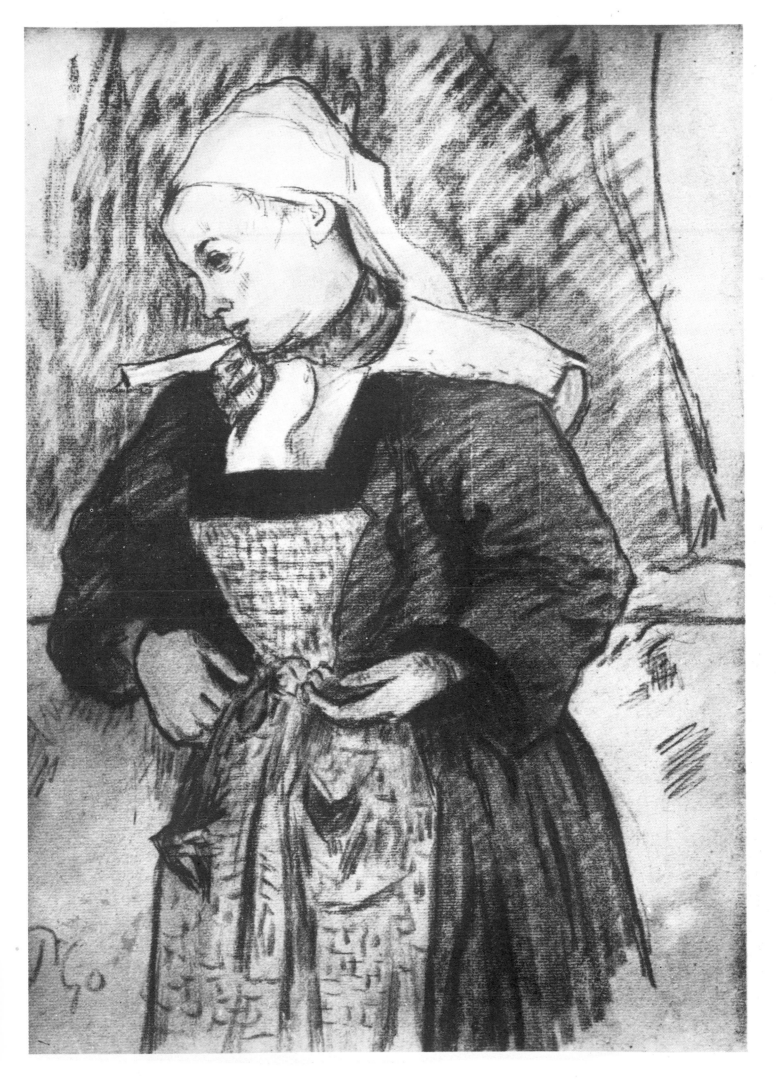

Plate 11

Plate 12

Plate 13

Plate 14

Plate 15

Plate 16

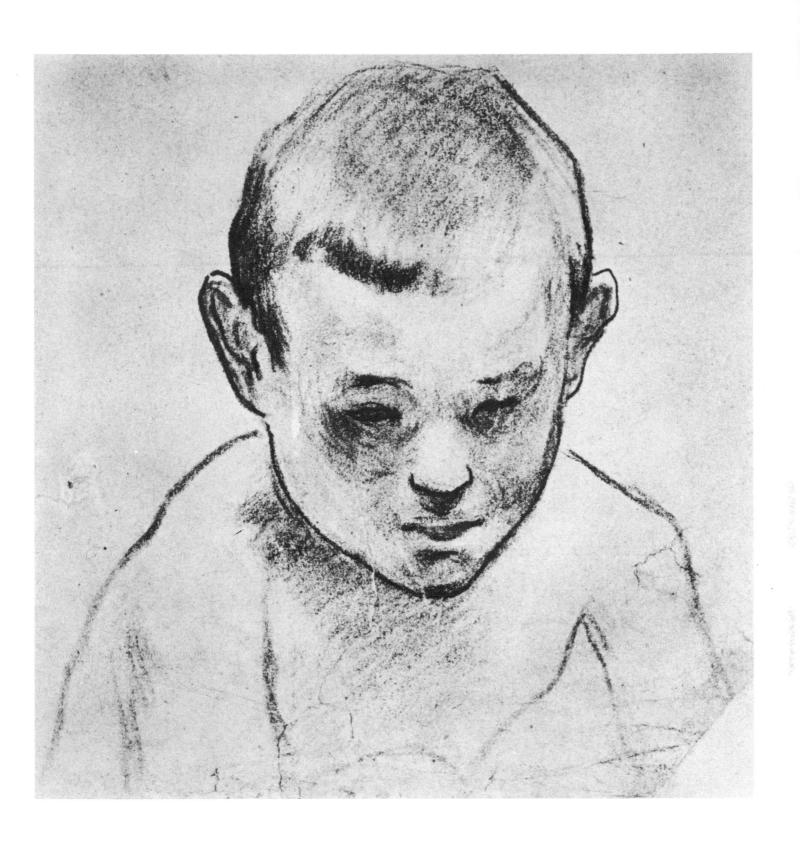

Plate 17

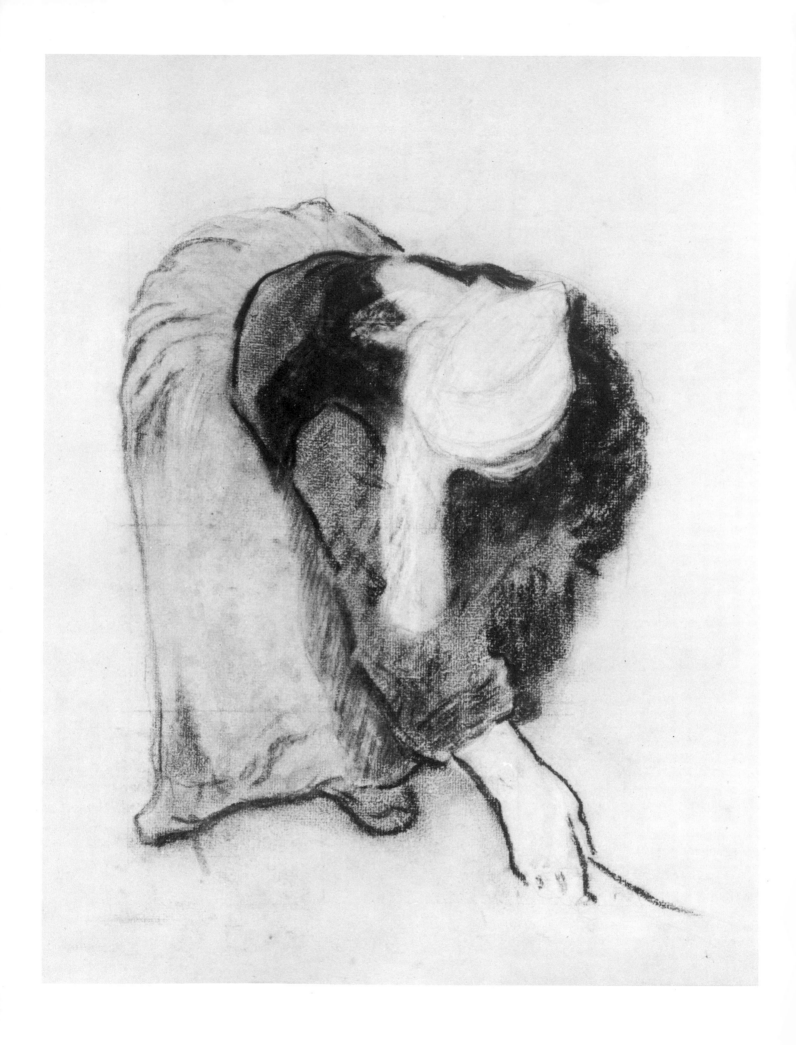

Plate 18

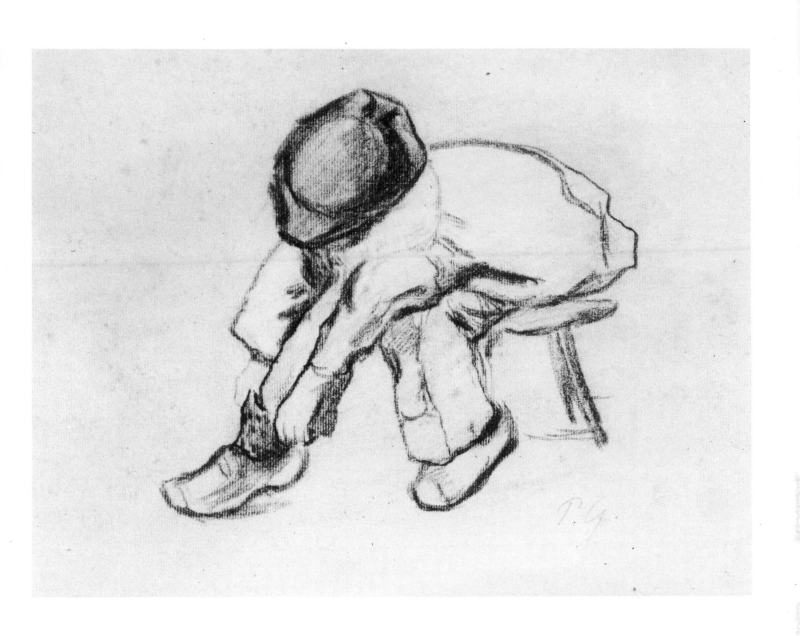

Plate 19

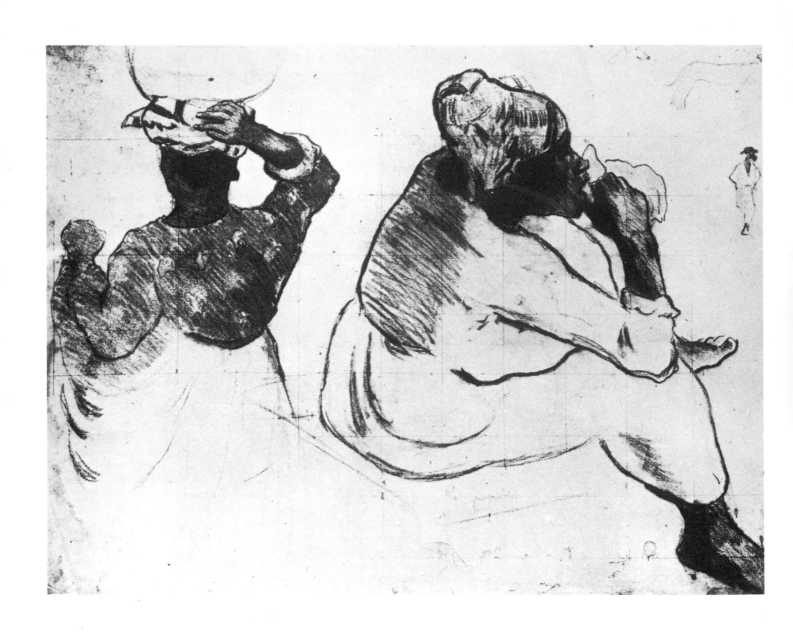

Plate 20

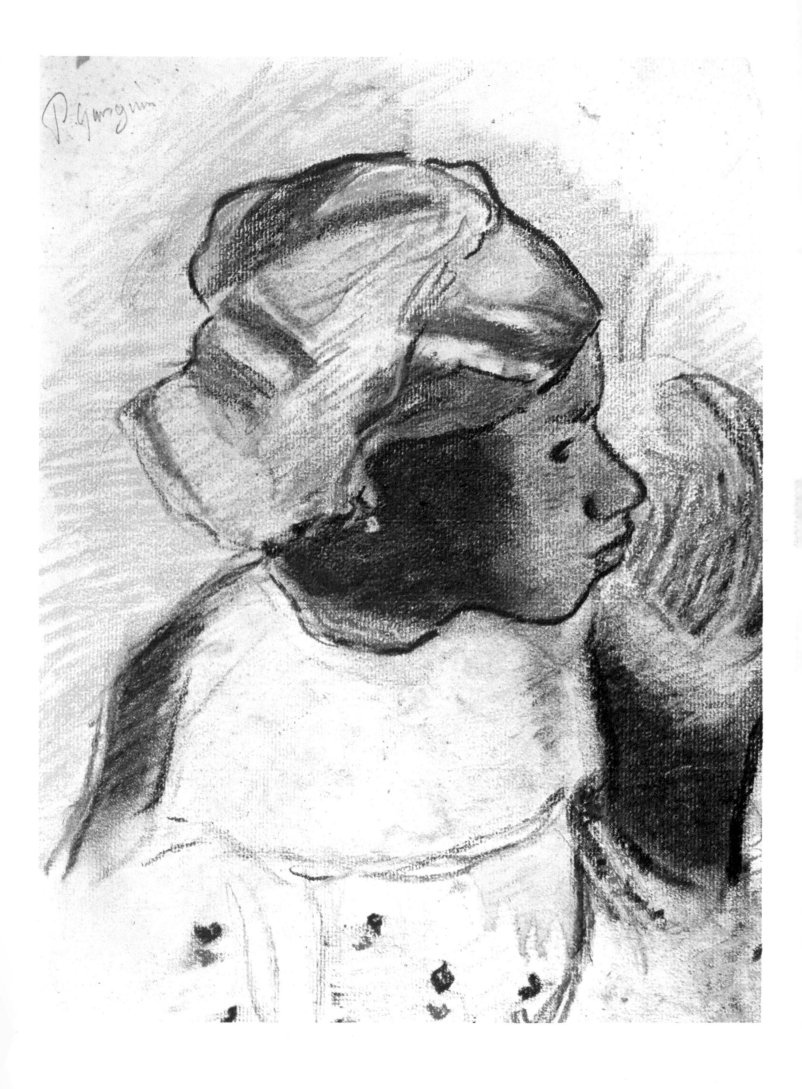

Plate III

Plate IV

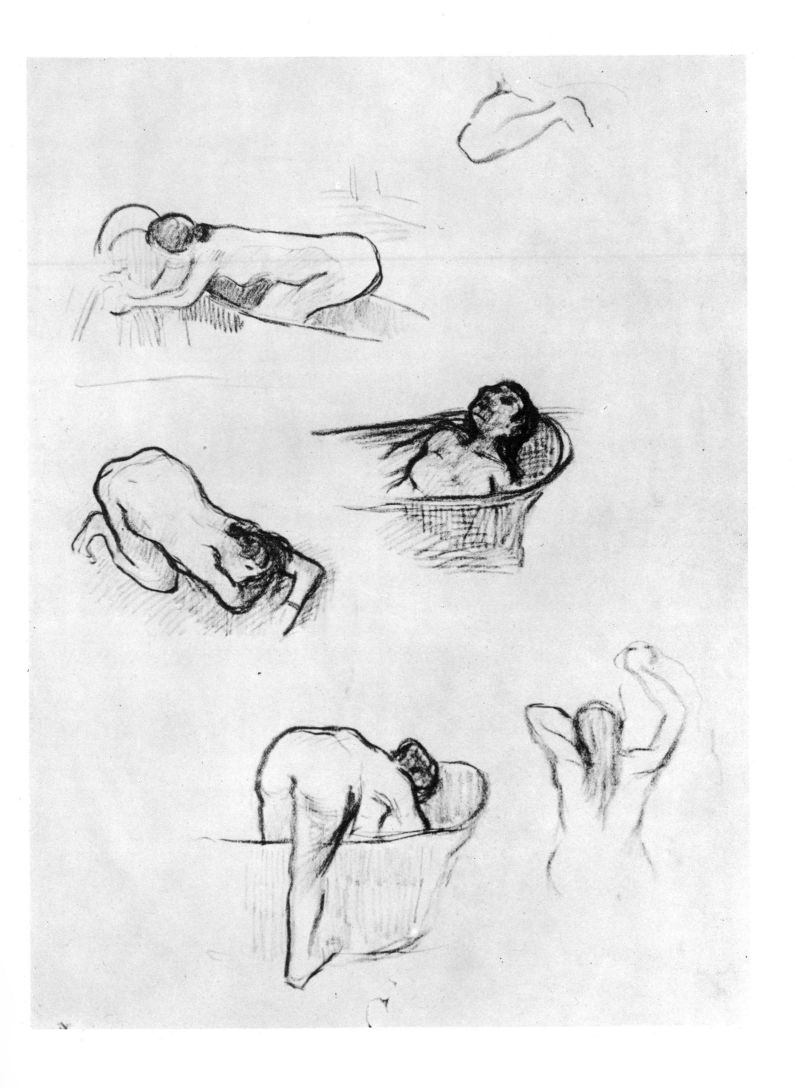

Plate 21

Plate 22

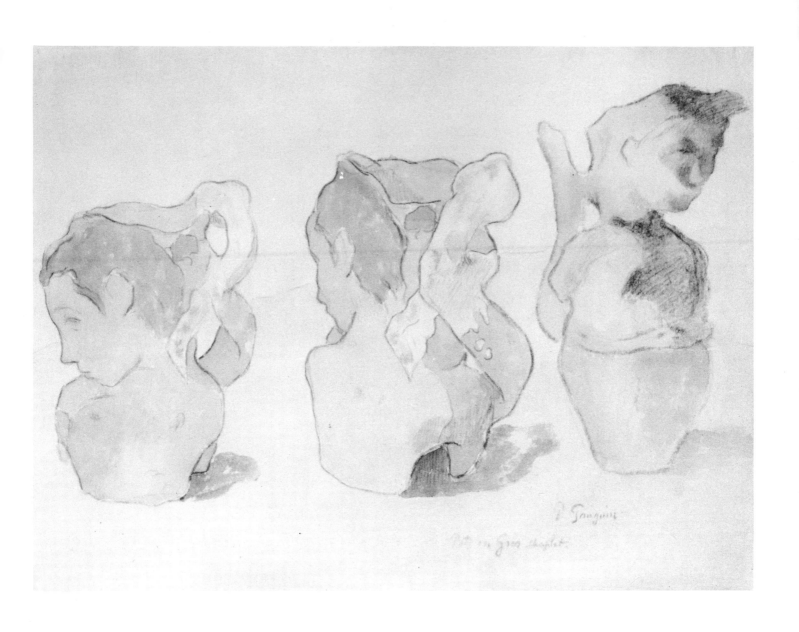

P. Gauguin

Plate 23

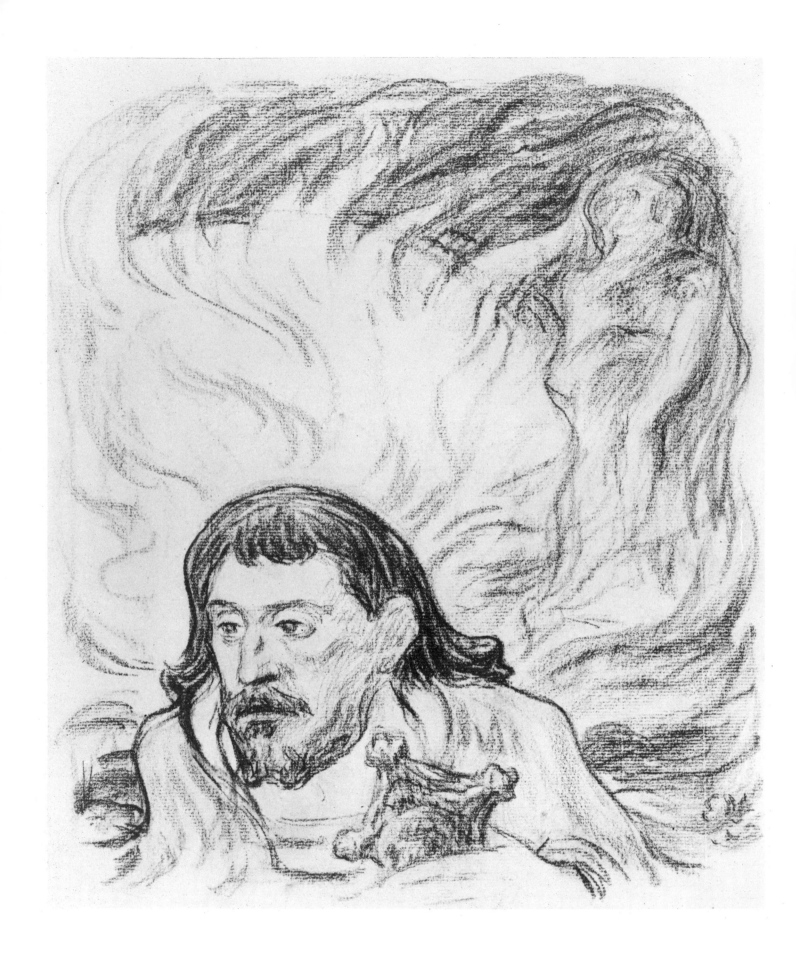

Plate 24

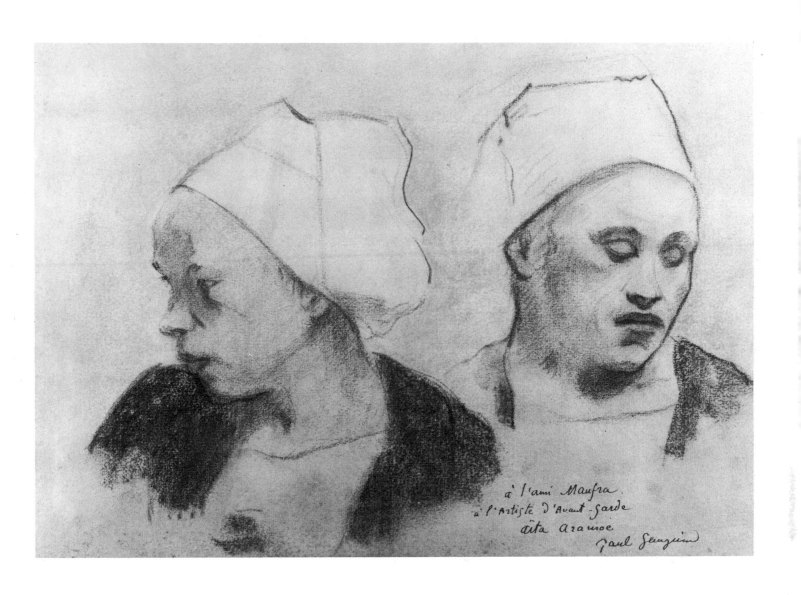

à l'ami Maufra,
à l'Artiste d'Avant-garde
aïta Aramoe
Paul Gauguin

Plate 25

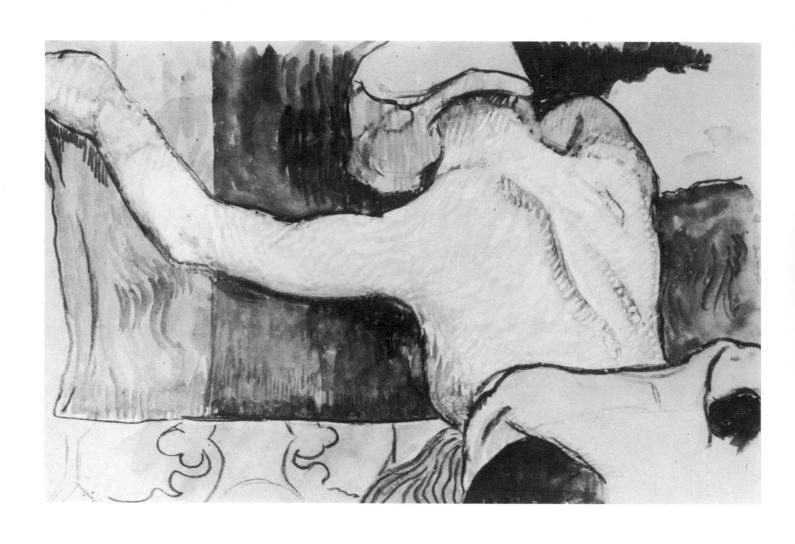

Plate 26

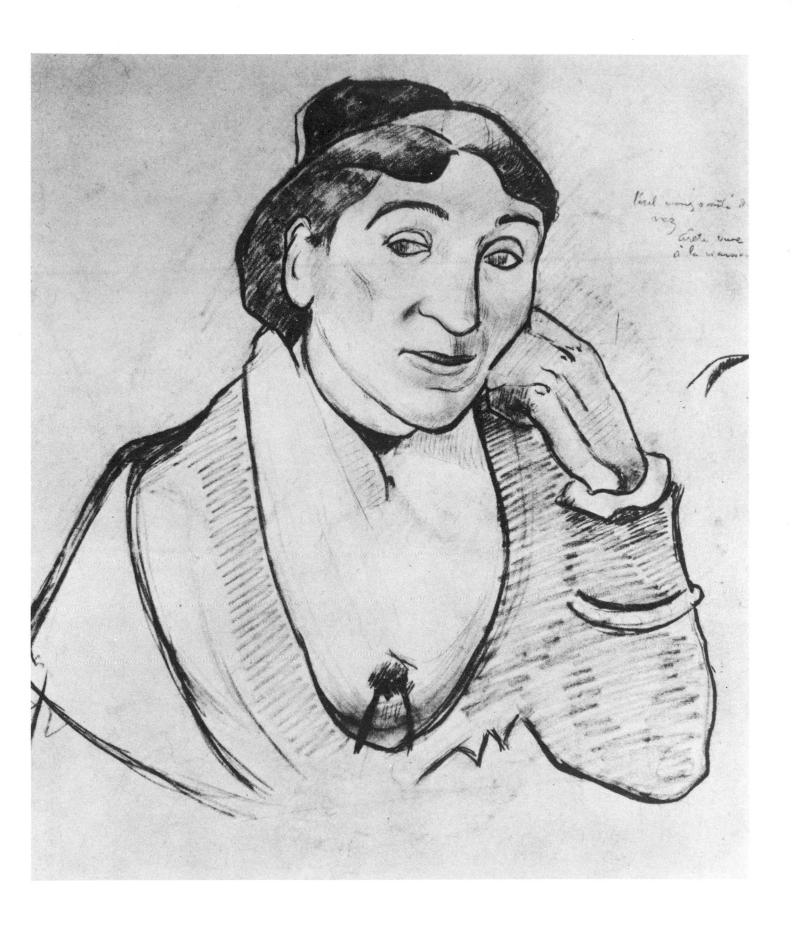

Plate 27

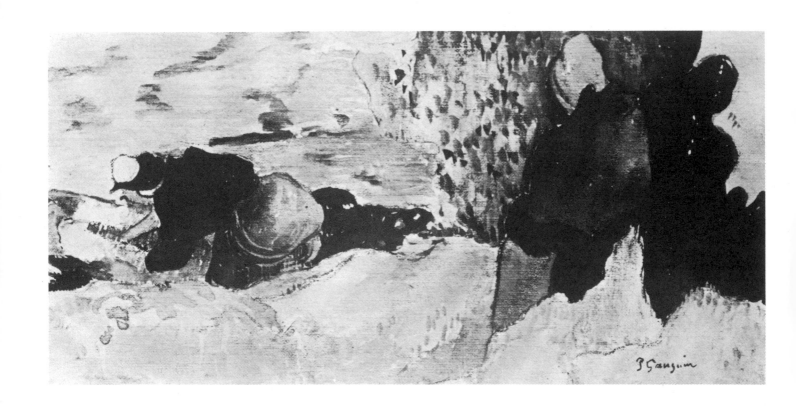

Plate 28

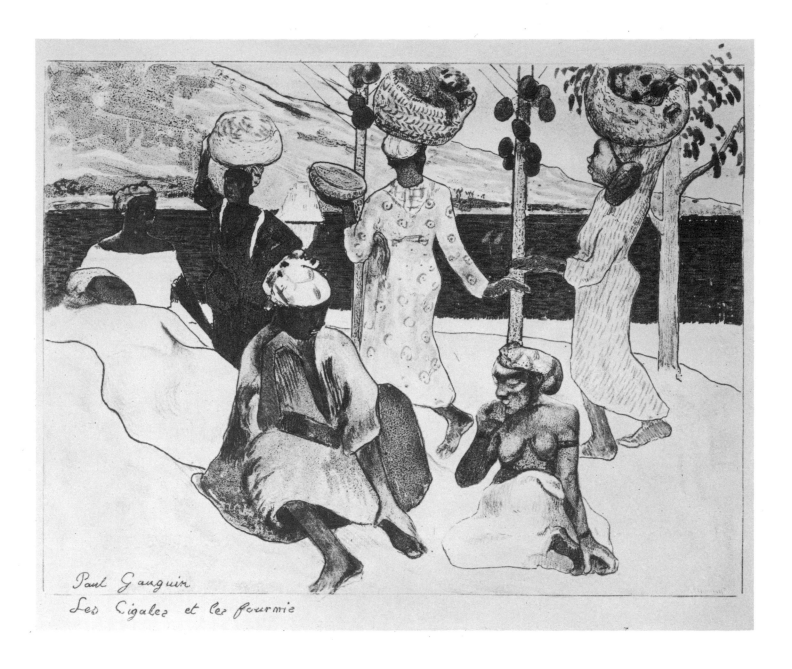

Paul Gauguin
Les Cigales et les fourmie

Plate 29

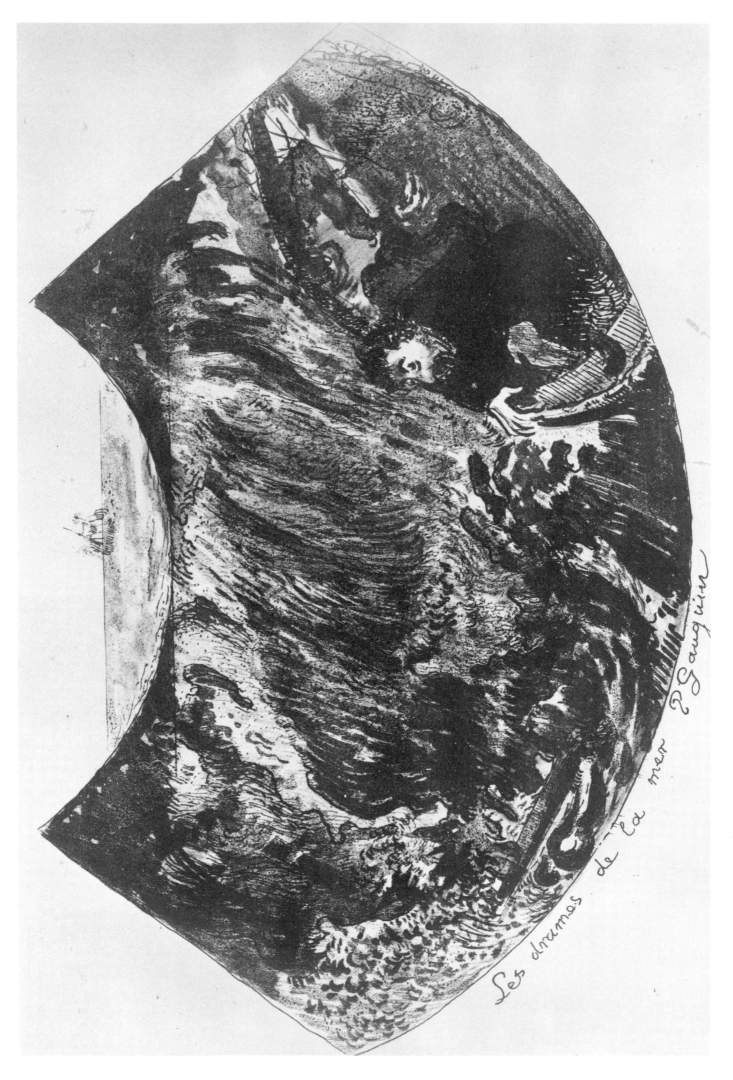

Les drames de la mer P Gauguin

Plate 30

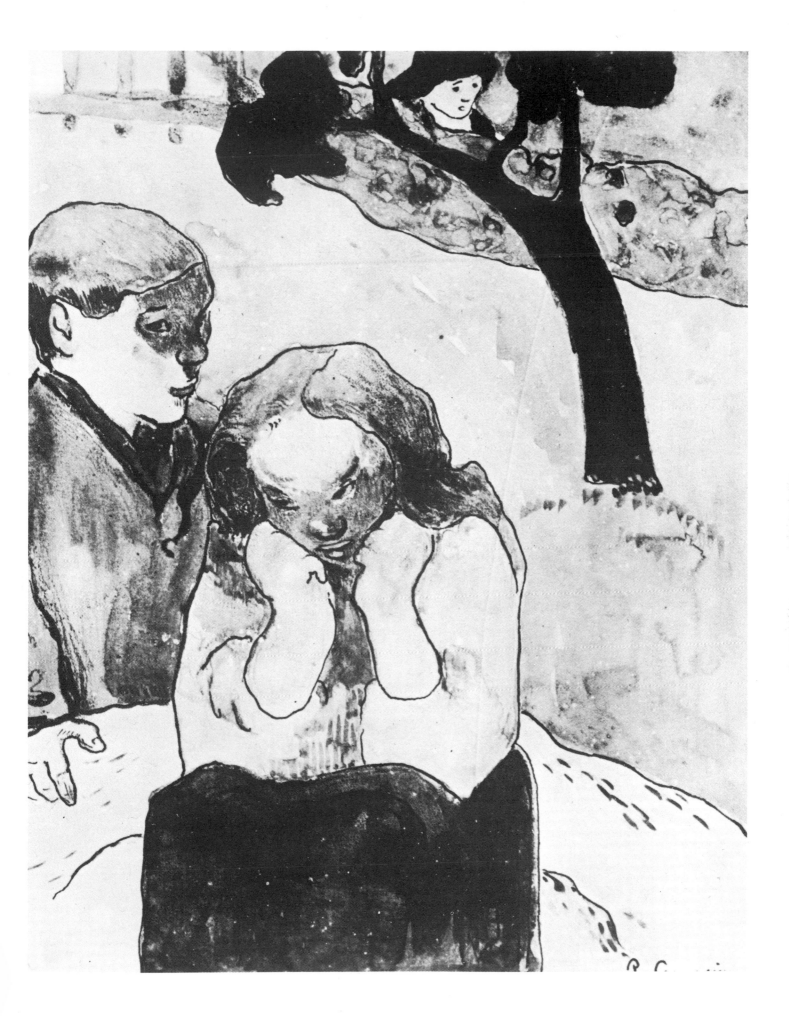

Plate 31

Plate 32

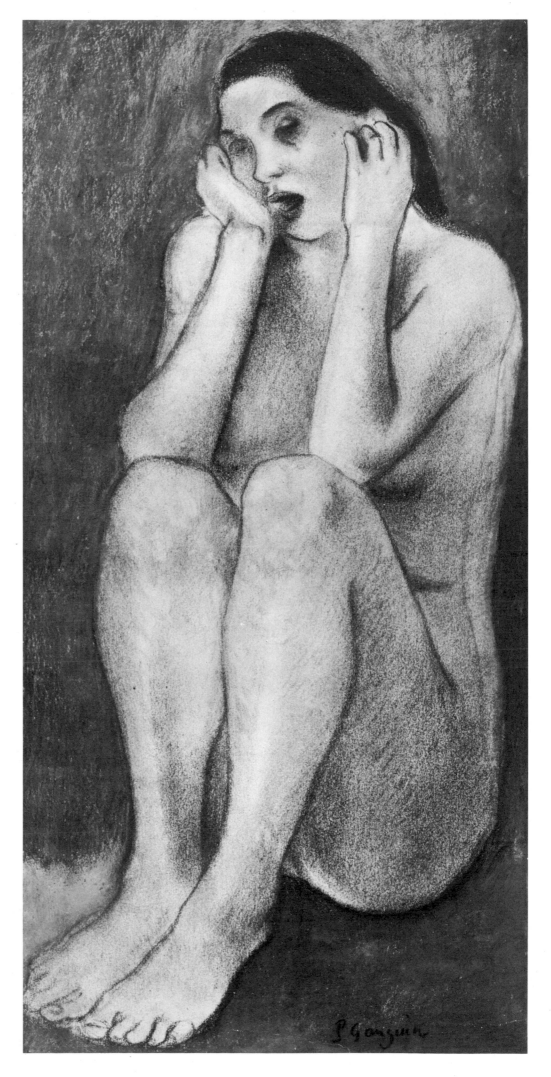

Plate 33

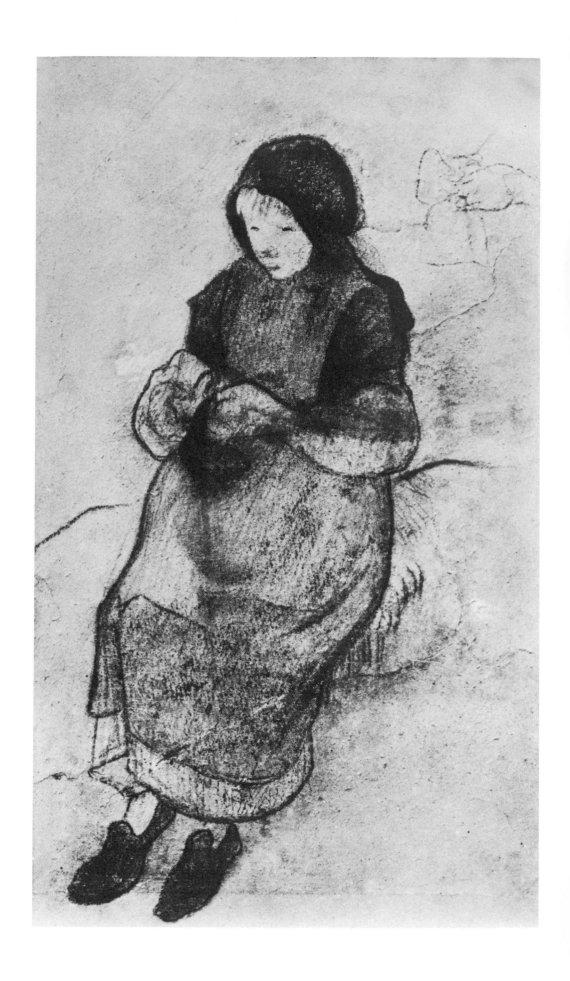

Plate 34

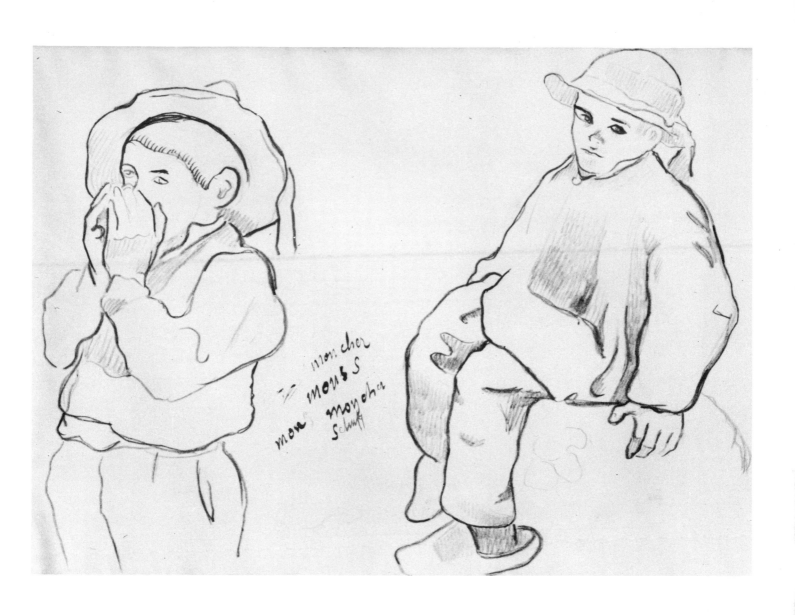

Plate 35

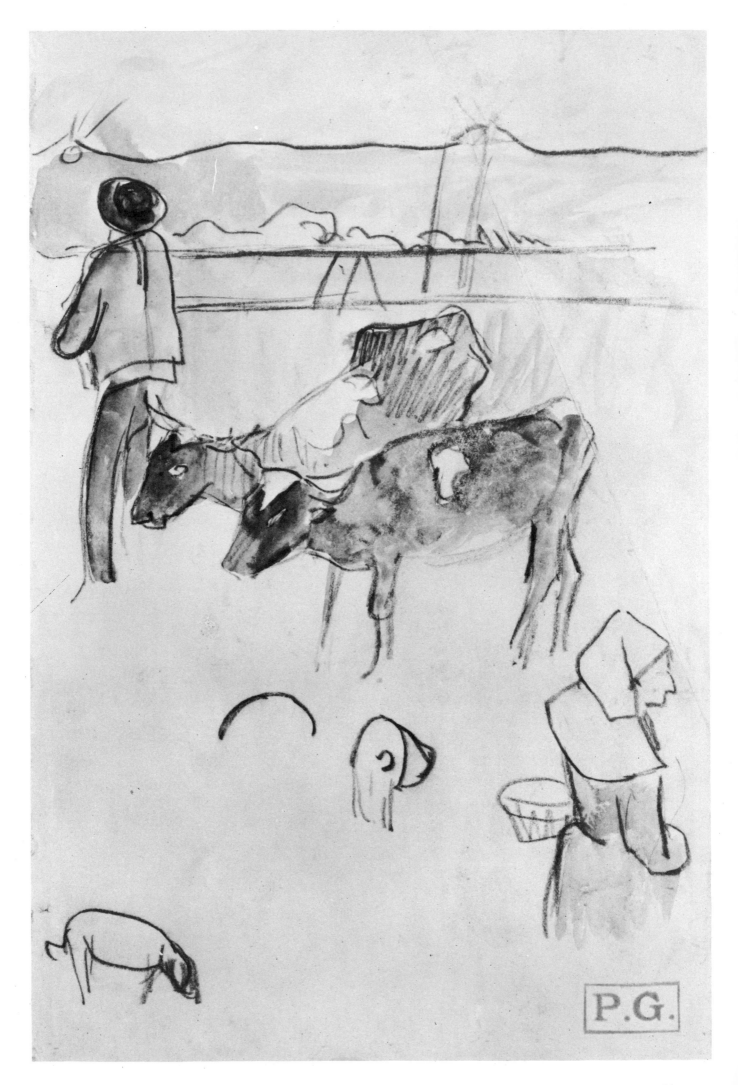

Plate 36

Plate V

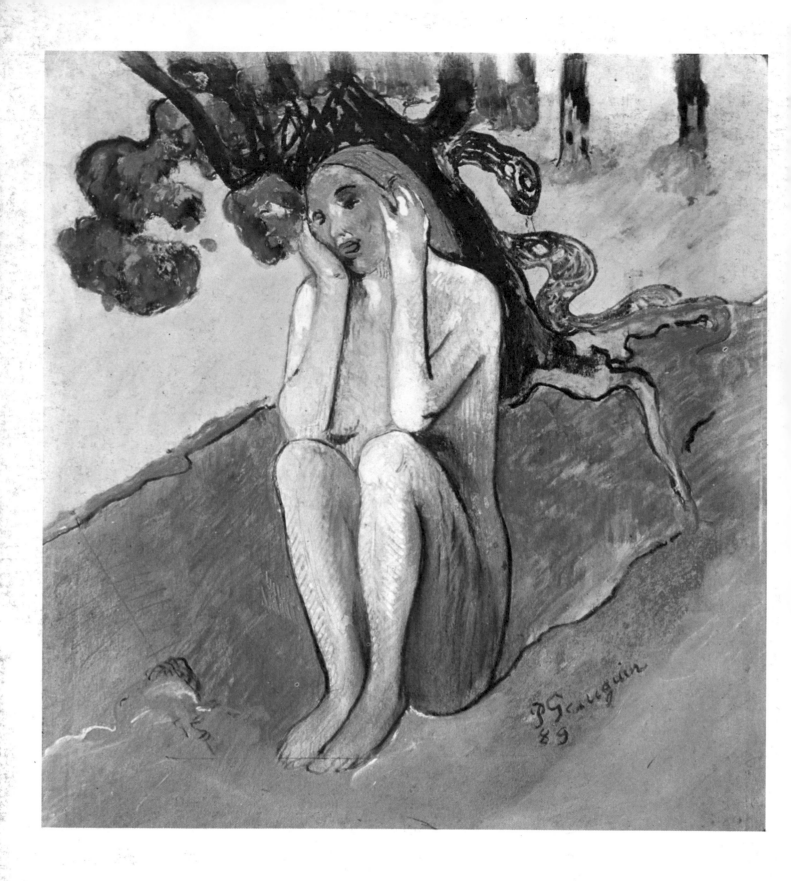

Plate VI

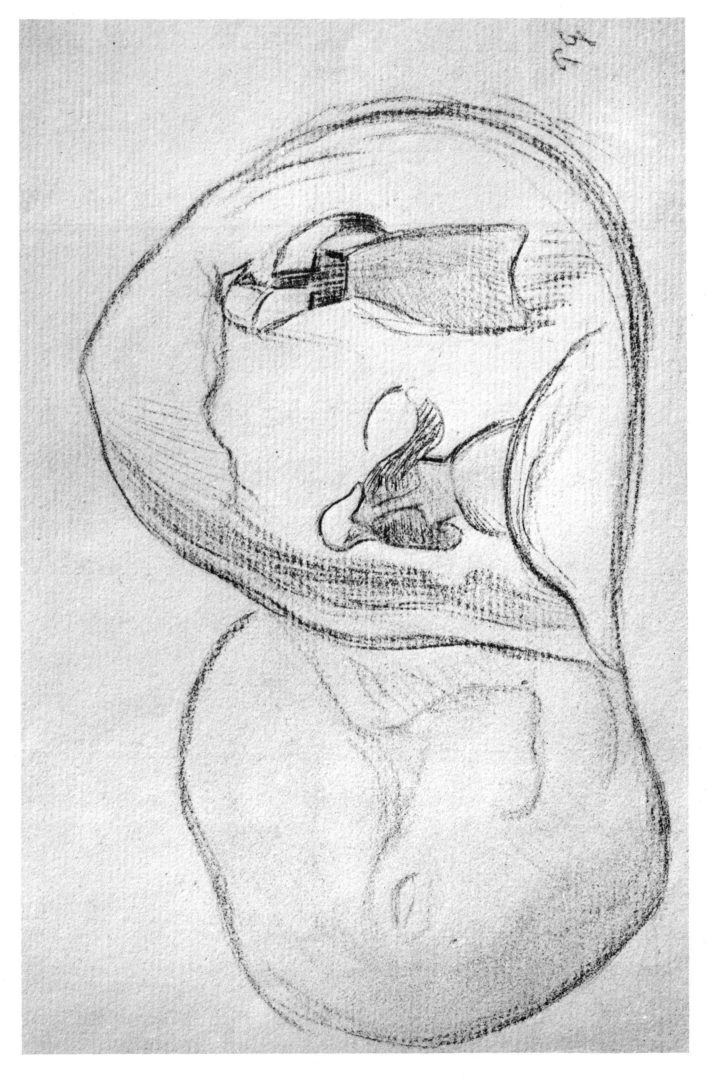

Plate 37

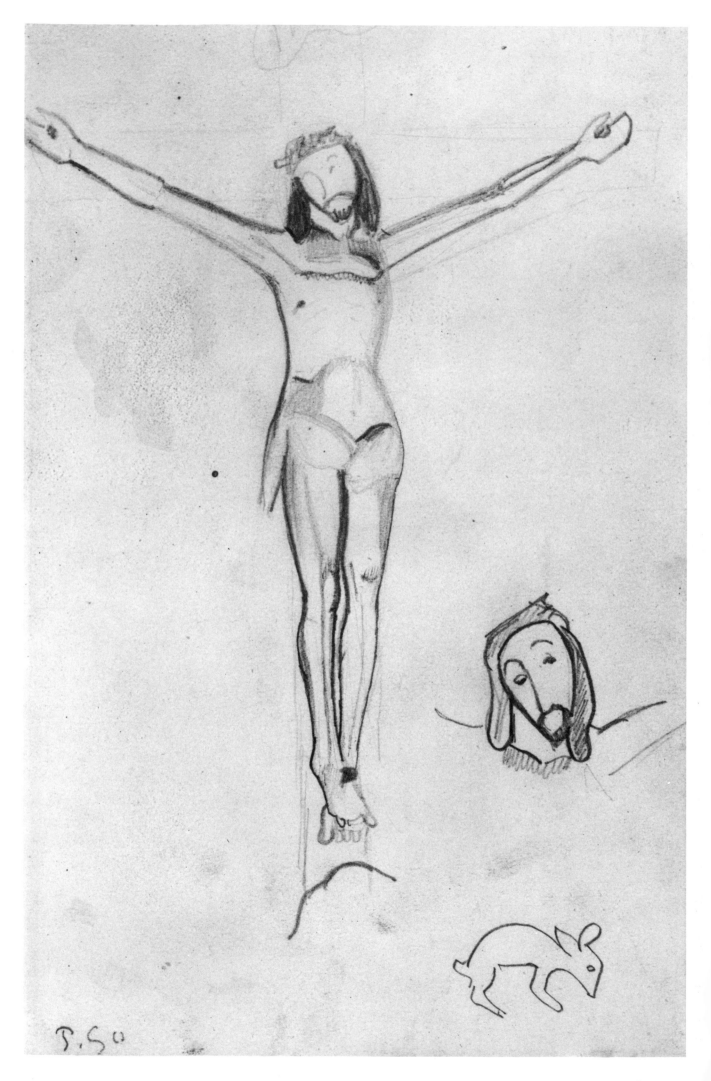

P.50

Plate 38

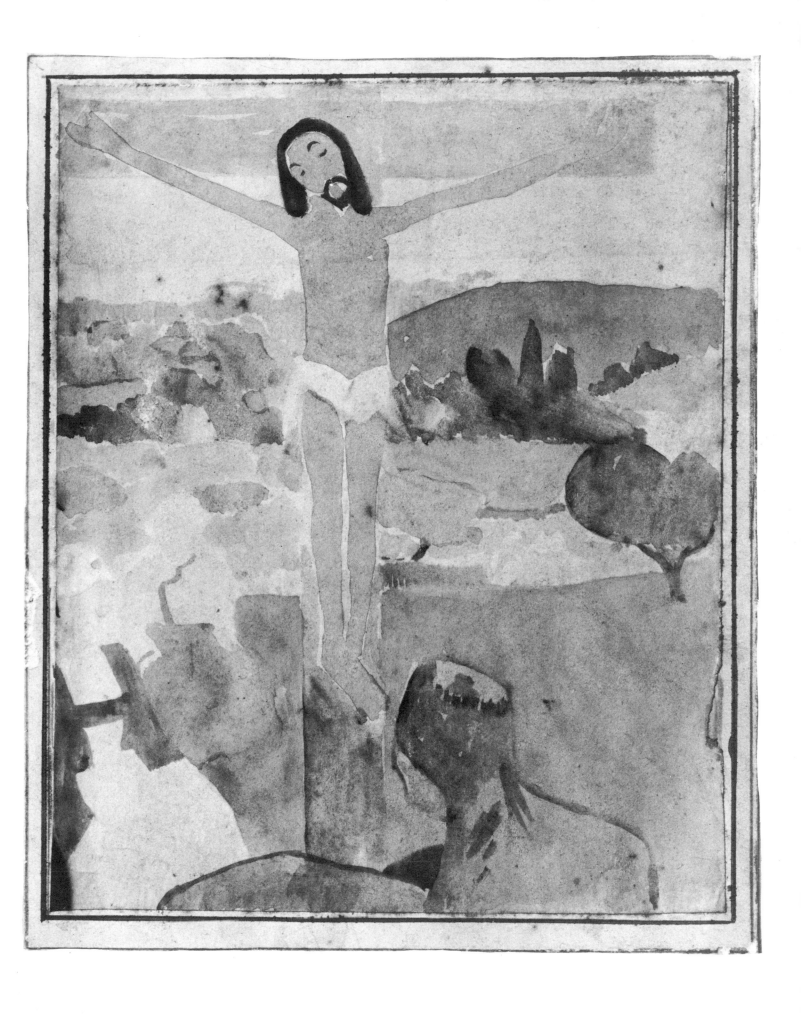

Plate 39

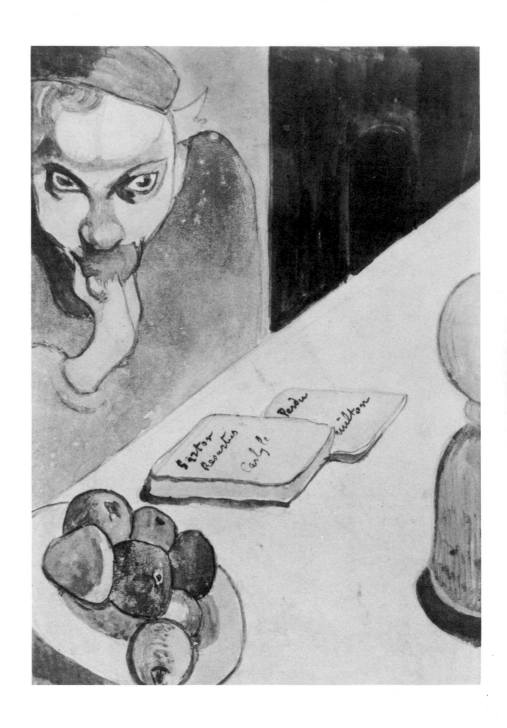

Plate 40

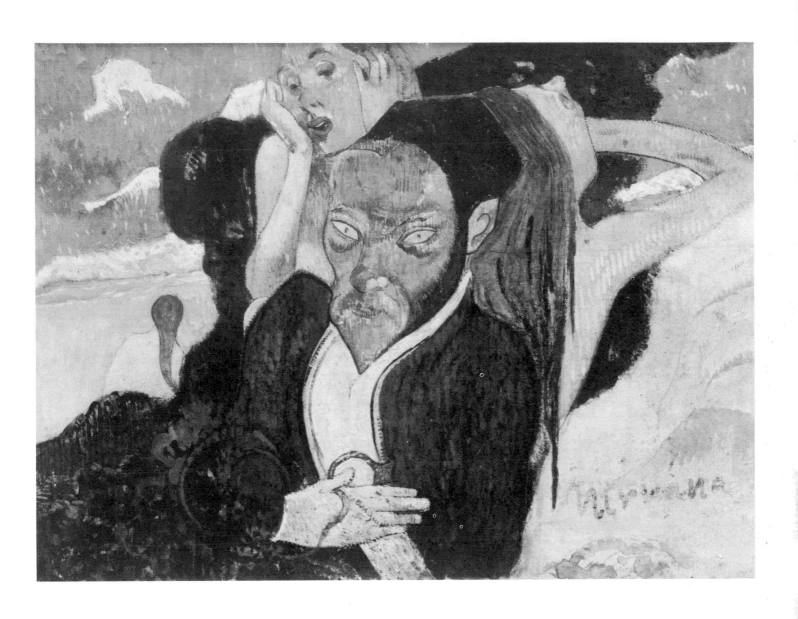

Plate 41

Plate 42

Plate 43

Plate 44

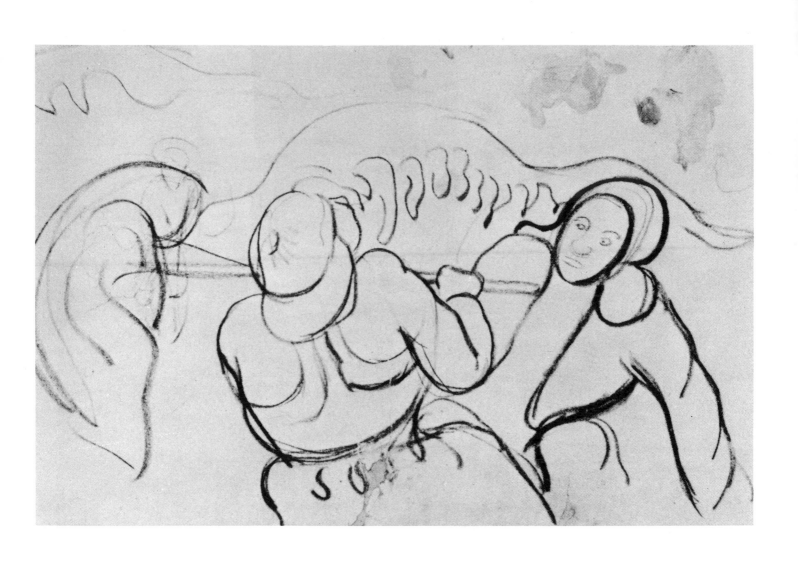

Plate 45

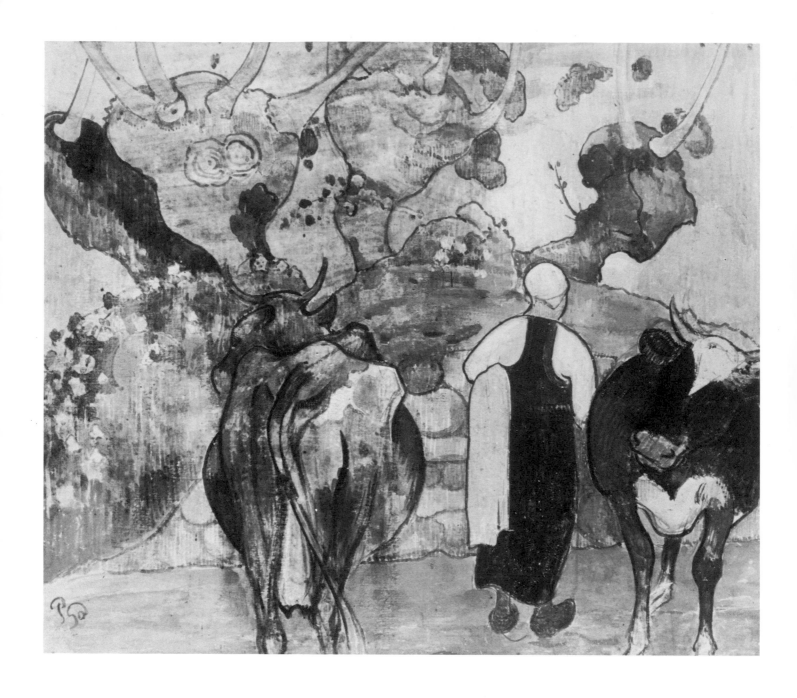

Plate 46

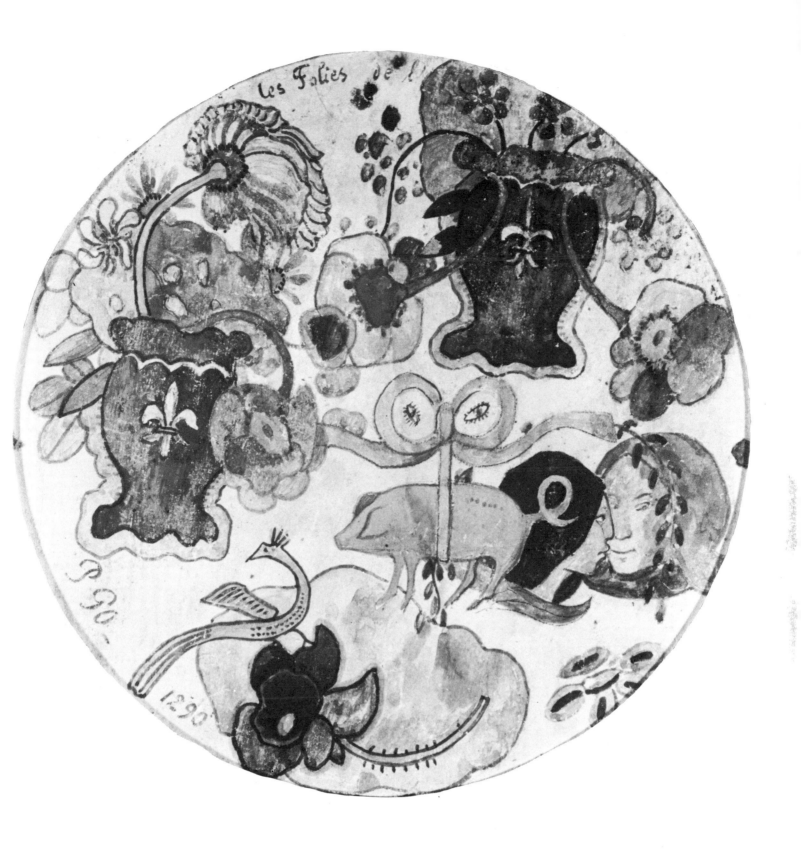

Plate 47

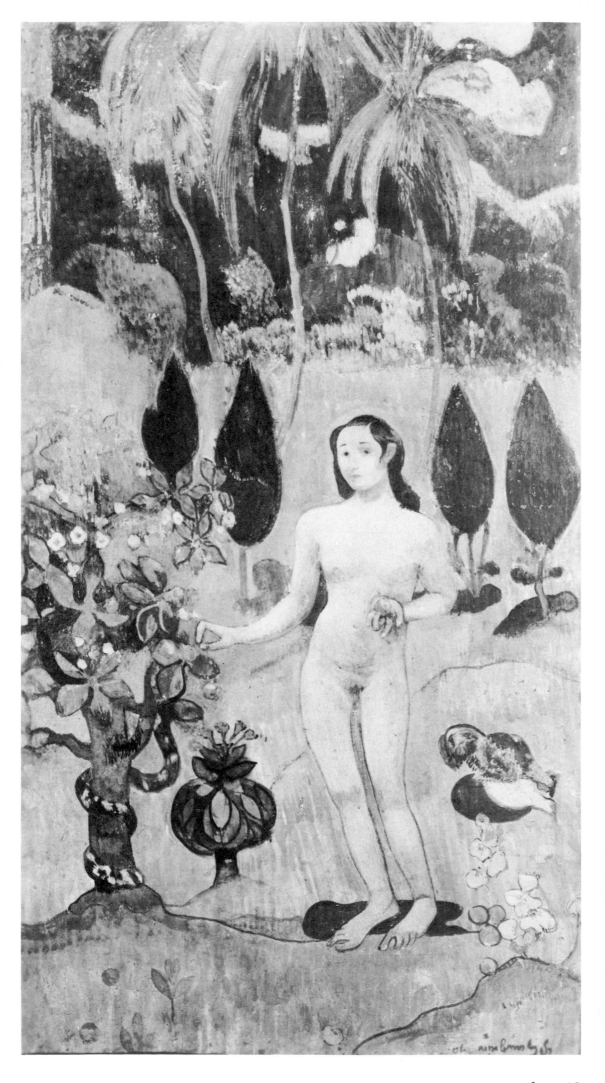

Plate 48

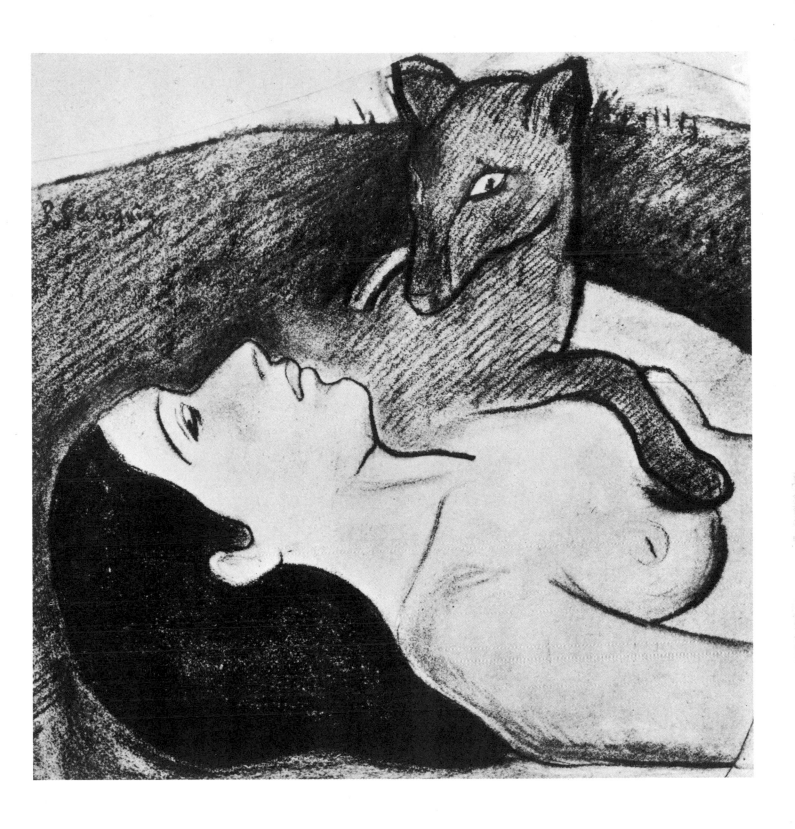

Plate 49

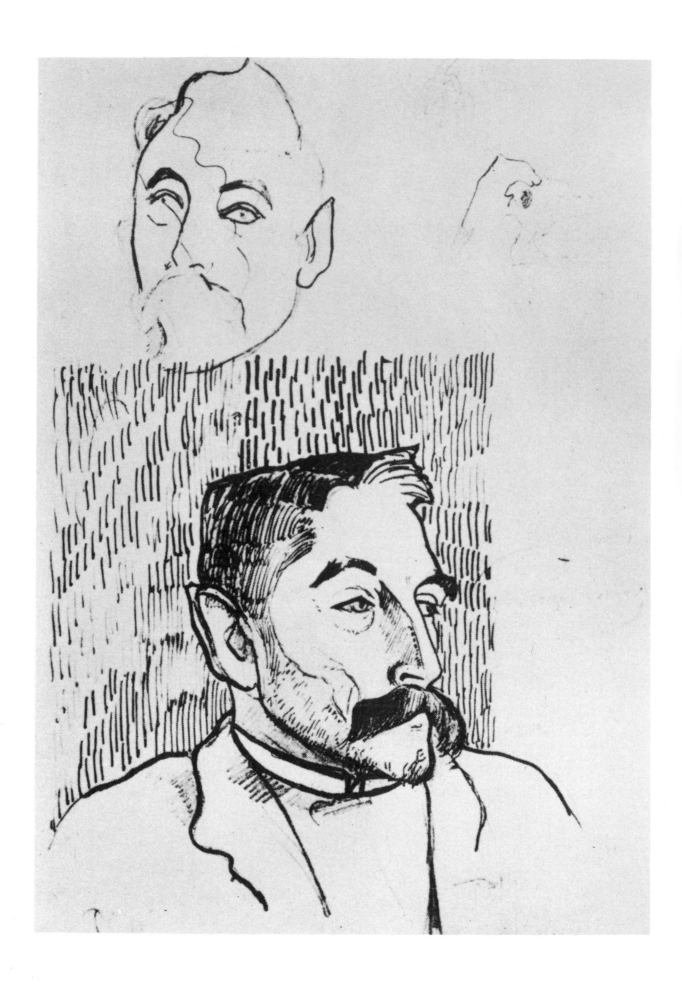

Plate 50

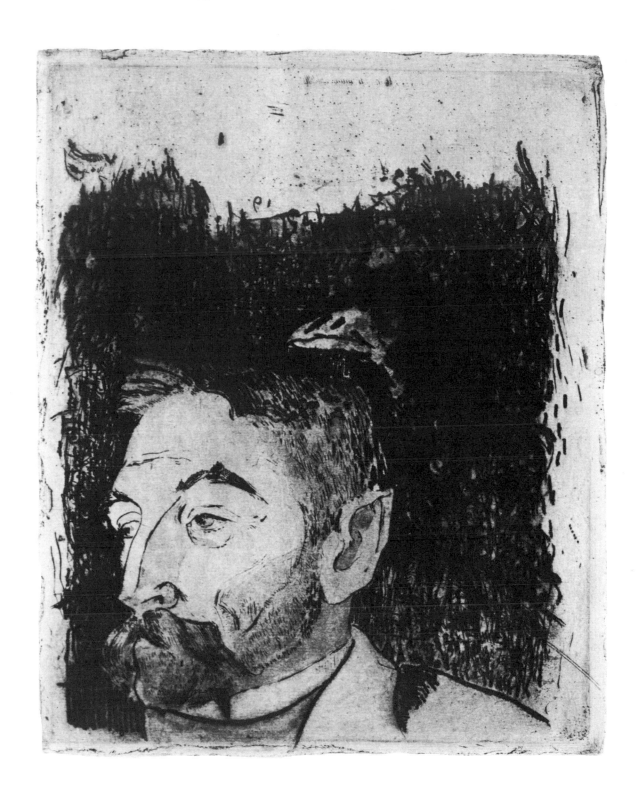

Plate 51

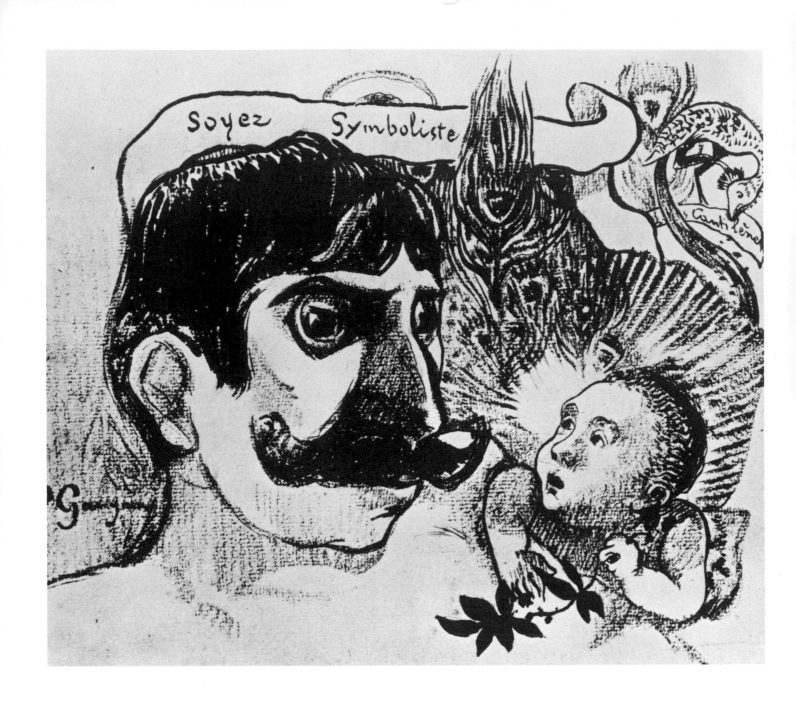

Plate 52

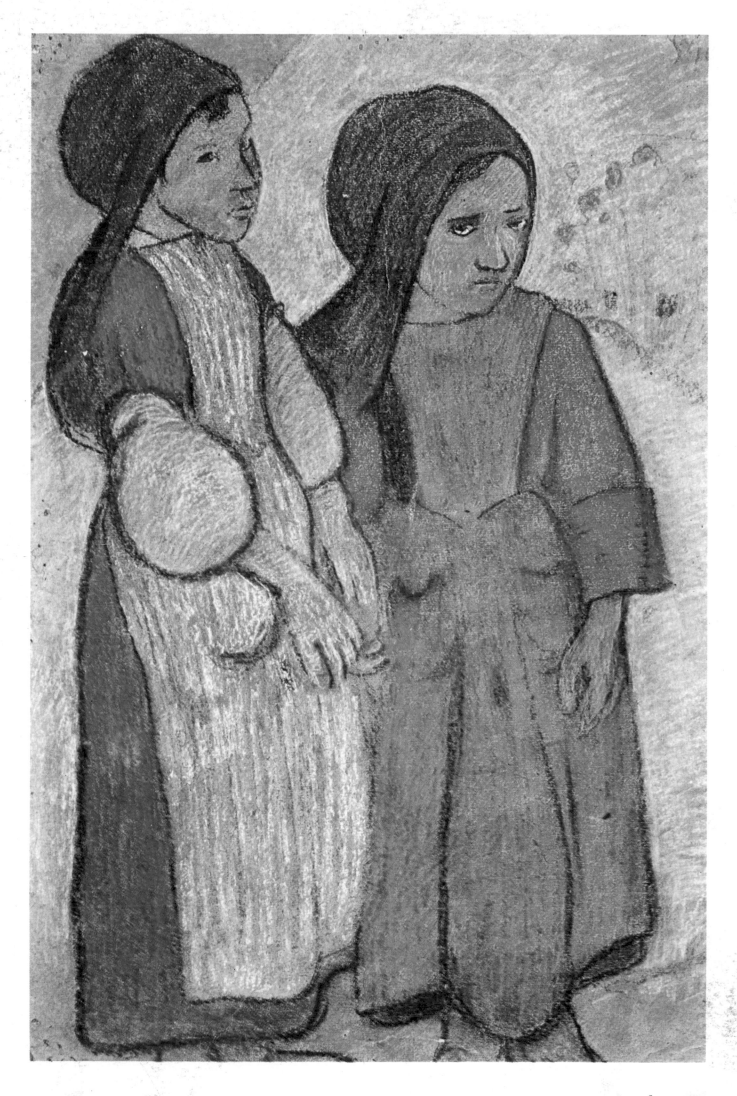

Plate VII

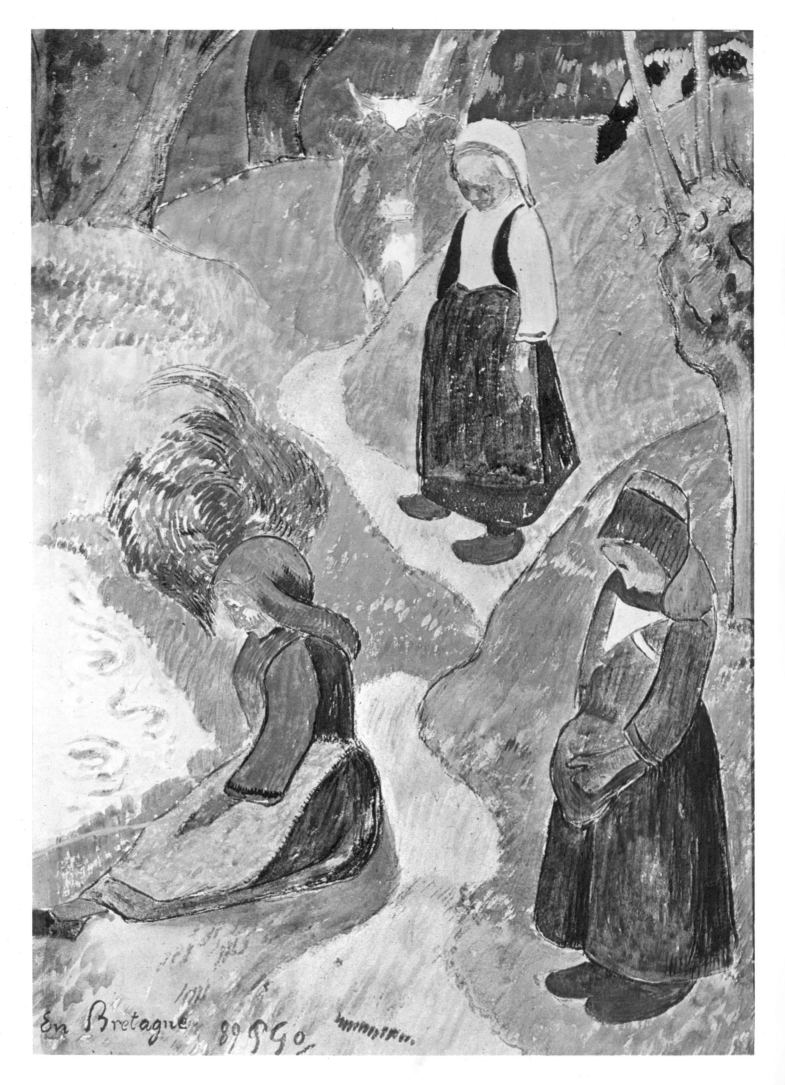

En Bretagne 89 PGo

Plate VIII

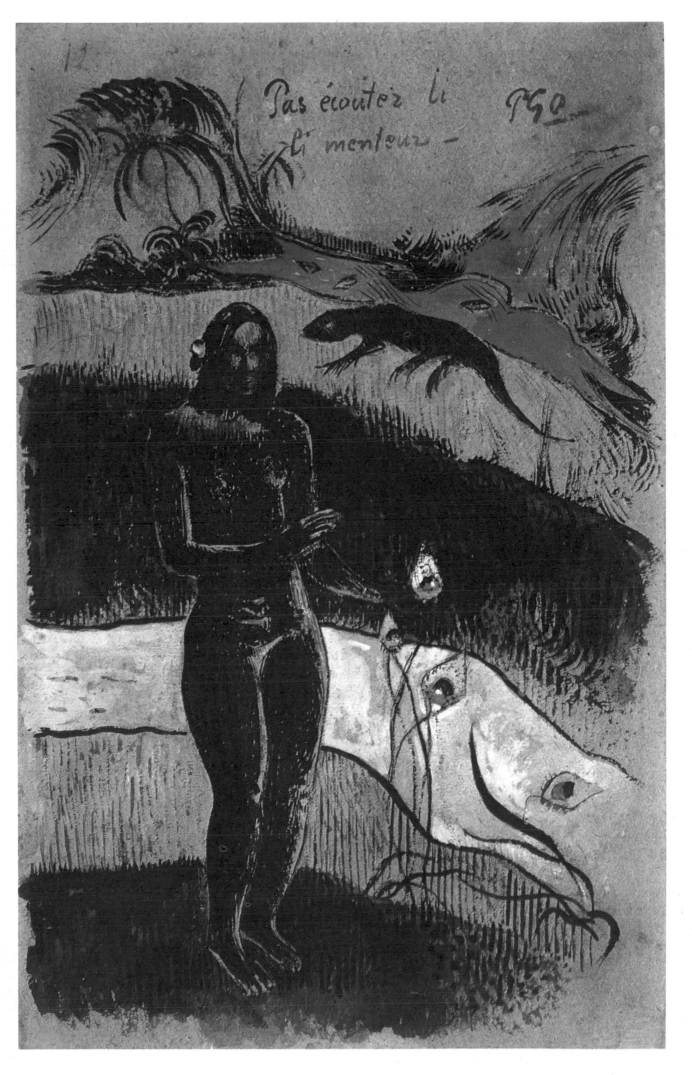

Plate IX

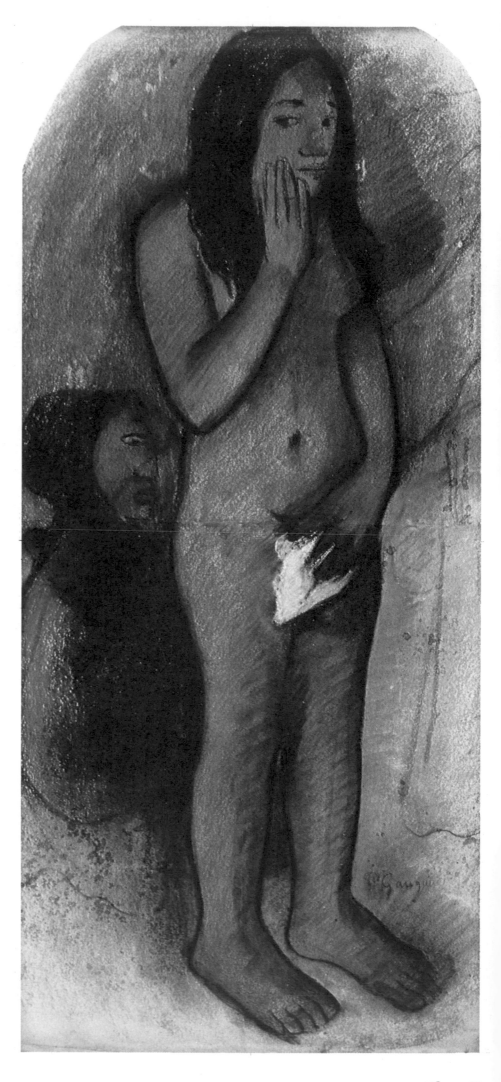

Plate X

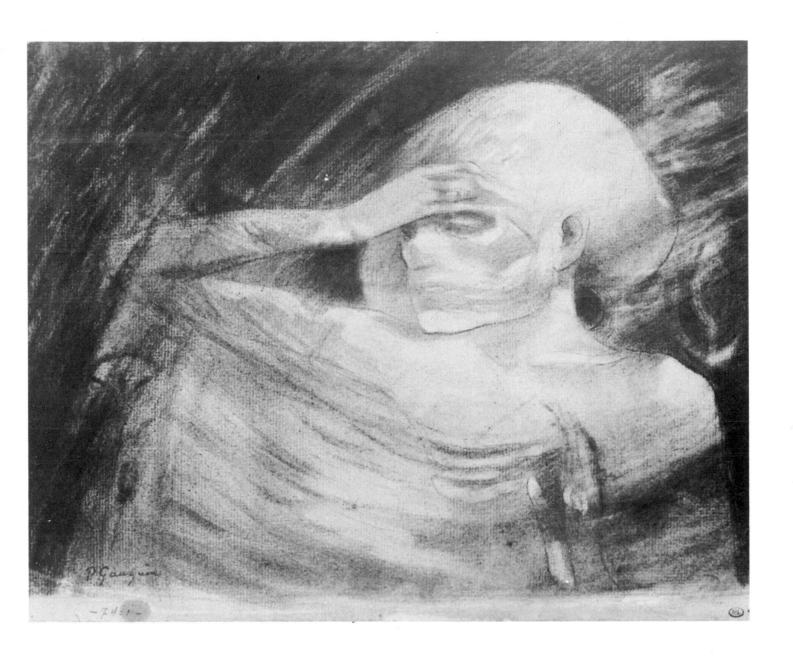

Plate 53

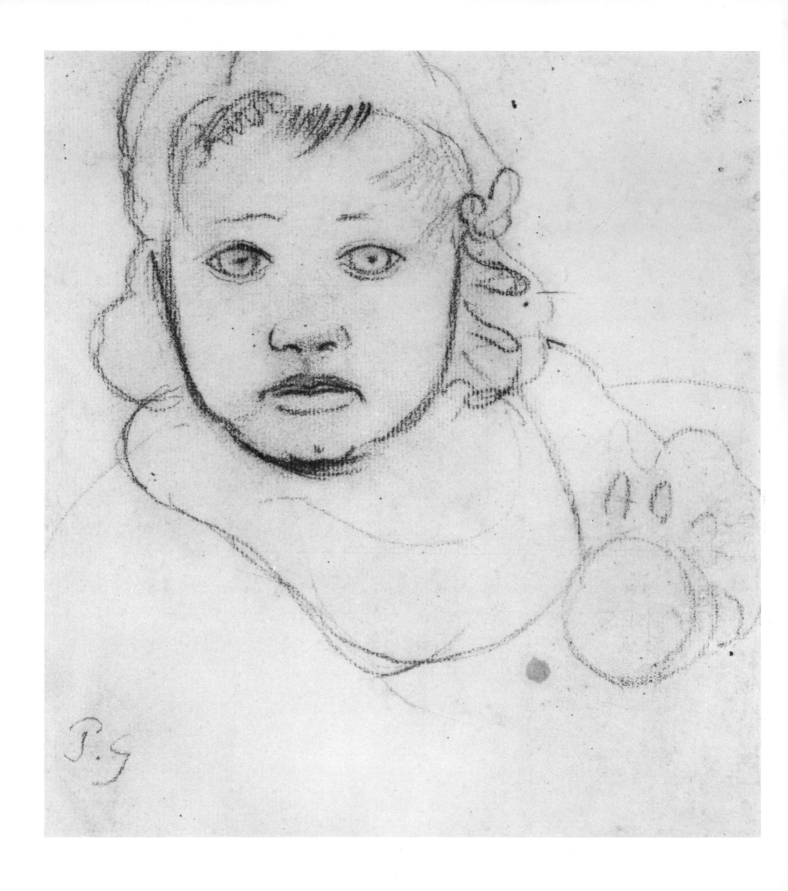

Plate 54

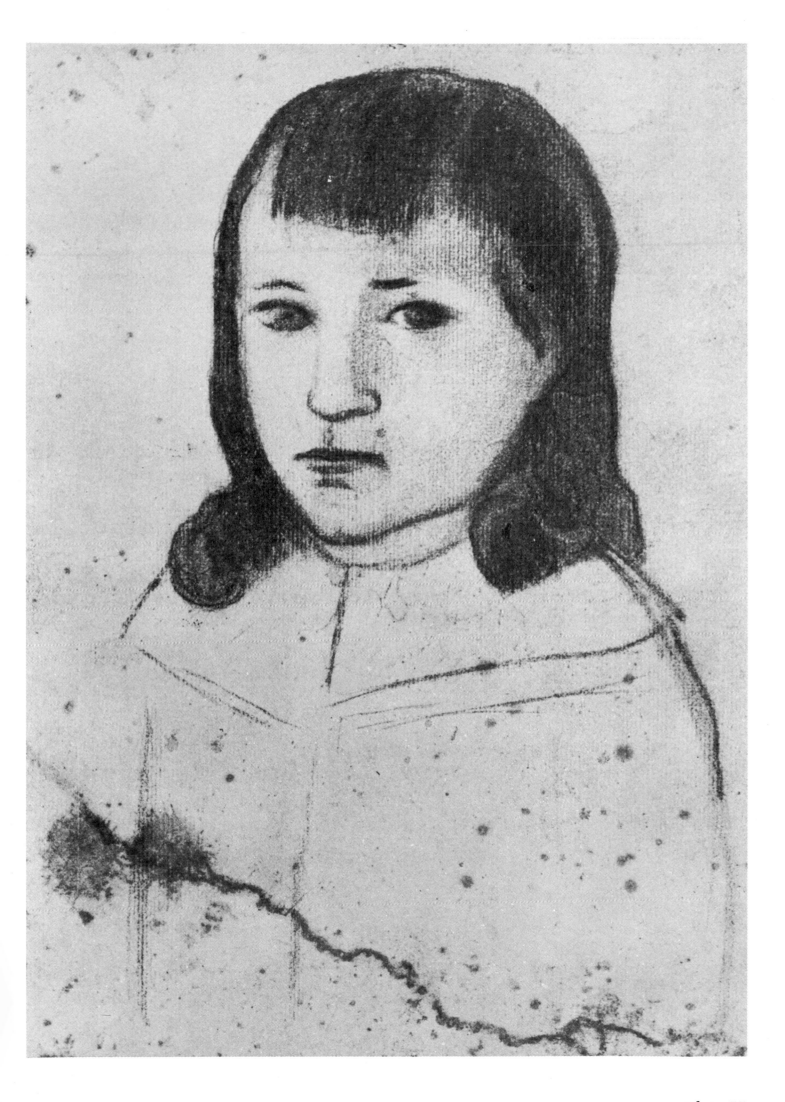

Plate 55

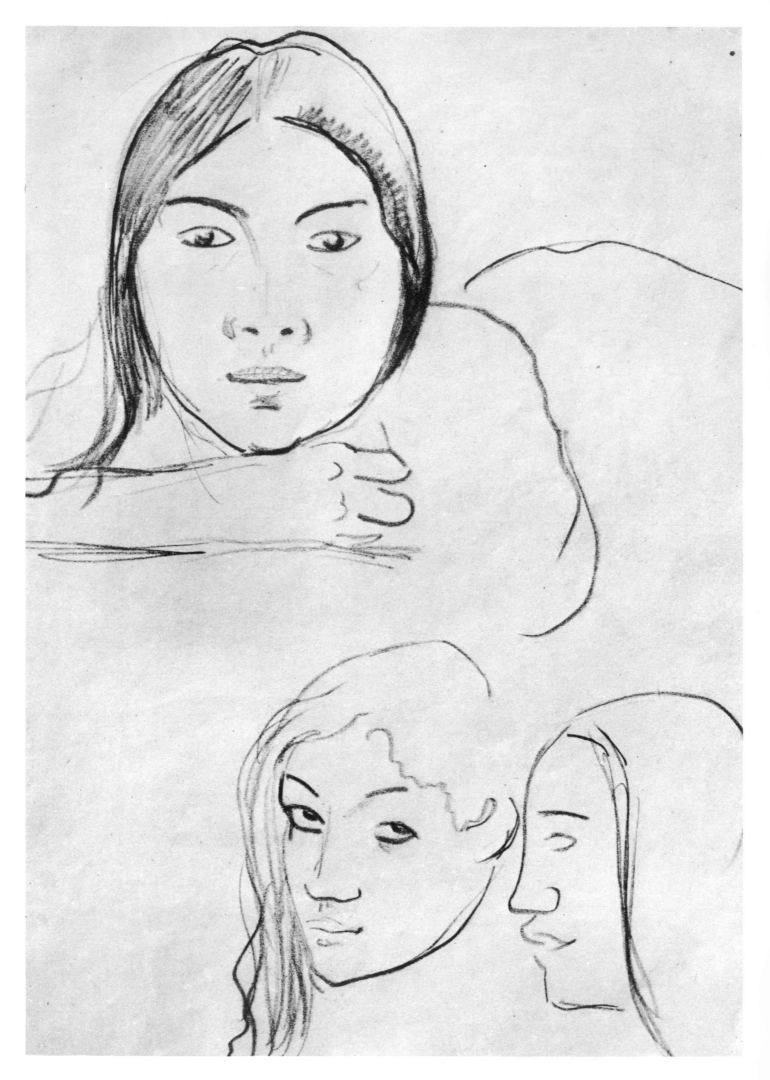

Plate 56

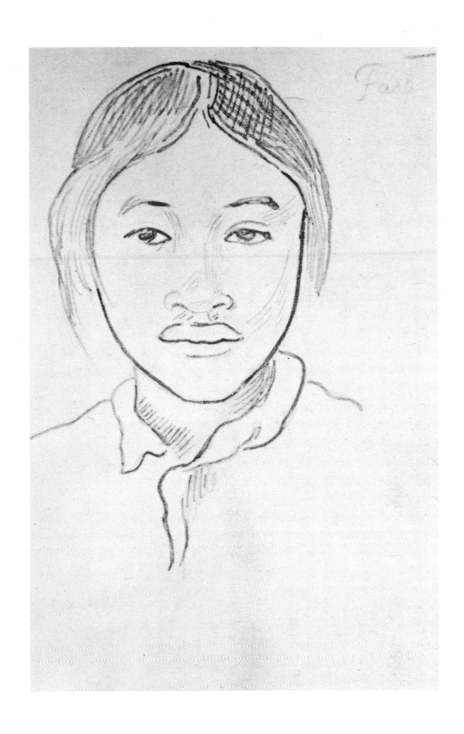

Plate 57

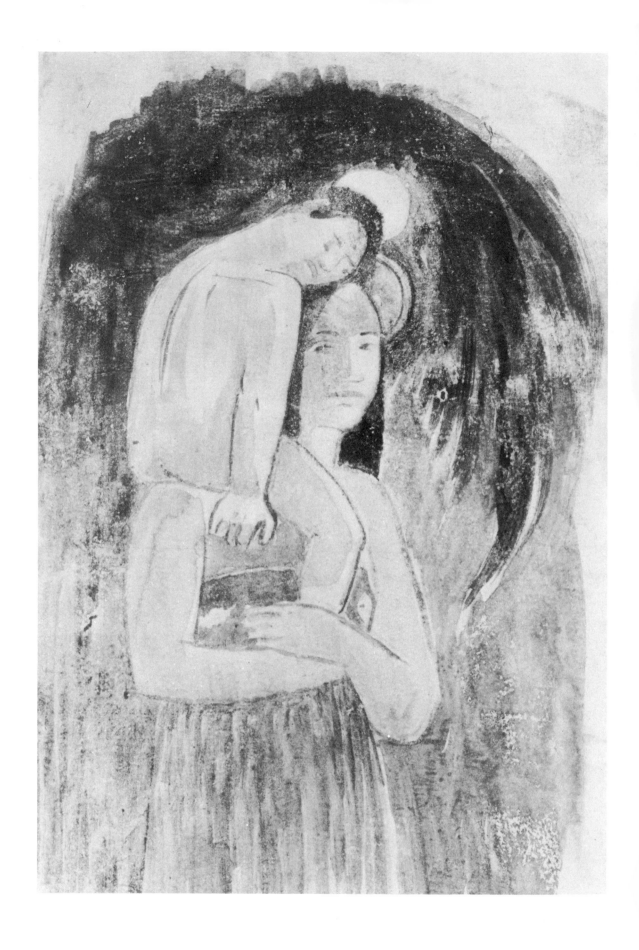

Plate 58

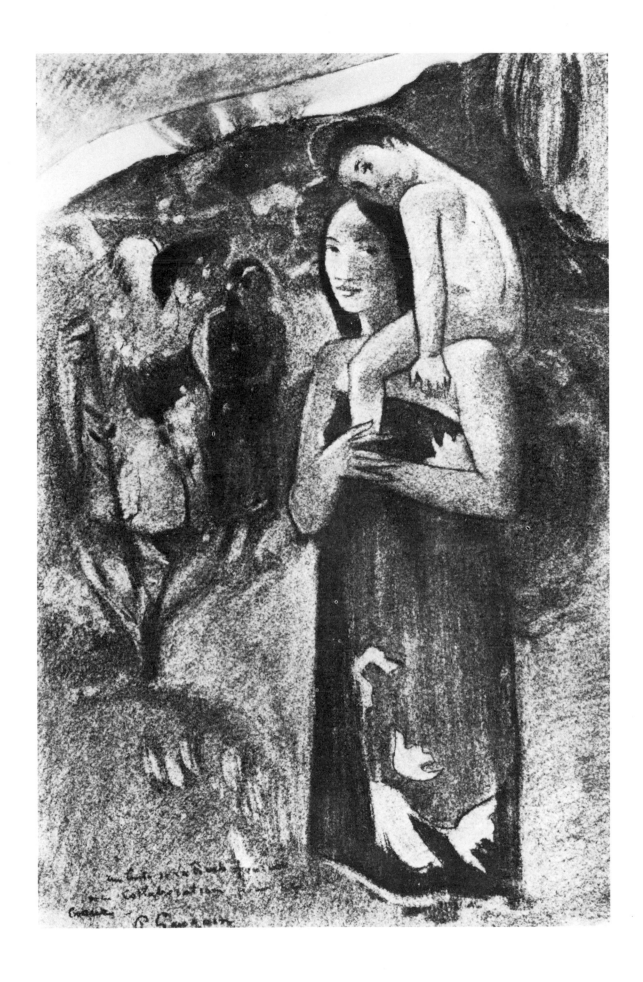

Plate 59

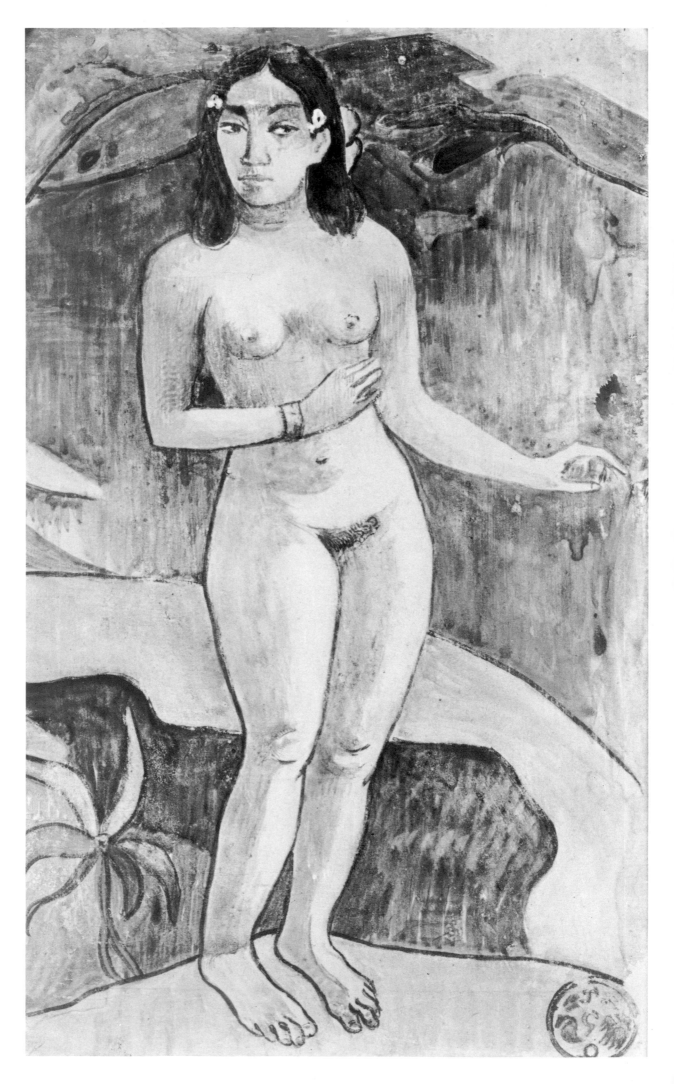

Plate 60

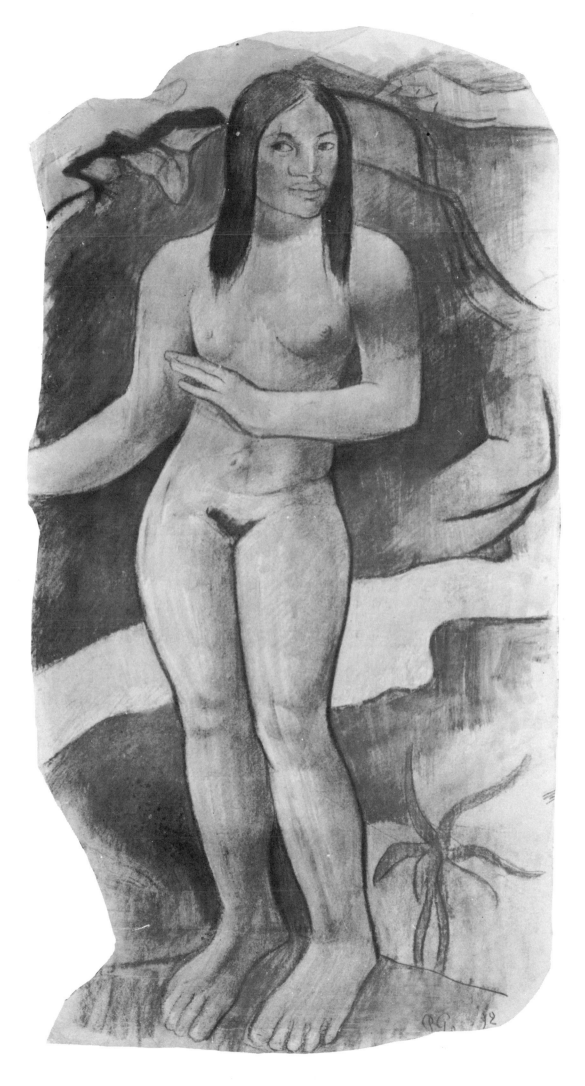

Plate 61

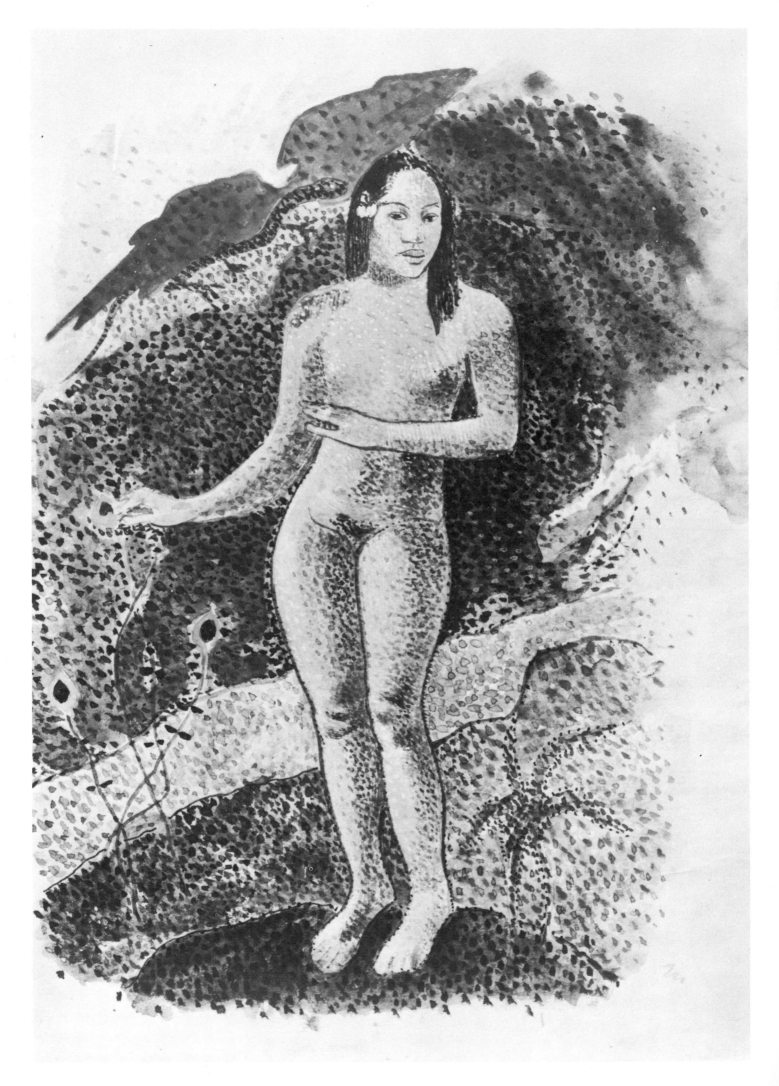

Plate 63

Plate 64

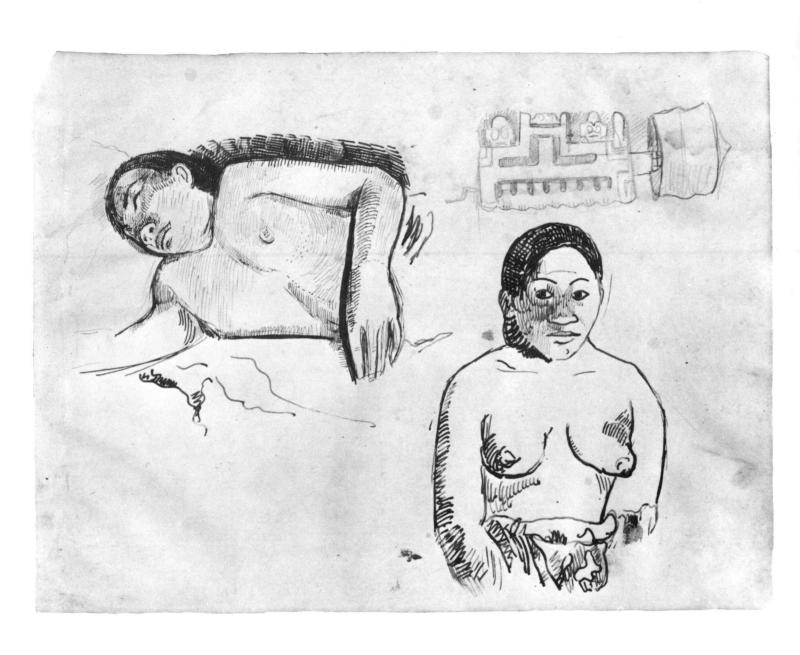

Plate 65

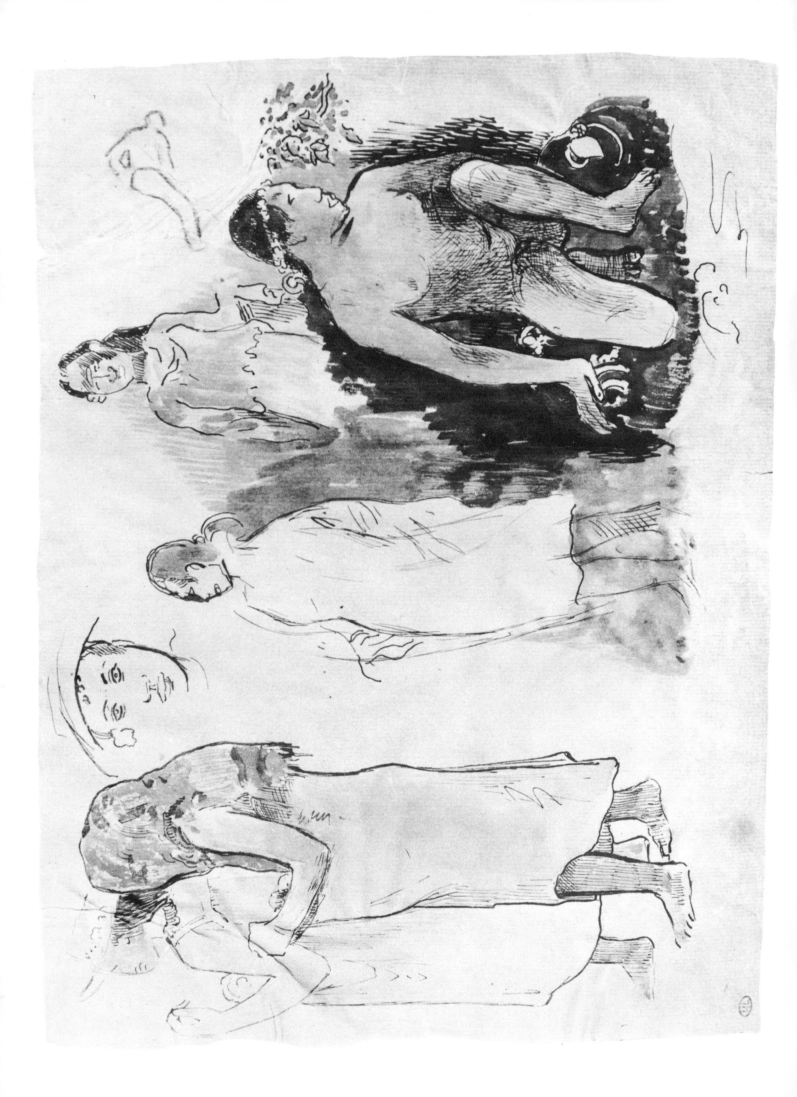

Plate 66

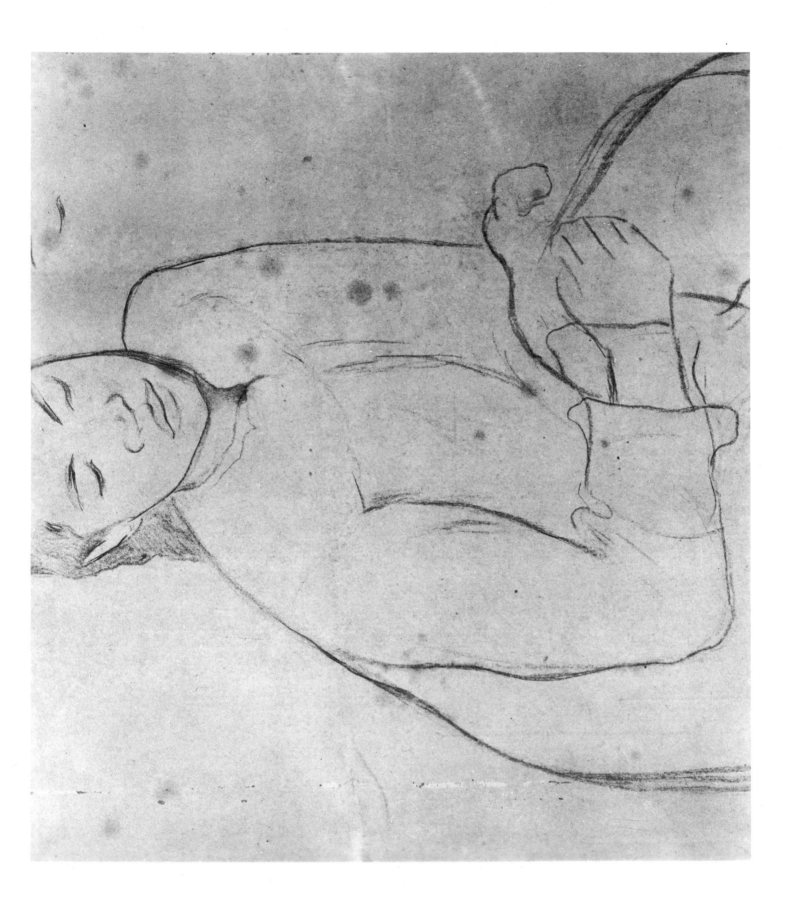

Plate 67

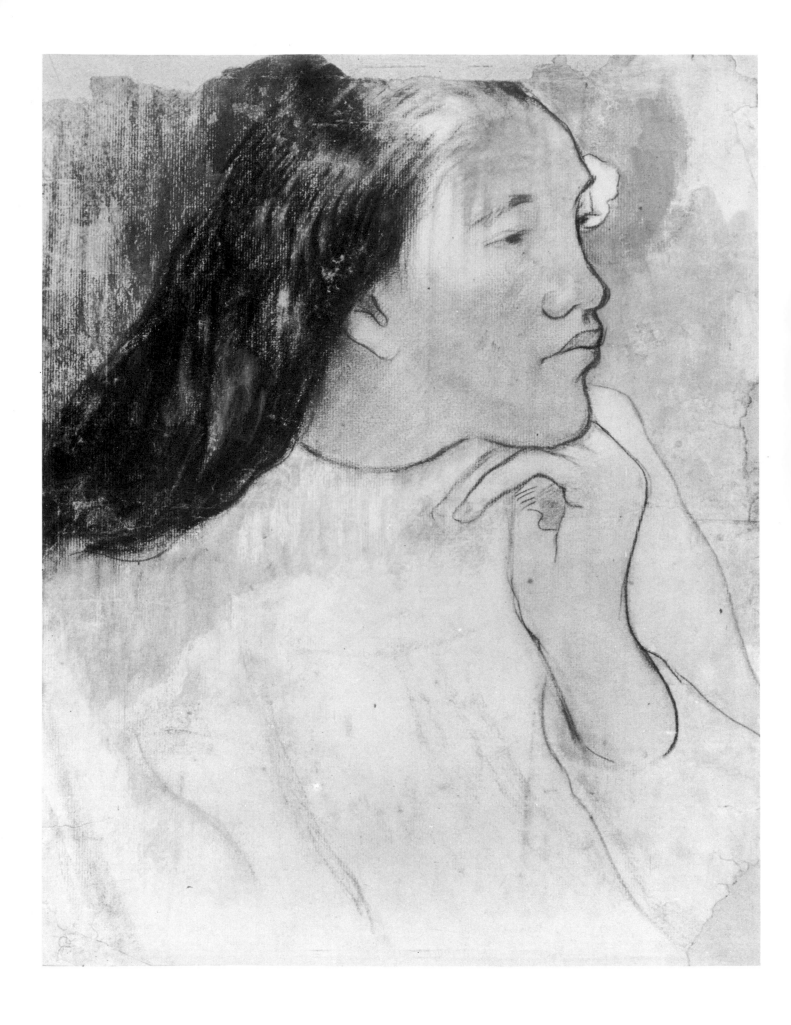

Plate 68

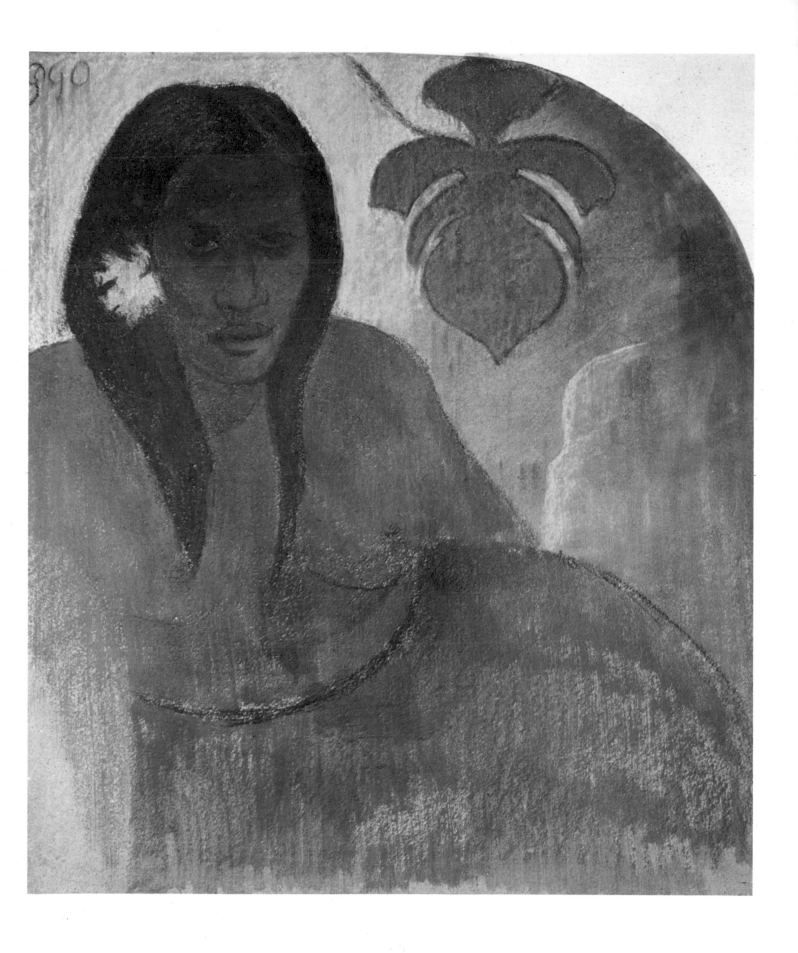

Plate XI

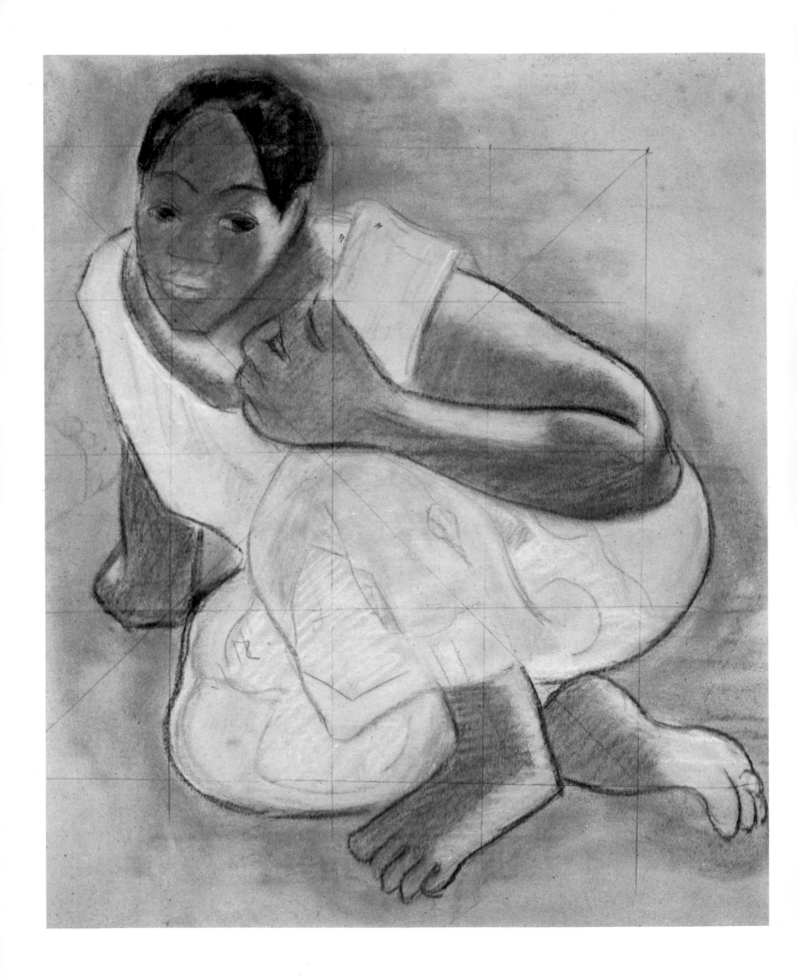

Plate XII

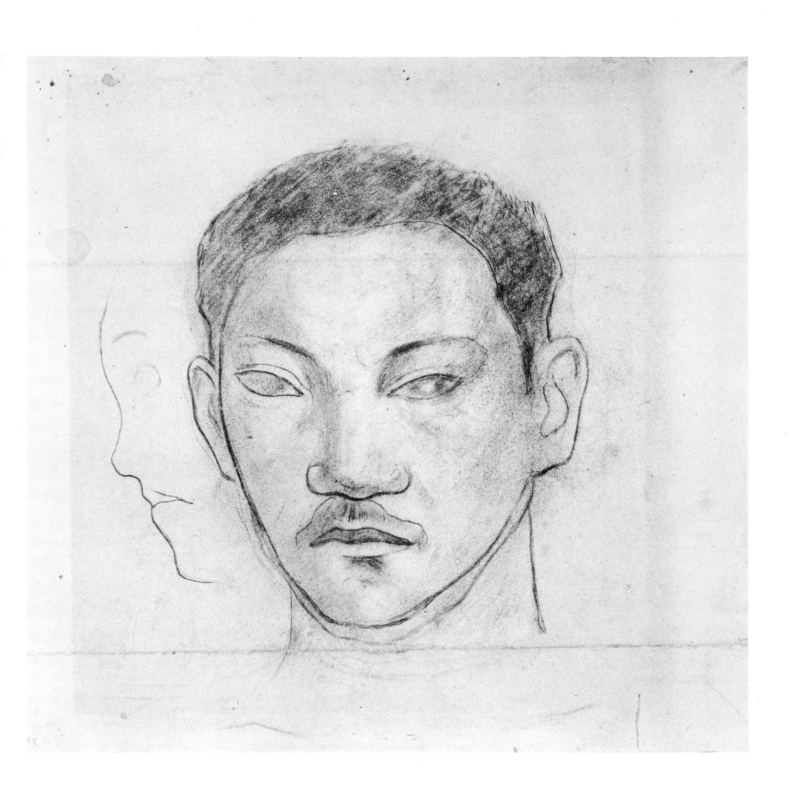

Plate 69

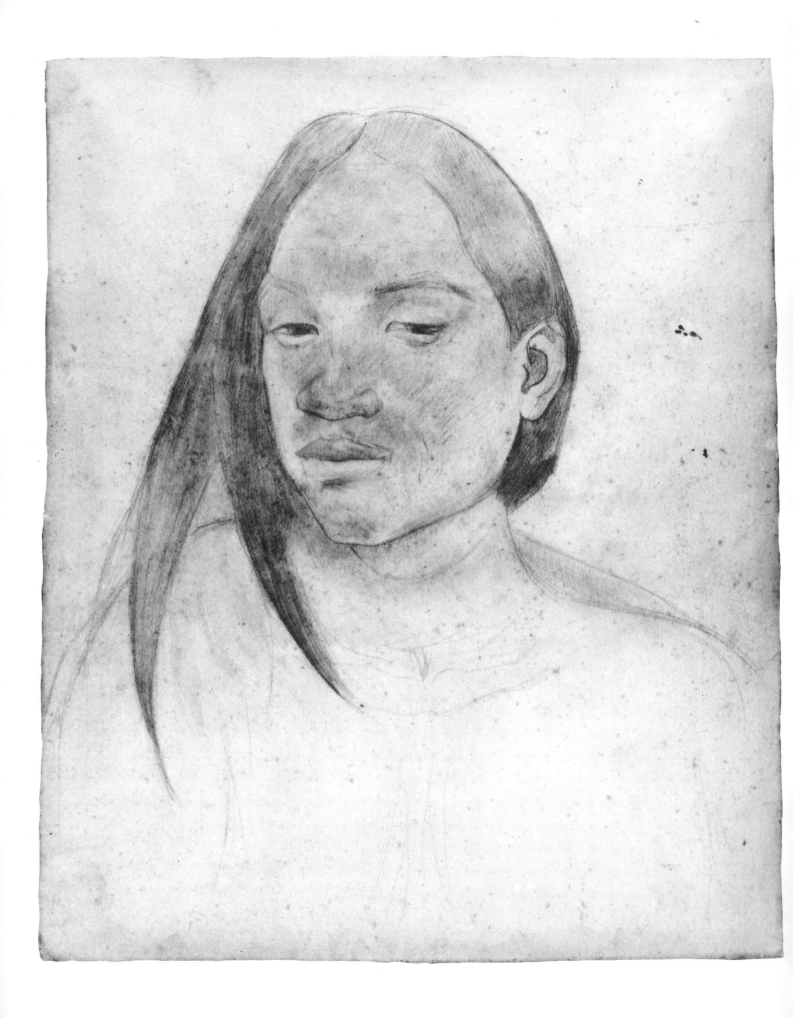

Plate 70

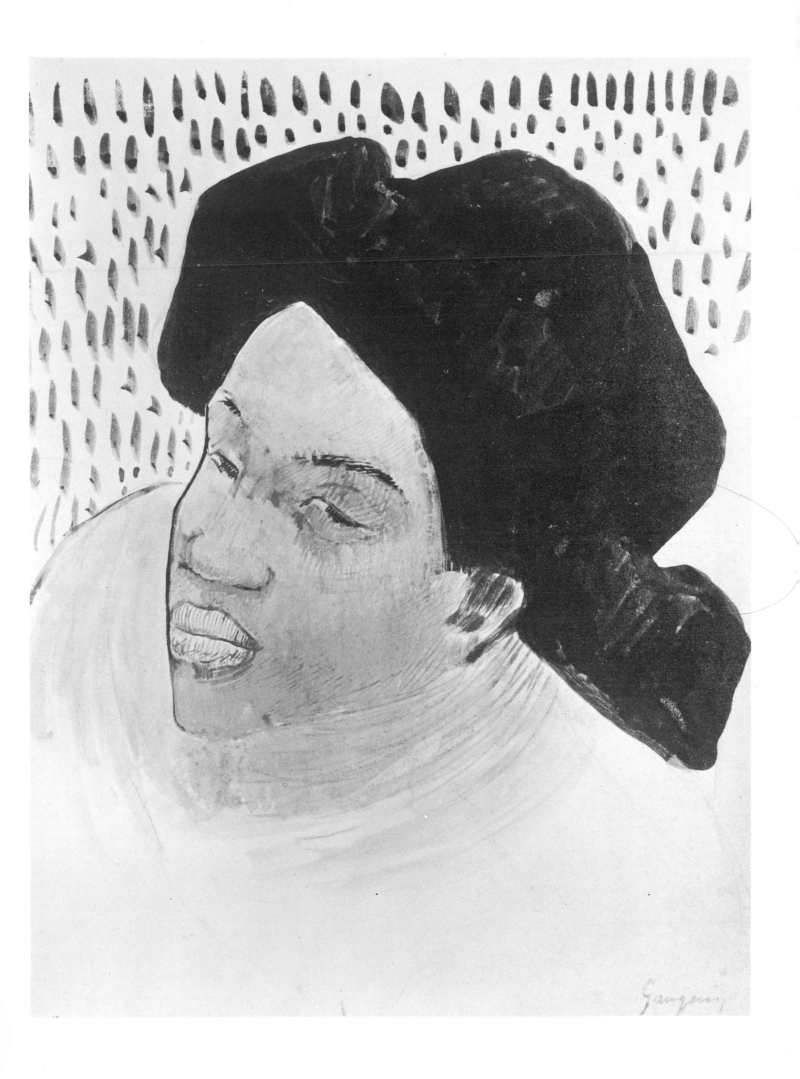

Plate 71

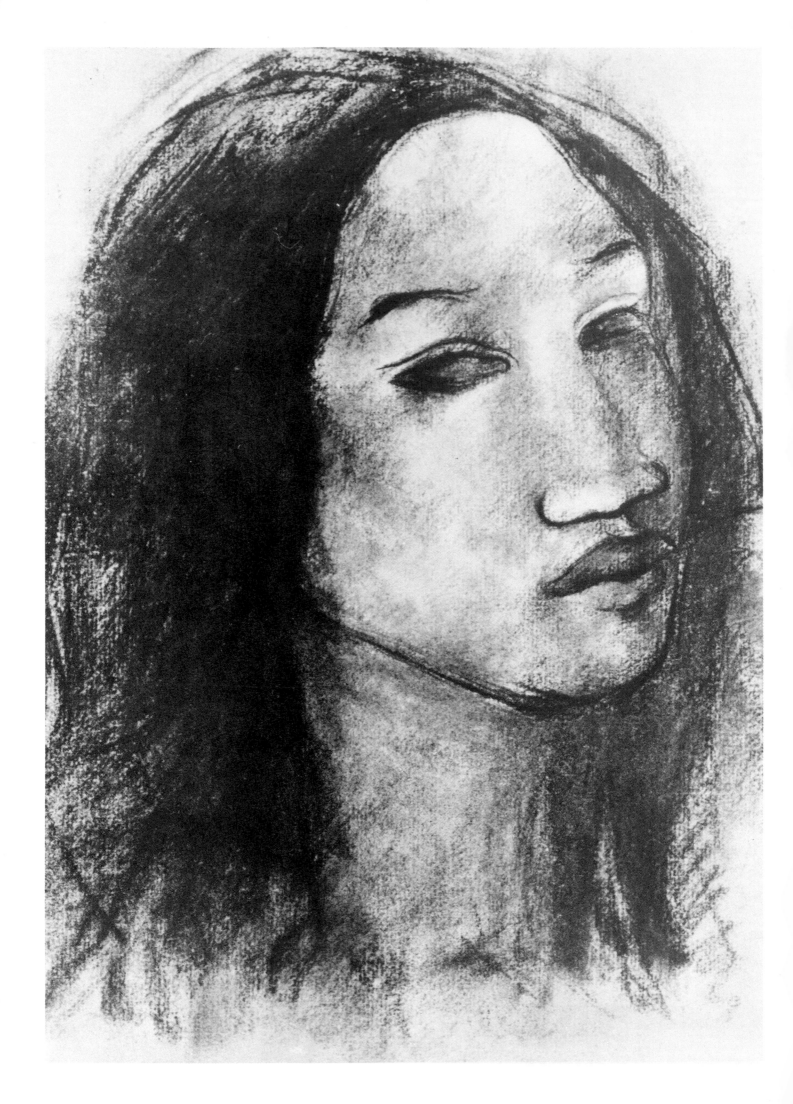

Plate 72

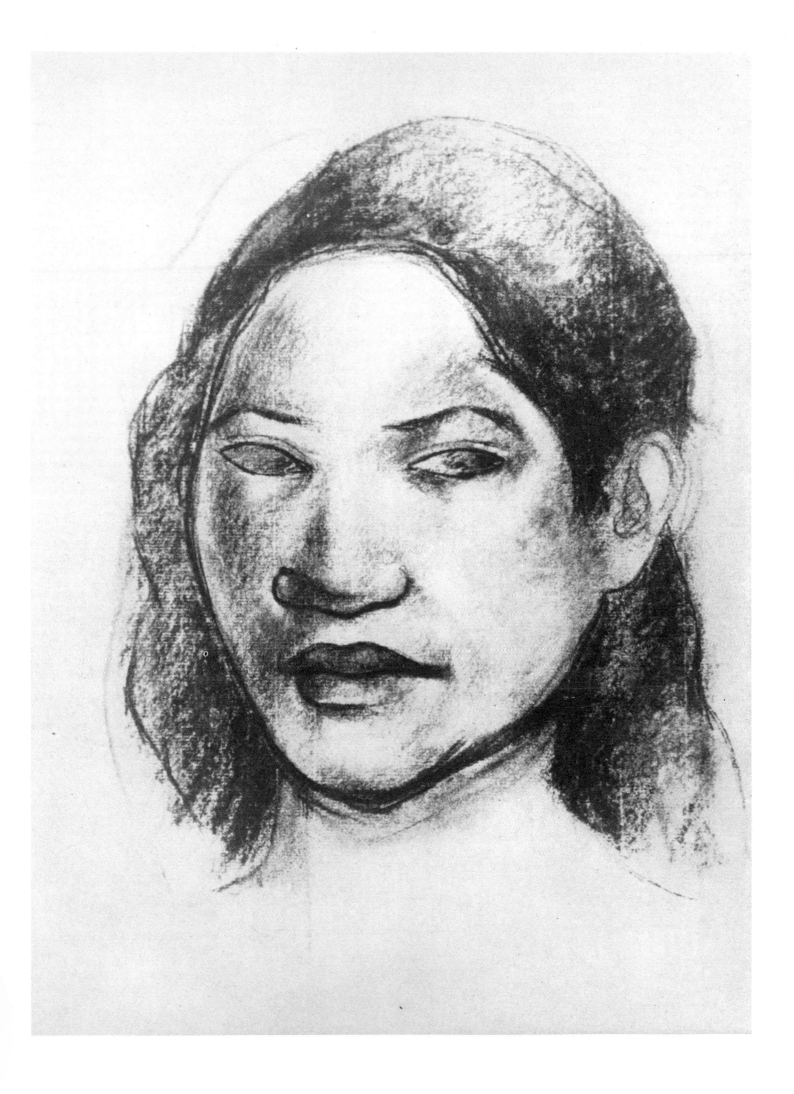

Plate 73

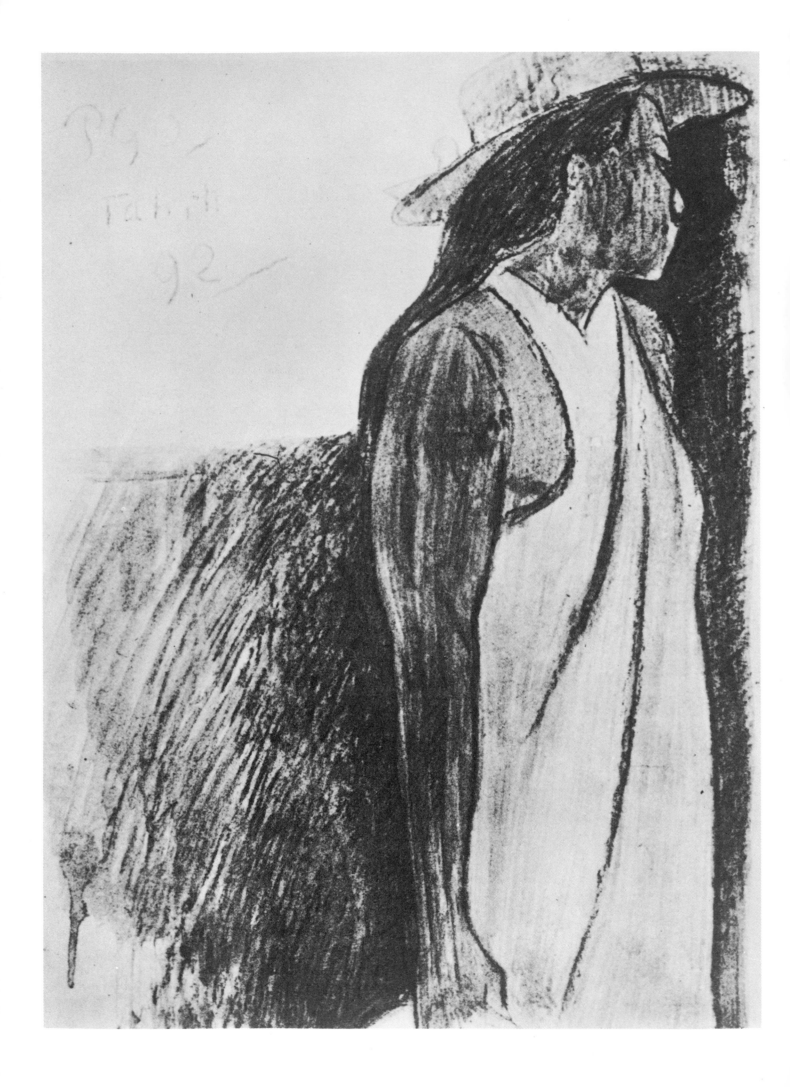

Plate 74

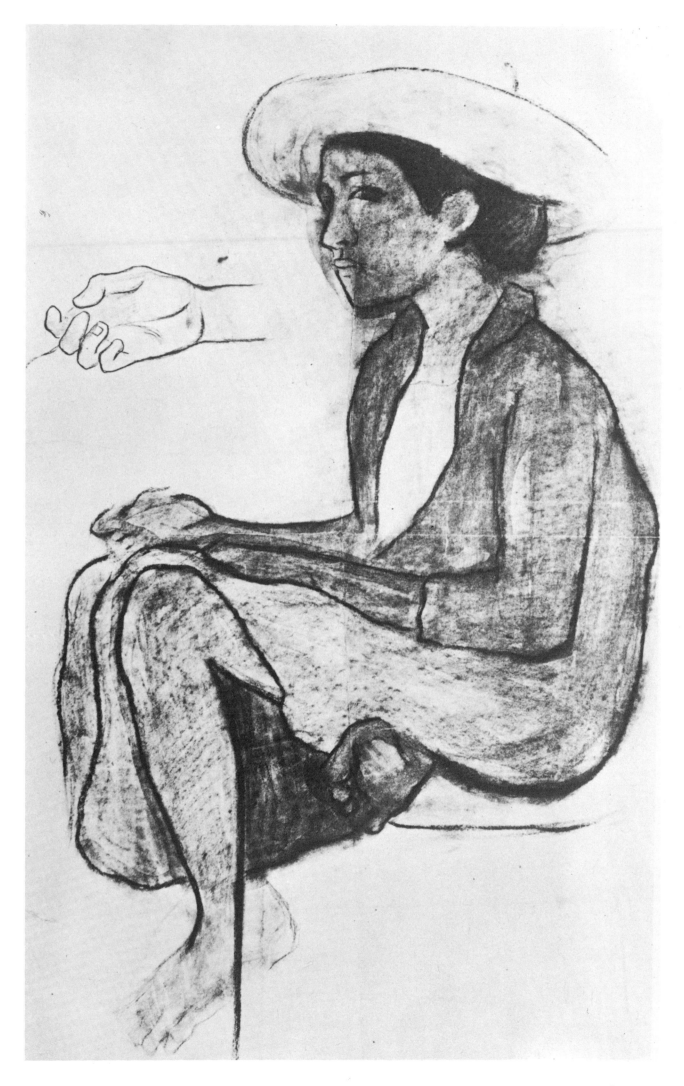

Plate 75

Plate 76

Plate 77

Plate 78

Plate 79

Plate 80

Plate 81

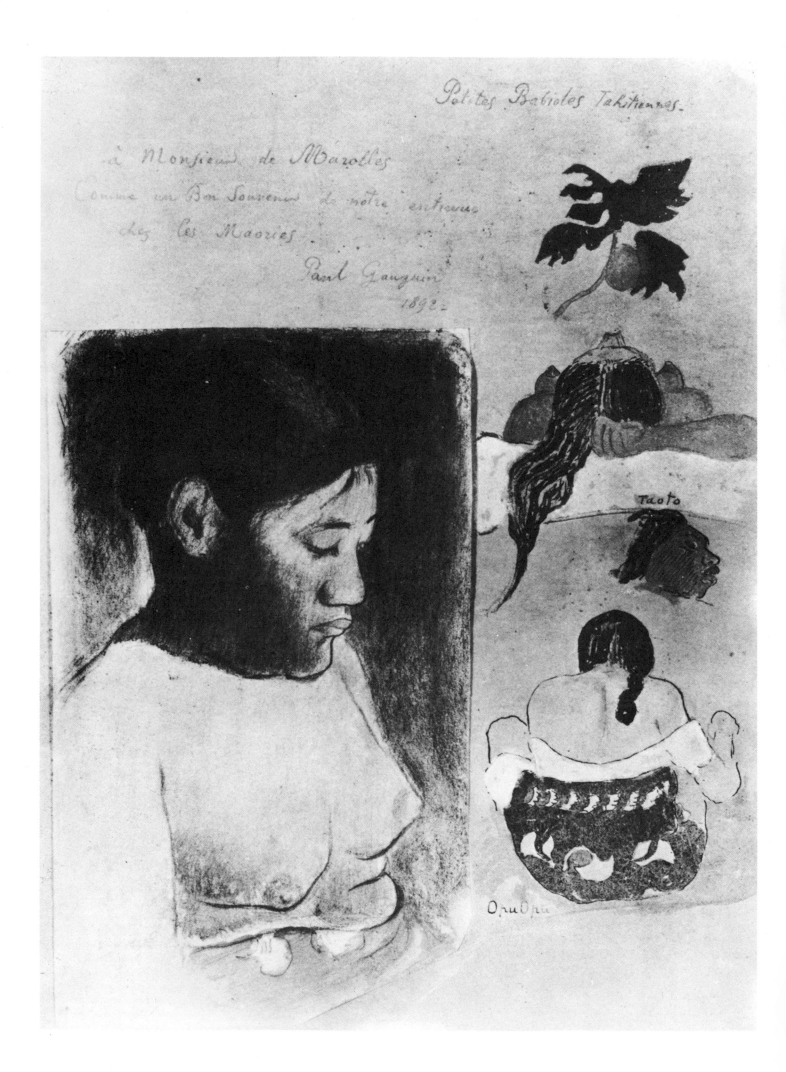

Petites Babioles Tahitiennes.

à Monsieur de Marolles
Comme un Bon Souvenir de notre entrevue
chez les Maories.

Paul Gauguin
1892.

Taoto

Opuopu

Plate 82

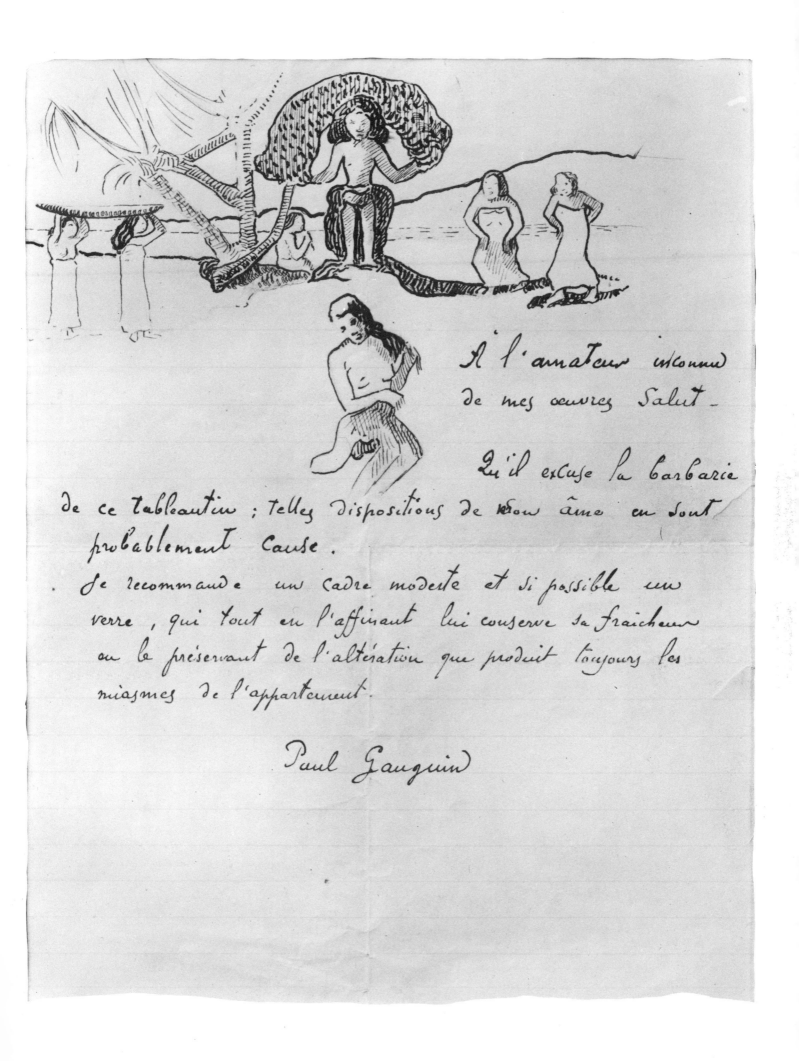

À l'amateur inconnu
de mes œuvres Salut —

Qu'il excuse la barbarie
de ce tableautin ; telles dispositions de mon âme en sont
probablement cause.

Je recommande un cadre modeste et si possible un
verre, qui tout en l'affinant lui conserve sa fraicheur
en le préservant de l'altération que produit toujours les
miasmes de l'appartement.

Paul Gauguin

Plate 83

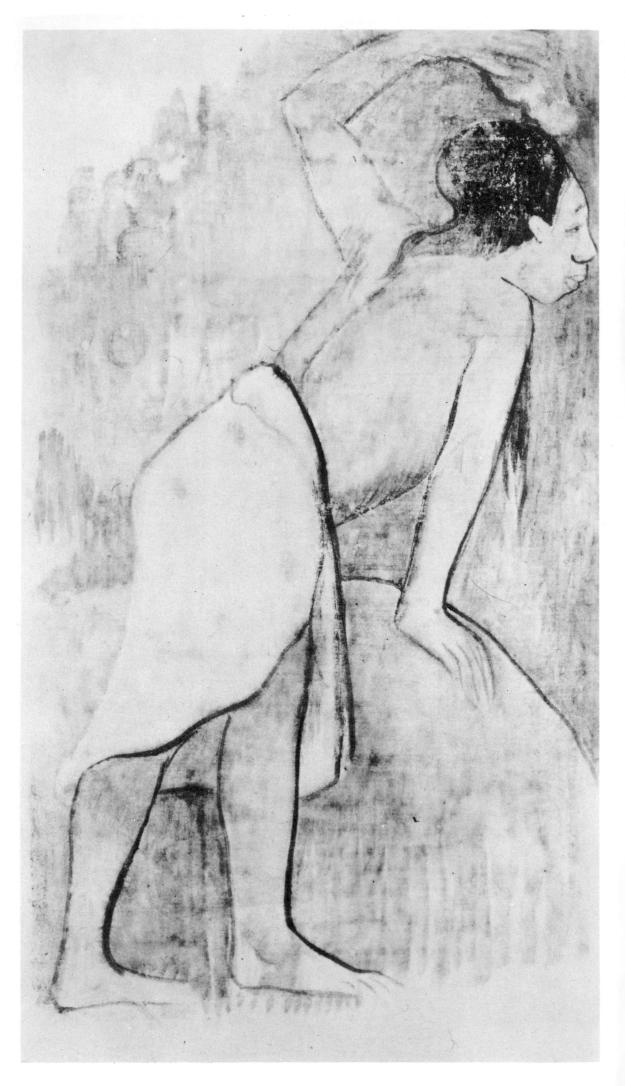

Plate 84

Plate XIII

Plate XIV

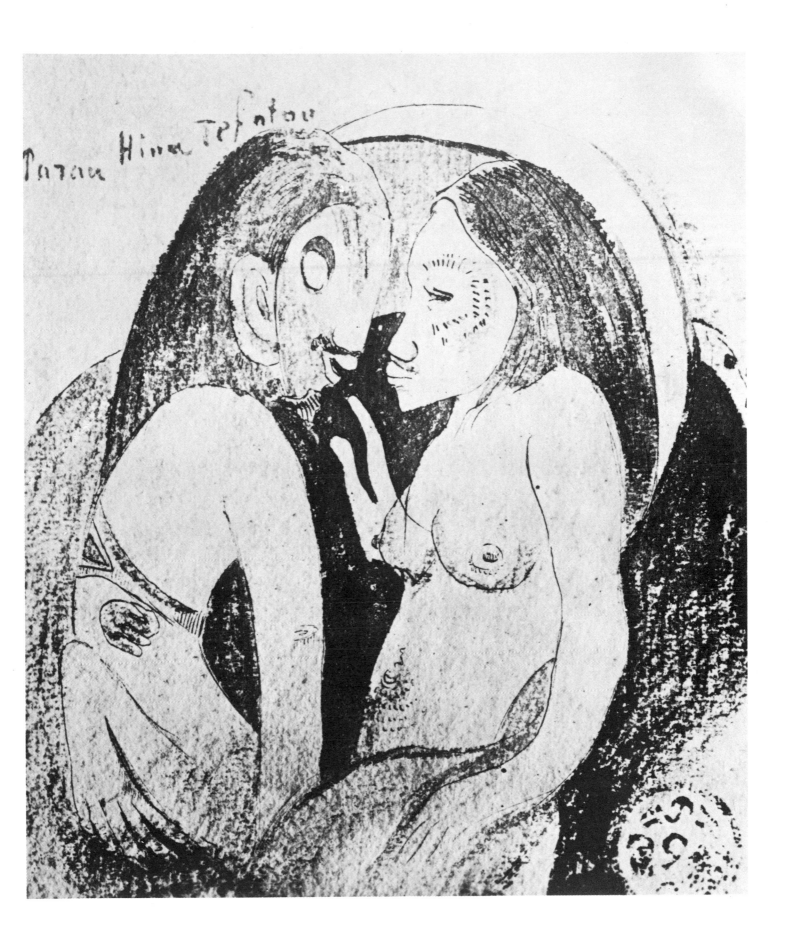

Plate 85

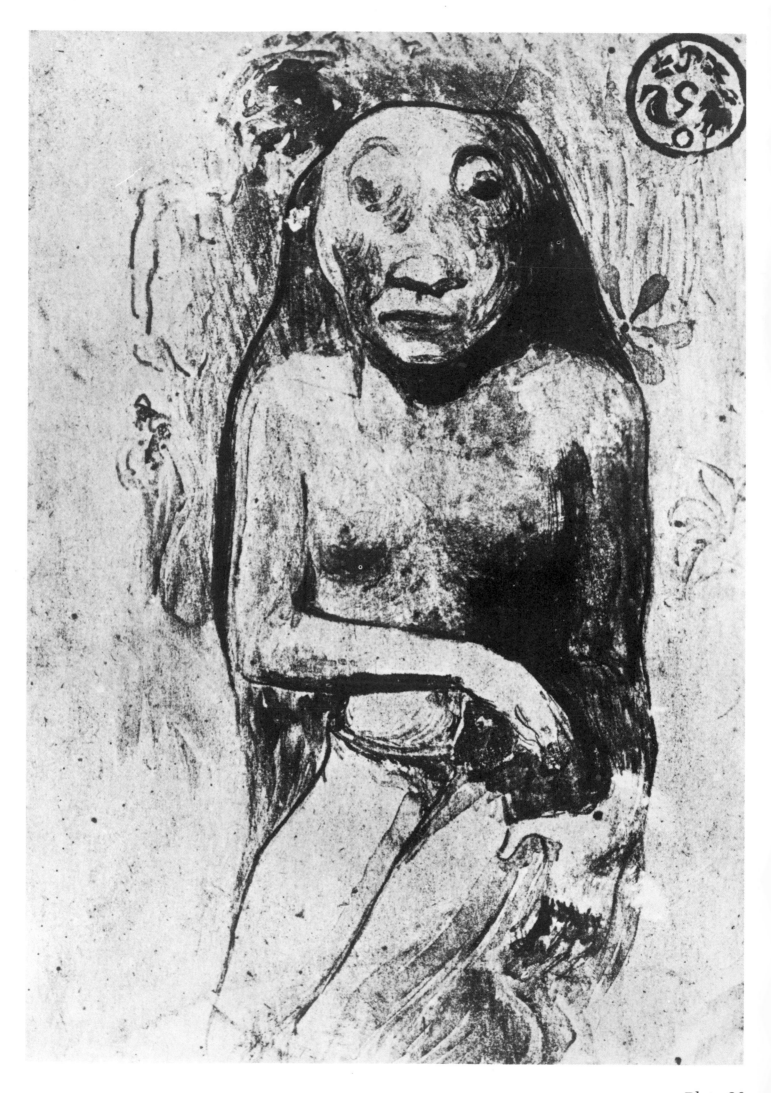

Plate 86

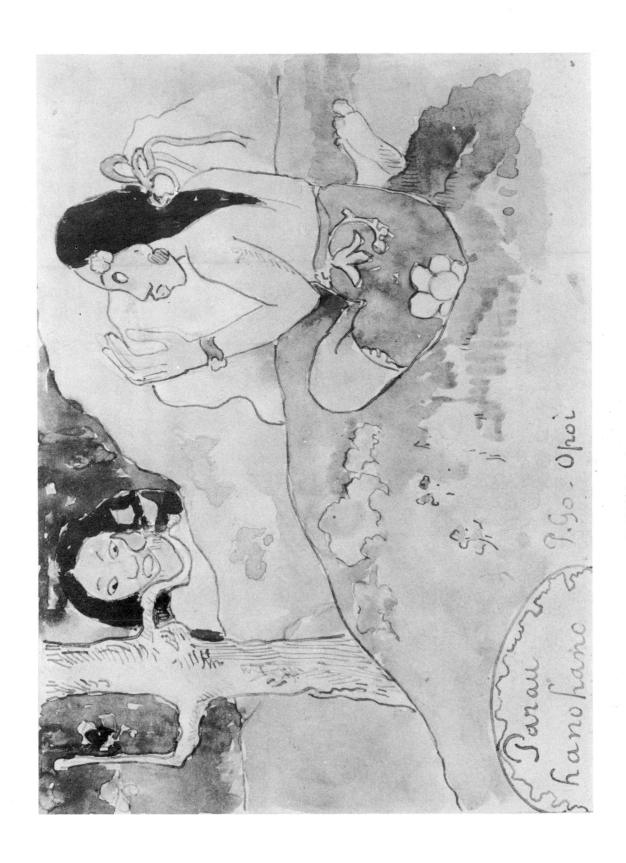

Plate 87

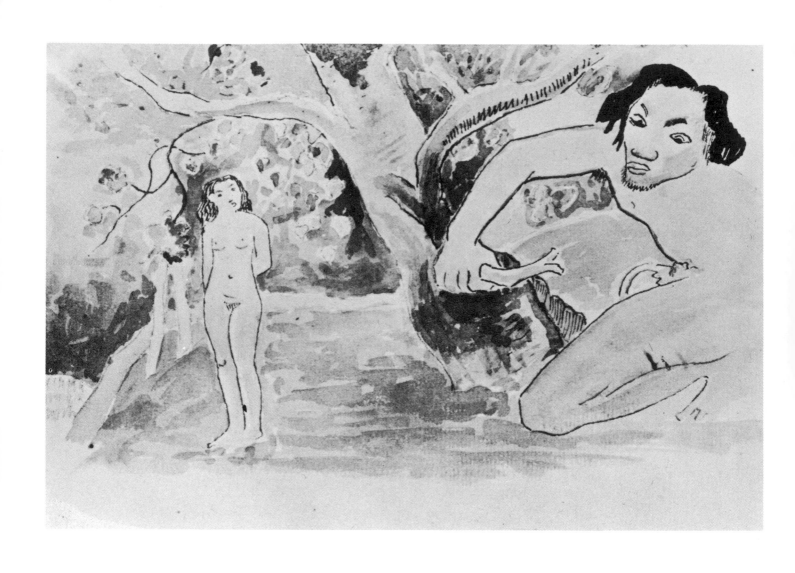

Plate 88

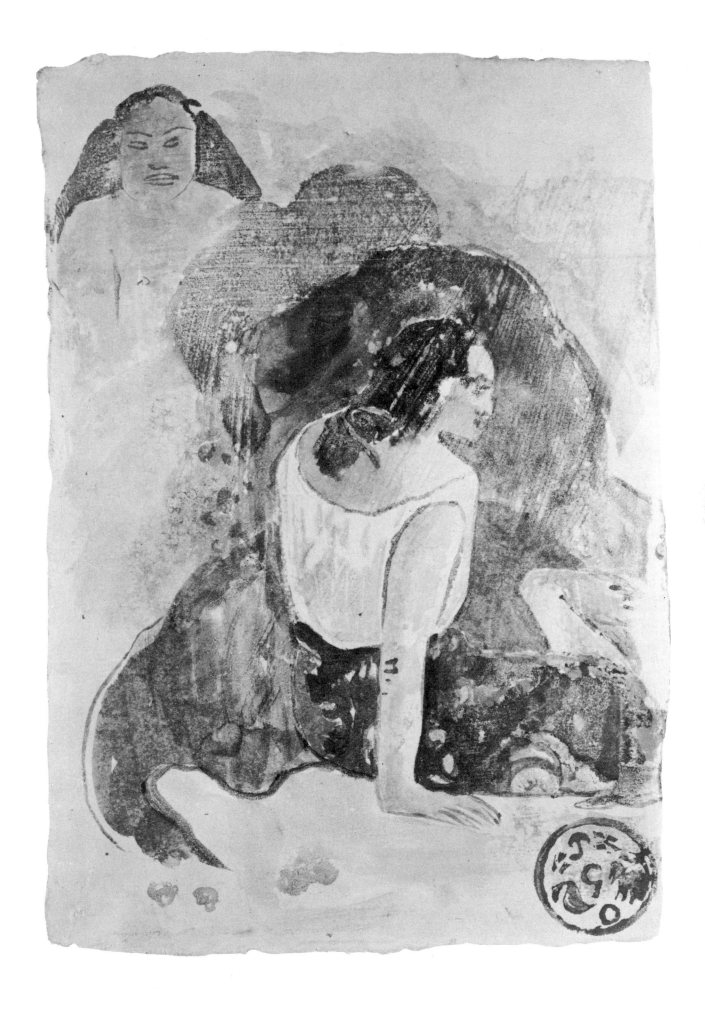

Plate 89

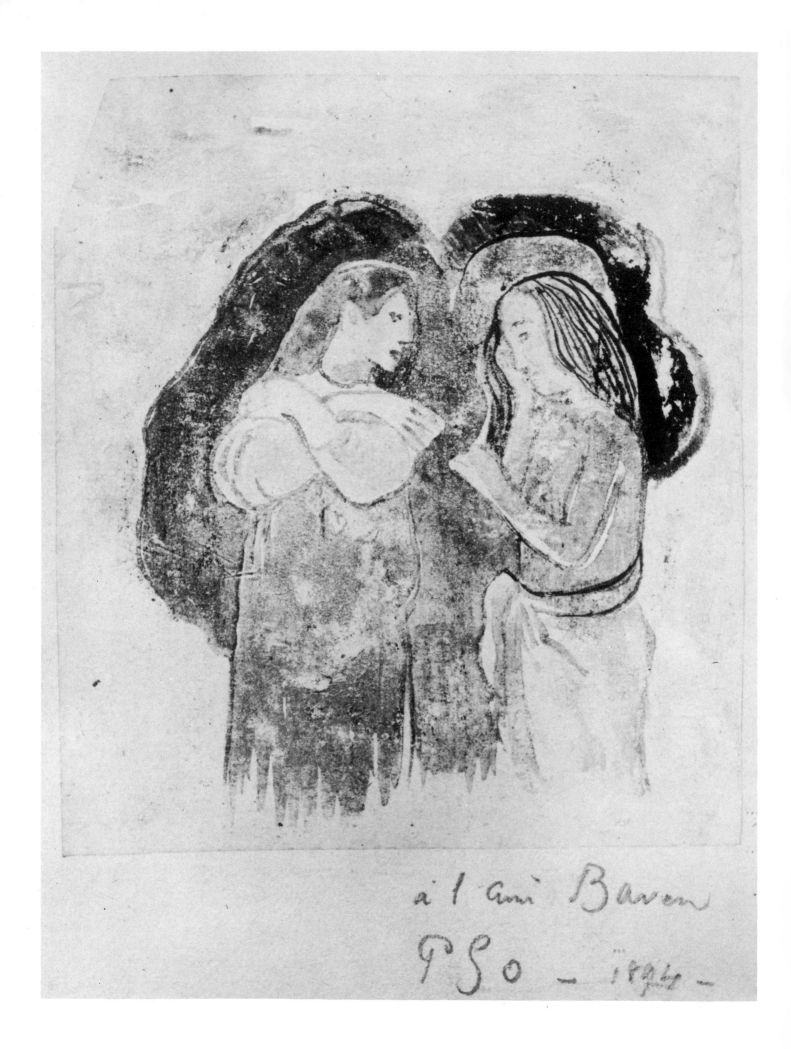

Plate 90

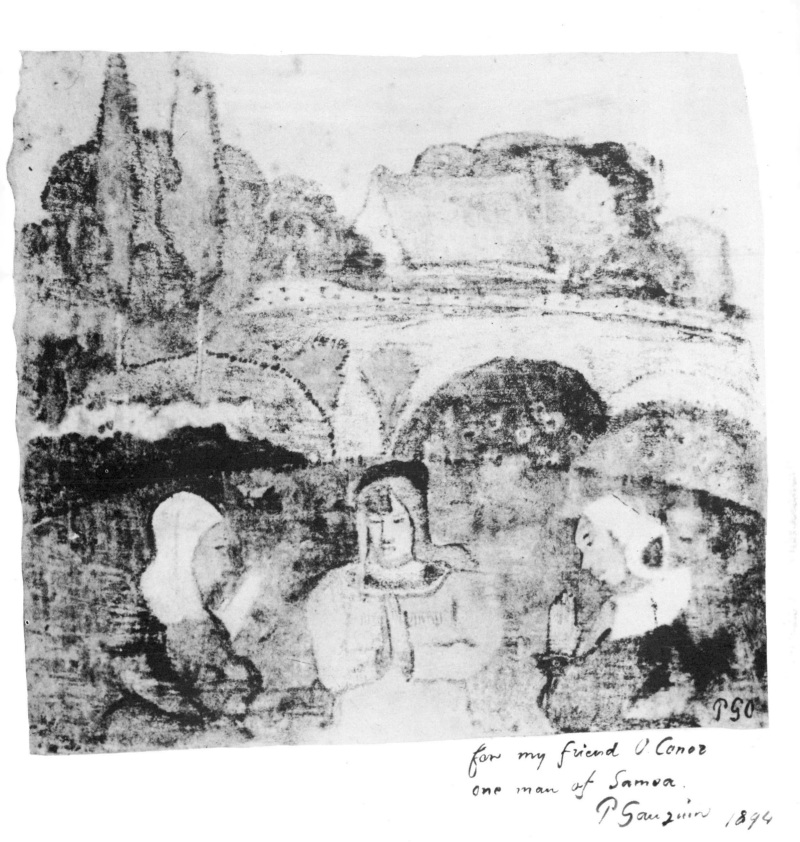

for my friend O. Conor
one man of Samoa.
P Gauguin 1894

Plate 91

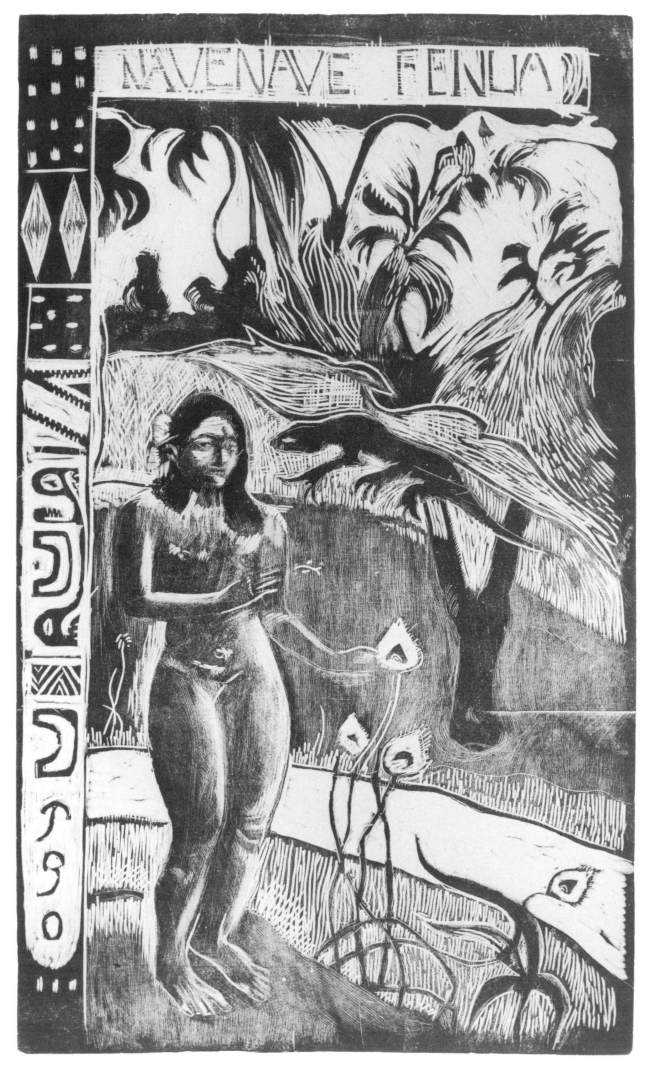

Plate 92

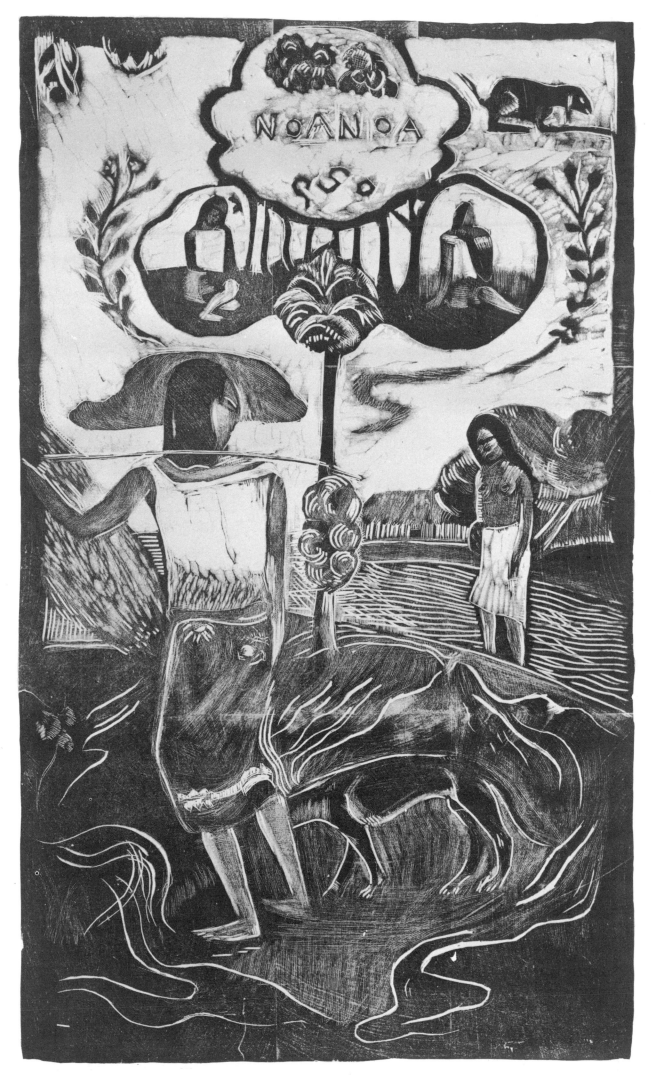

Plate 93

Plate 94

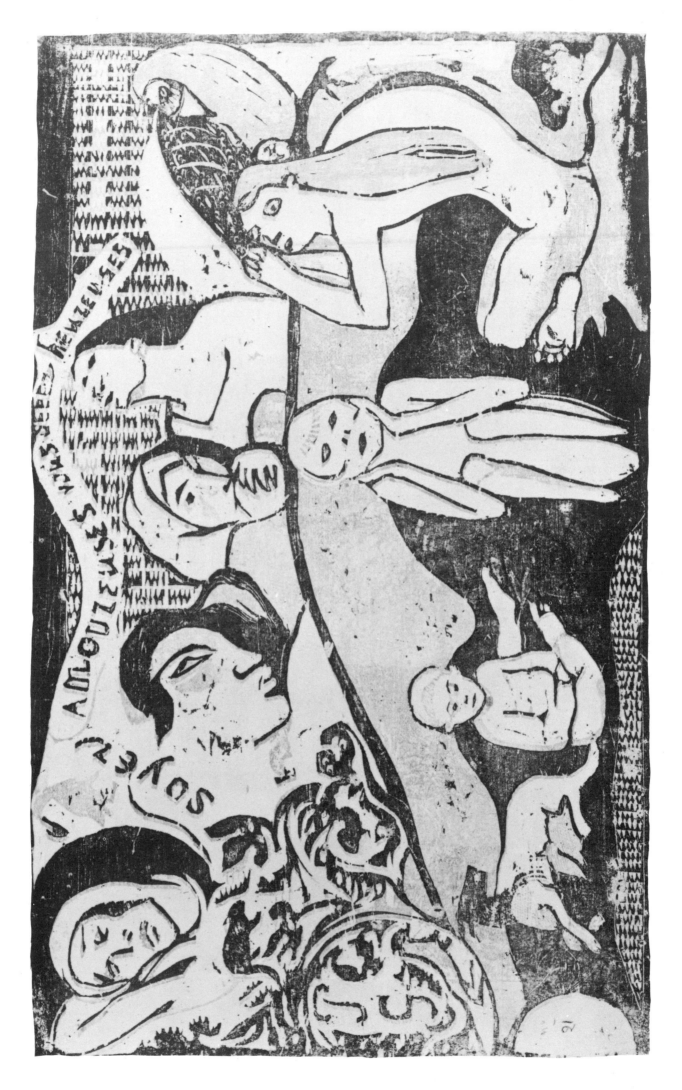

Plate 95

Plate 96

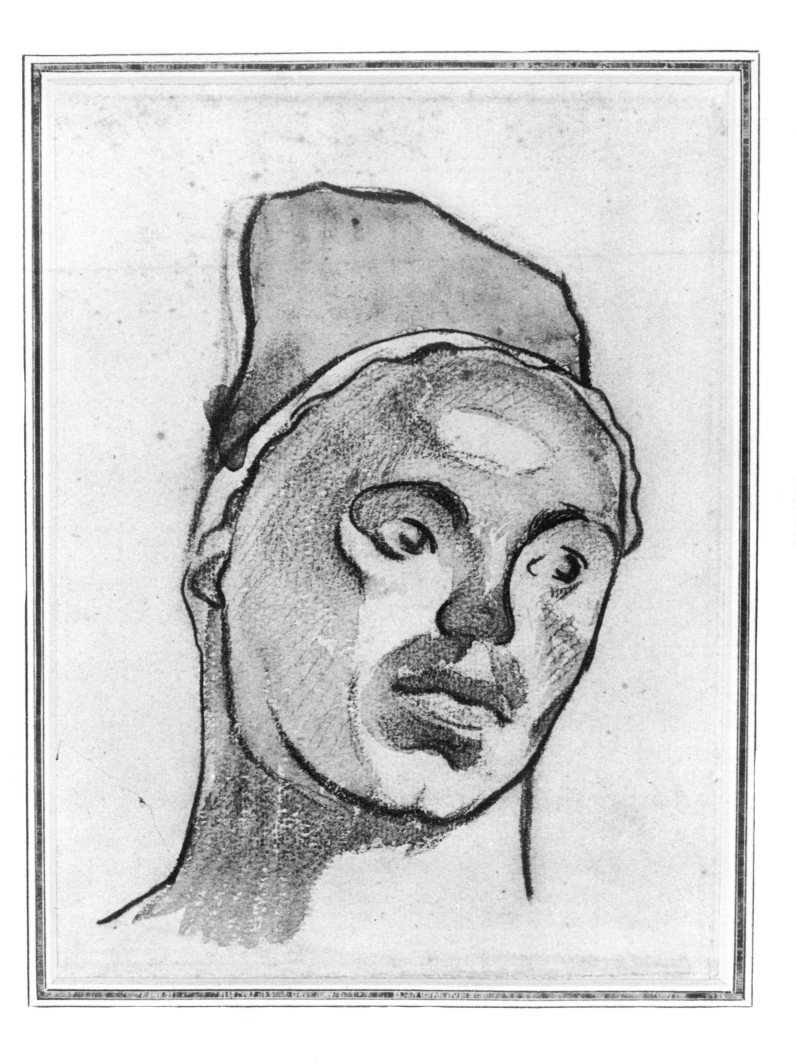

Plate 97

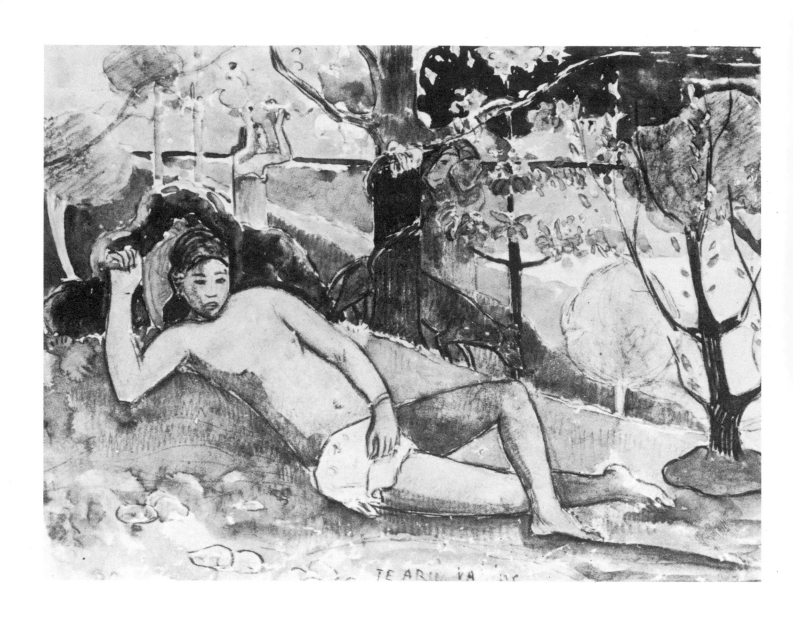

Plate 98

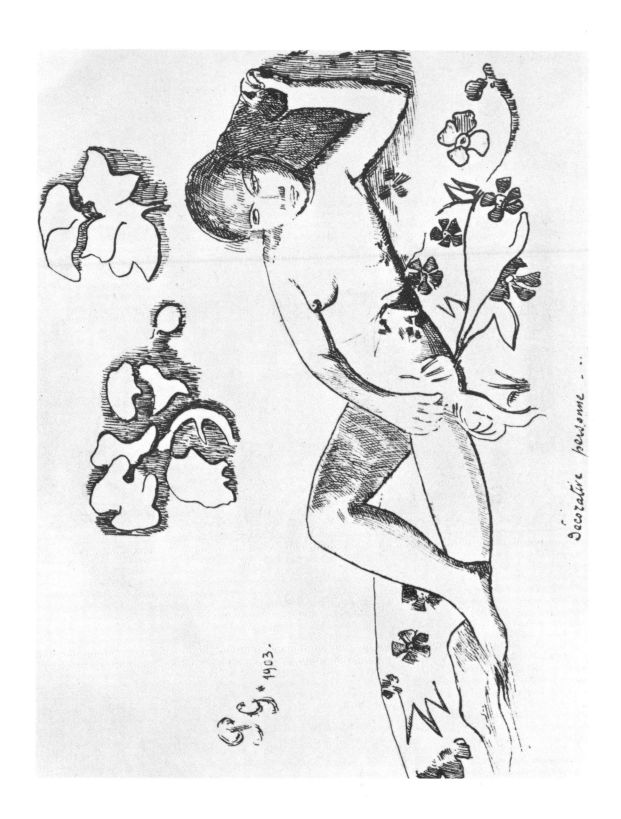

Plate 99

Plate 100

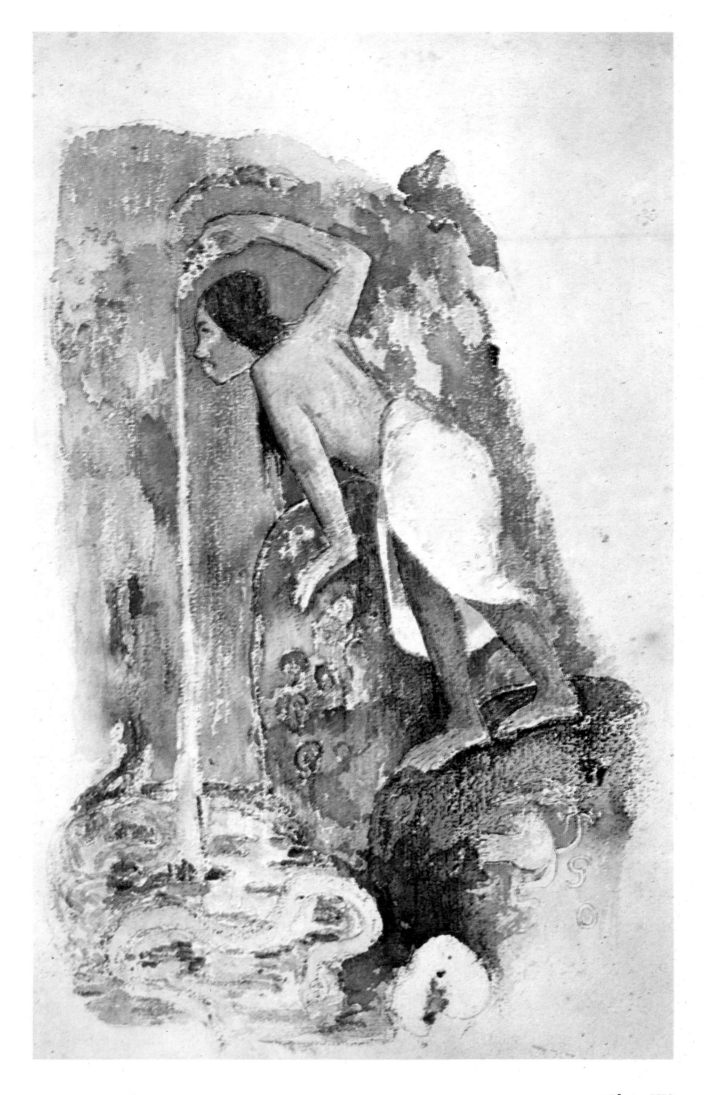

Plate XV

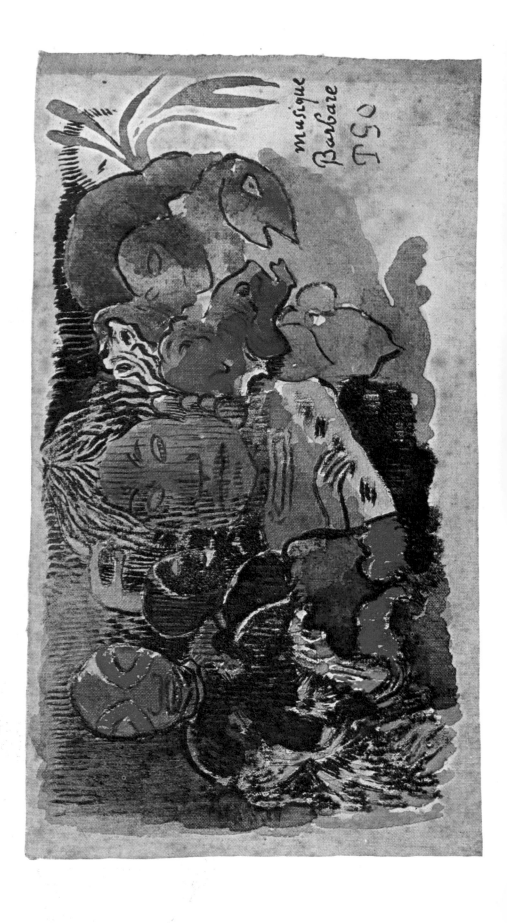

Plate XVI

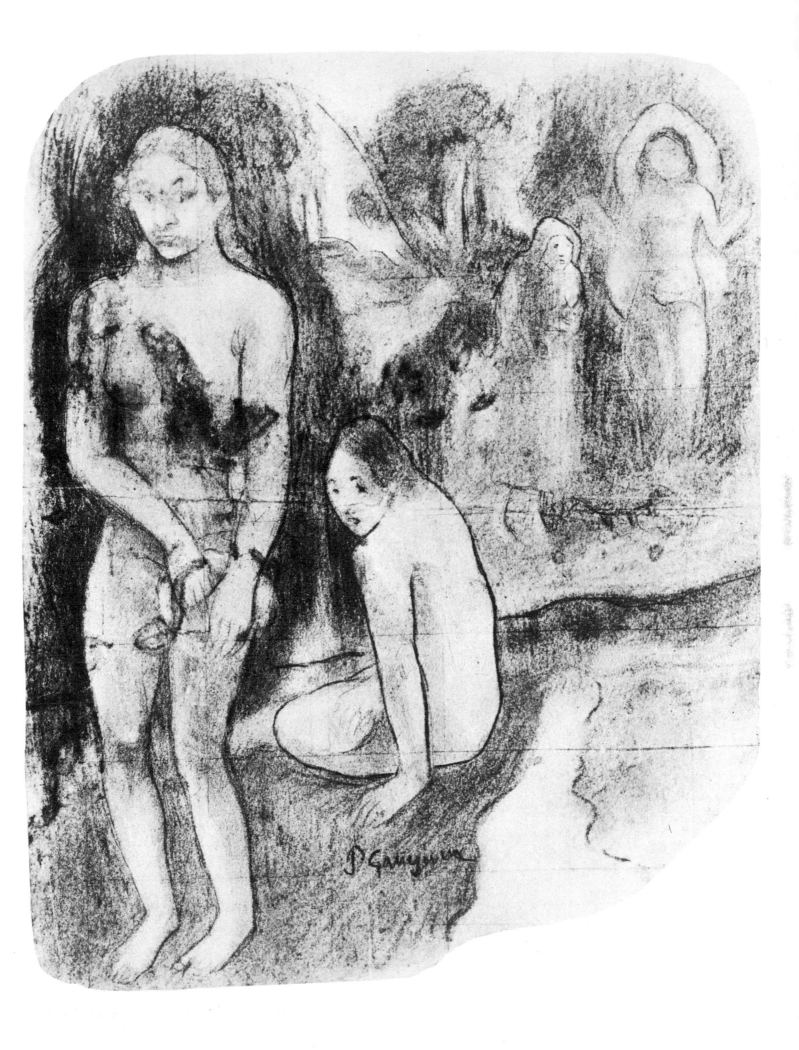

Plate 101

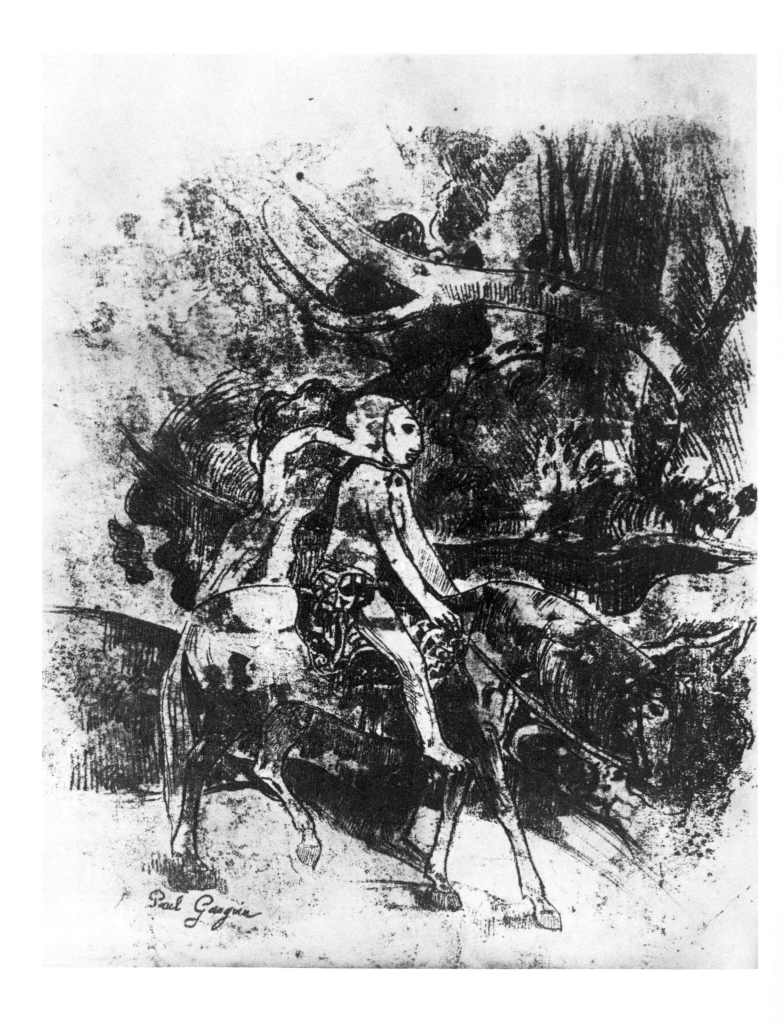

Paul Gauguin

Plate 102

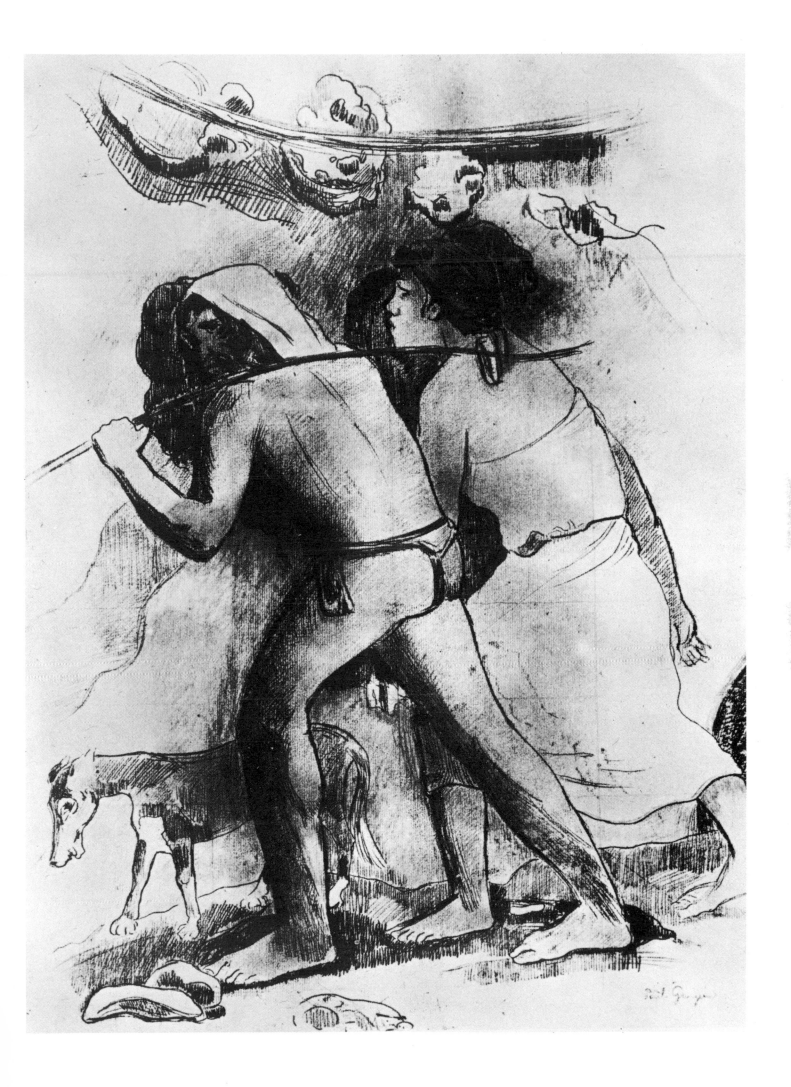

Plate 103

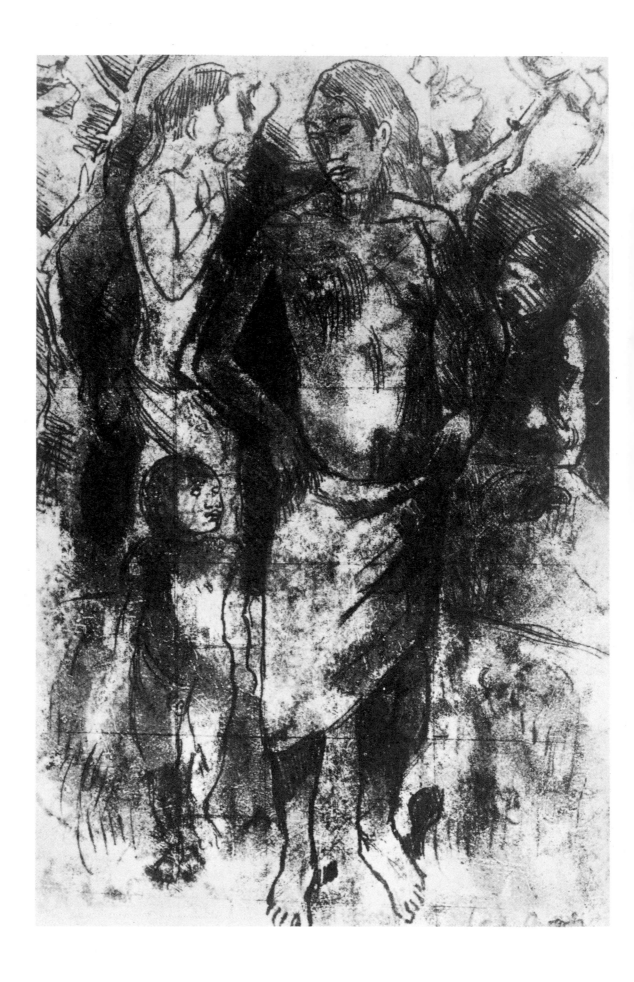

Plate 104

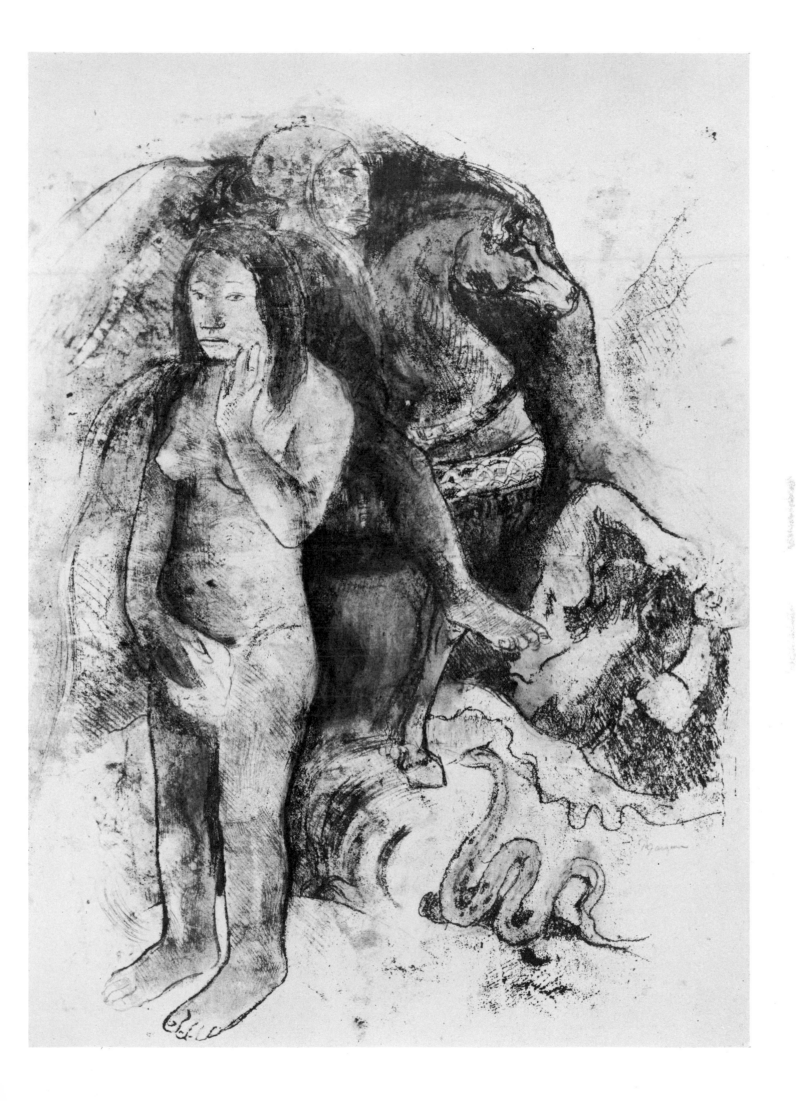

Plate 105

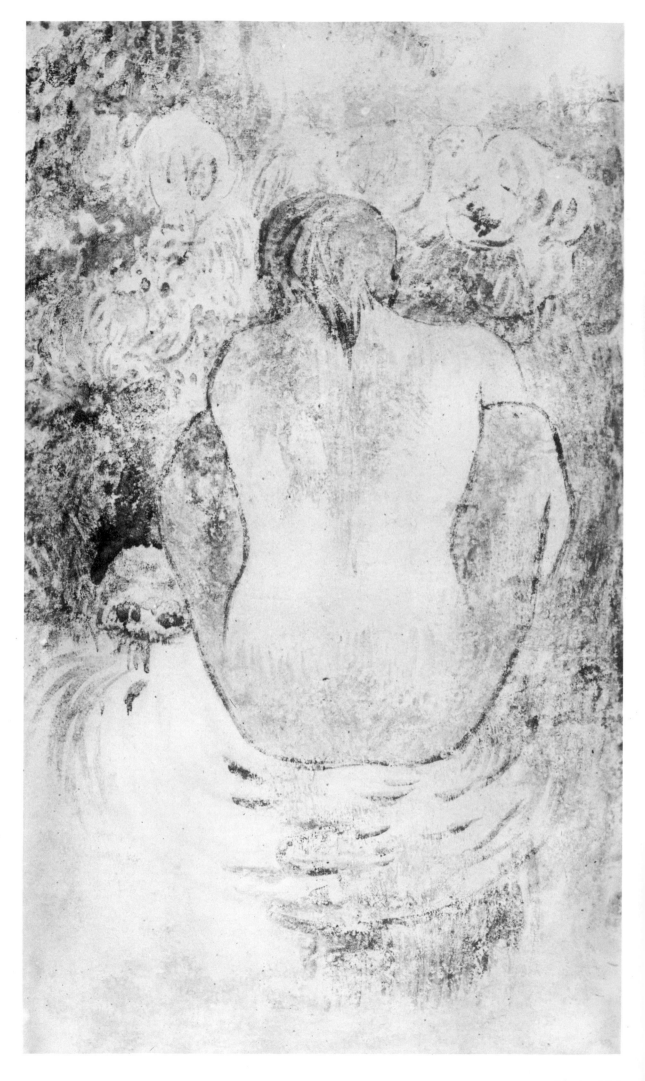

Plate 106

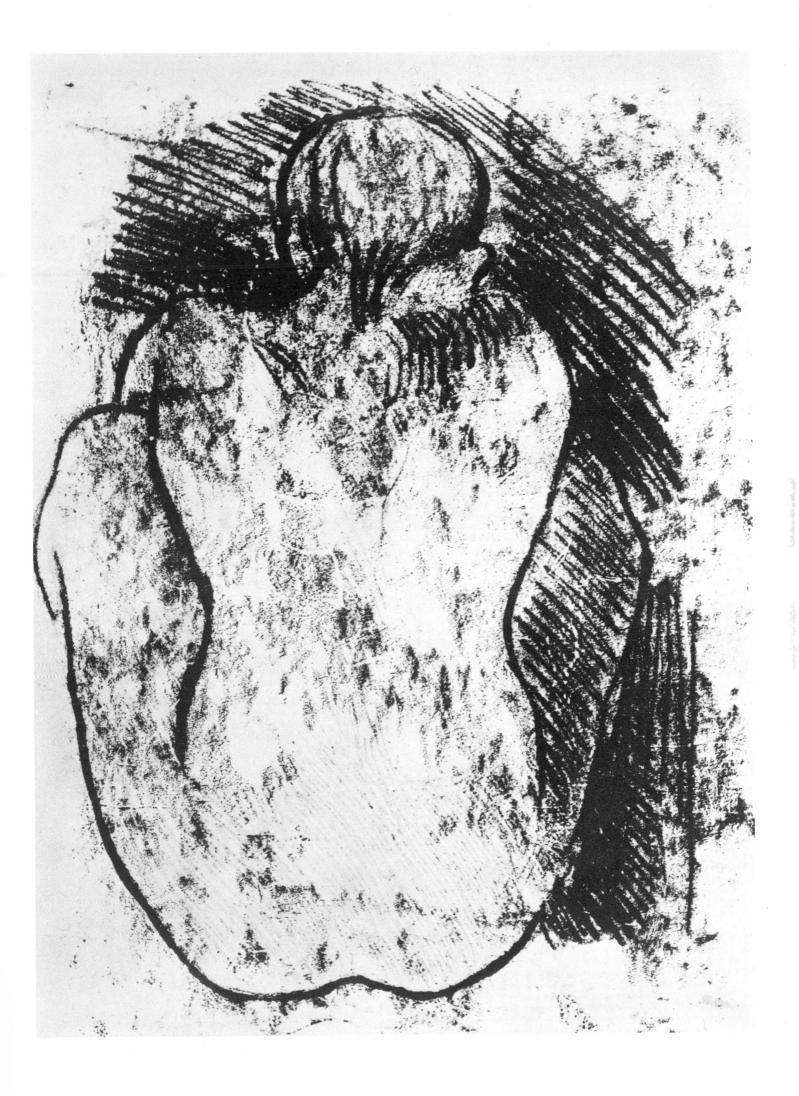

Plate 107

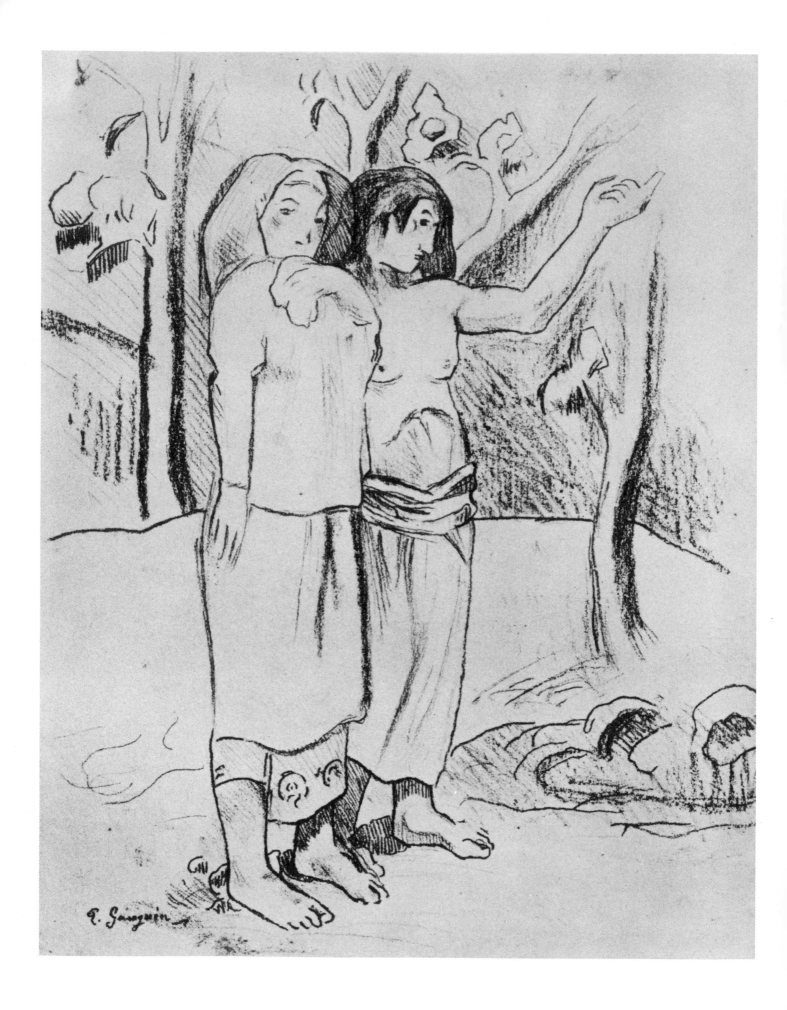

Plate 108

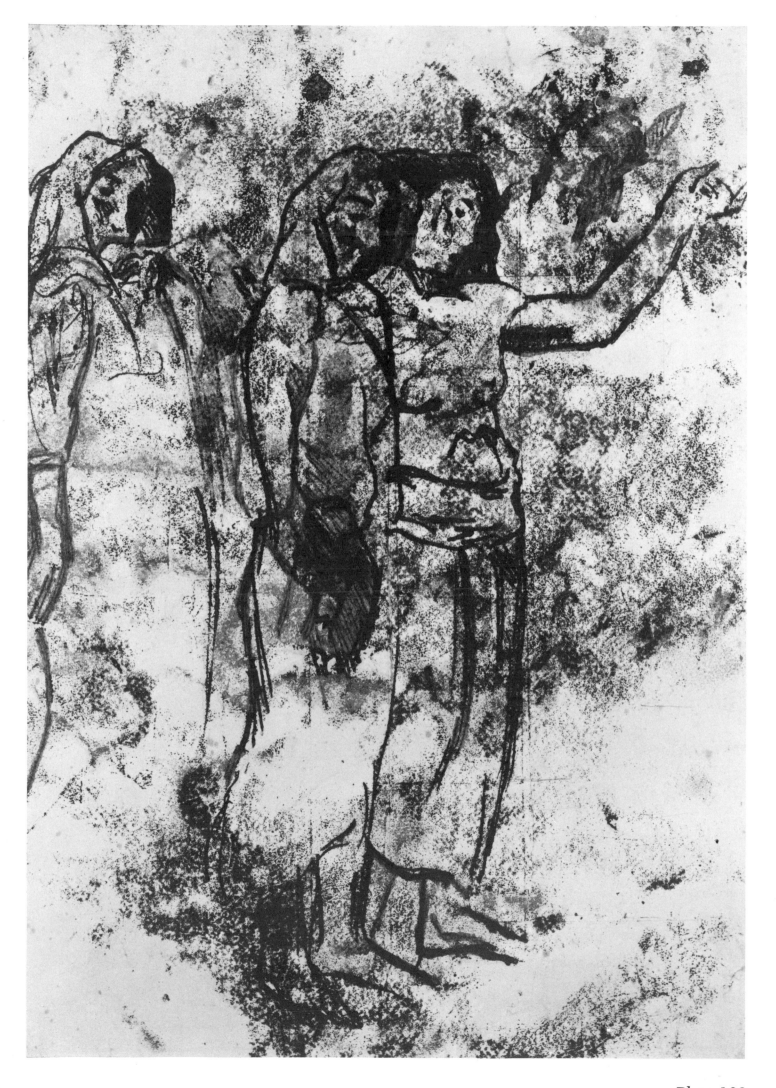

Plate 109

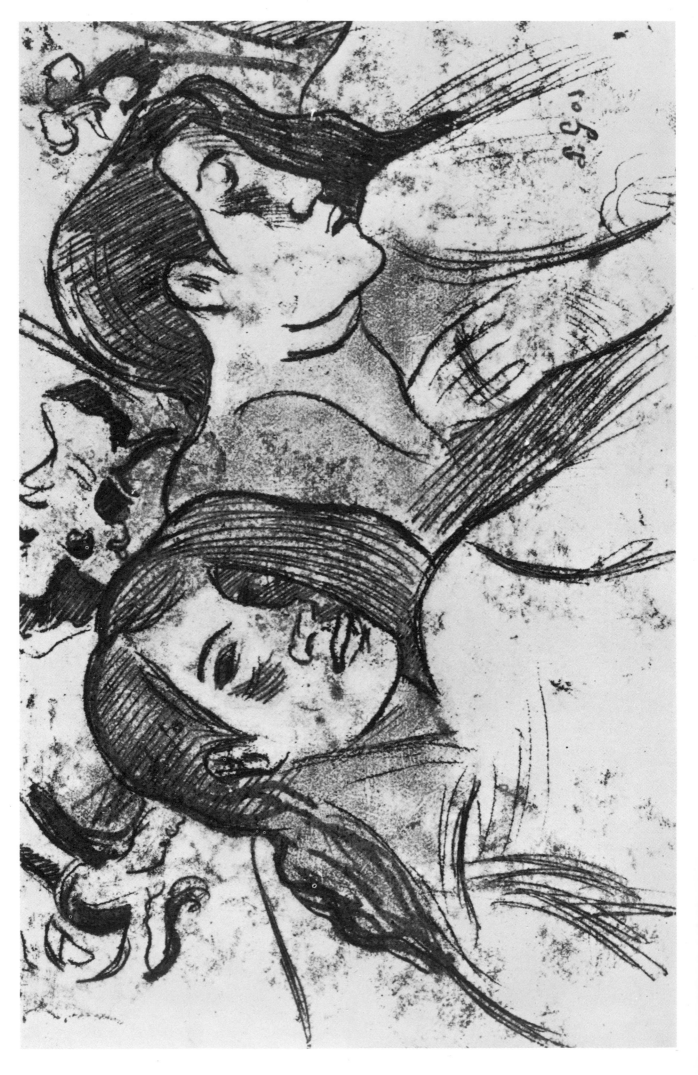

Plate 110

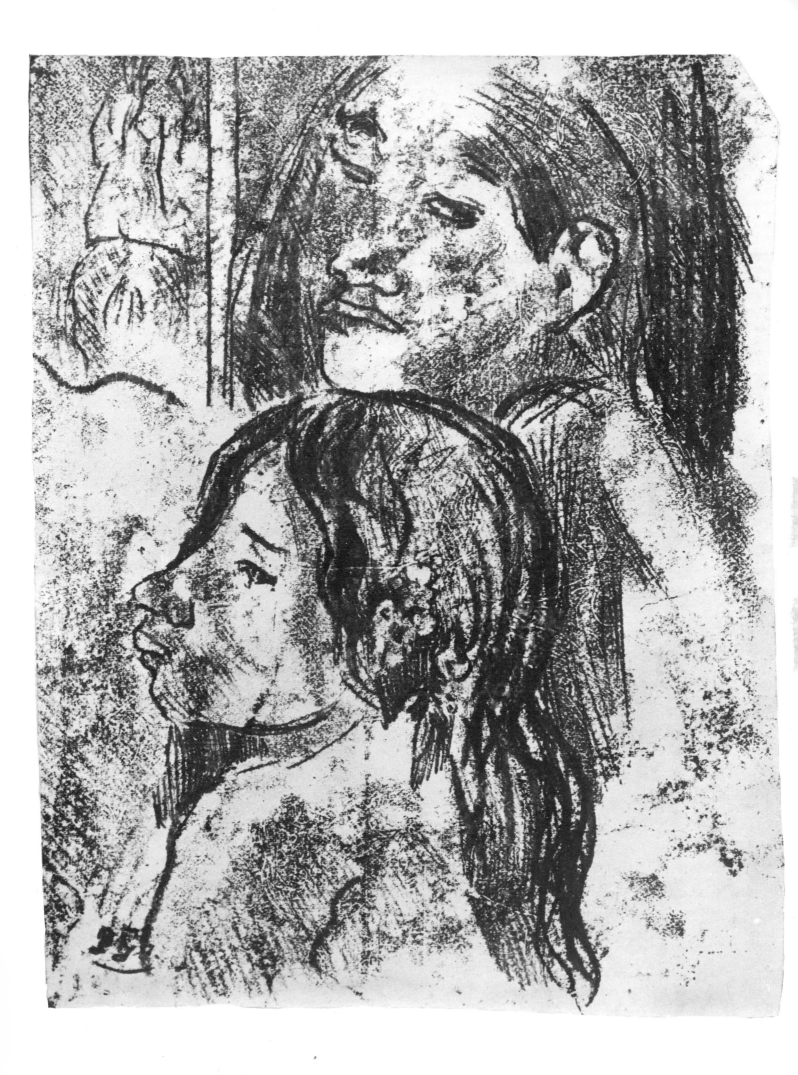

Plate 111

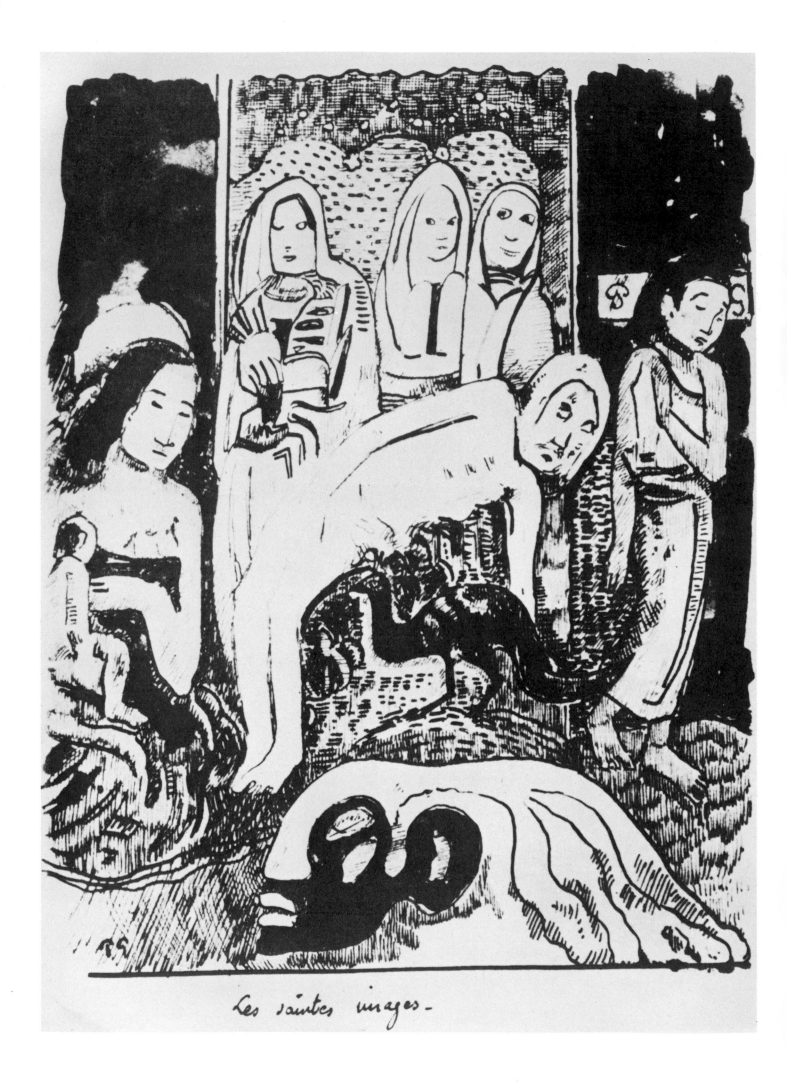

Les saintes images.

Plate 112

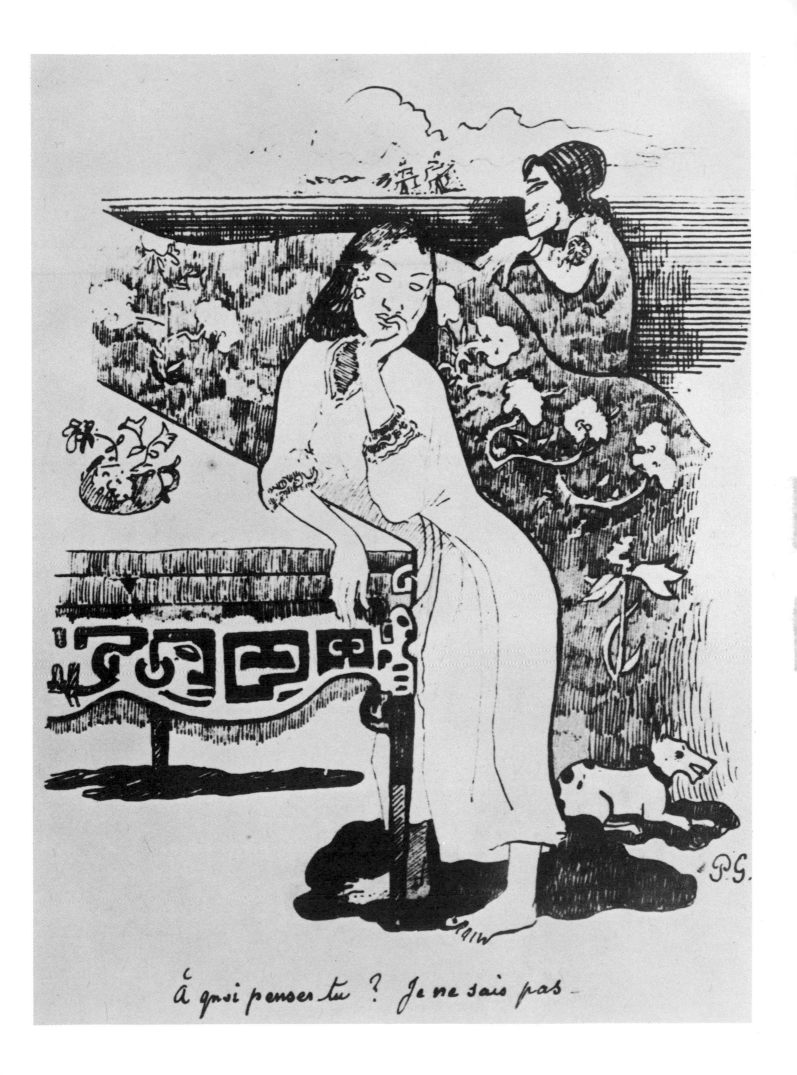

à quoi penses tu ? Je ne sais pas -

Plate 113

Plate 114

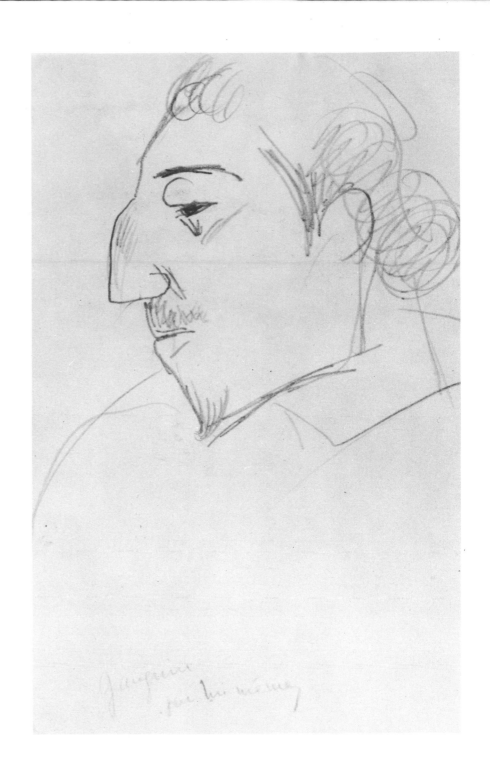

Plate 115

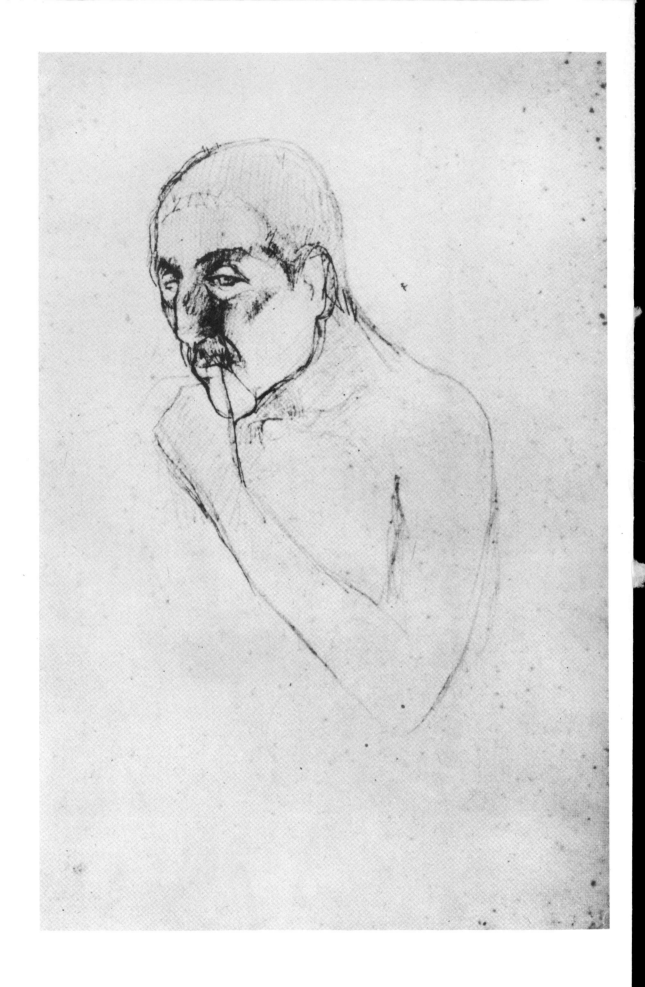

Plate 116